# THE GWR BRISTOL TO TAUNTON LINE

# THE GWR BRISTOL TO TAUNTON LINE

COLIN G. MAGGS

AMBERLEY

Front cover: Ivatt Class 2 2-6-2T No. 41241 taking on water at Yatton, 22 August 1962. (*Author*)

First published 2013

Amberley Publishing
The Hill, Stroud
Gloucestershire, GL5 4EP

www.amberleybooks.com

British Library Cataloguing in Publication Data.
A catalogue record for this book is available from the British Library.

ISBN 978 1 4456 0194 6

Typeset in 10pt on 12pt Sabon.
Typesetting and Origination by Amberley Publishing.
Printed in the UK.

# Contents

# Acknowledgements

Acknowledgements for help are due to Kevin Boak and Colin Roberts.

Train times in this book are those as given in official timetables, the twelve-hour clock being used previous to June 1963 and the twenty-four-hour clock subsequently.

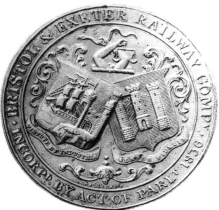

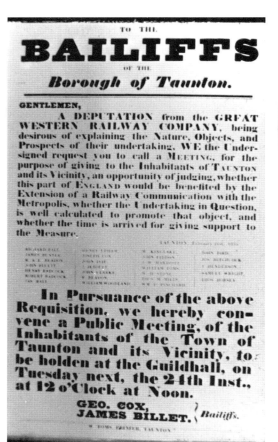

*Above:* The Bristol & Exeter Railway Company's seal.

*Left:* Notice of a meeting at Taunton, 24 February 1835, to discuss the desirability of building a railway to London. (*Author's collection*)

# Introduction

It was a line just asking to be made. Once the GWR Act had been passed for building a railway from Bristol to London, there was obviously great scope in extending it westwards to Exeter and, who knows, perhaps in due course reaching Plymouth, or even Penzance?

It would be a relatively easy line to build as the route was almost flat between Bristol and Taunton, and so needed few substantial earthworks apart from a tunnel and cutting west of Bristol and a couple of other deep cuttings. Thus on 1 October 1835 a group of Bristol merchants issued a prospectus for the Bristol & Exeter Railway. £1.5 million was required in £100 shares, and these were soon taken up. Isambard Kingdom Brunel was appointed engineer-in-chief by a narrow majority. William Gravatt, one of Brunel's assistants, made a survey and a bill deposited in the 1836 Parliamentary session.

The only opposition came from canal companies serving Bridgwater and Taunton, the commissioners for the drainage of the moors of central Somerset, and a few landowners. All were appeased by protective clauses and the bill became an Act of Parliament on 19 May 1836.

There was certainly enough passenger traffic to support a railway, because daily ten coaches ran from London to Bridgwater, Taunton and Exeter; nine from Bristol to Bridgwater, Minehead, Taunton and Exeter; five from Bath to Exeter, Taunton, Tiverton, Barnstaple and Lyme Regis, and seven from Bristol and Bath to Weston-super-Mare, Clevedon, Yatton and Wrington.

The company's first general meeting was held on 2 July 1835 and Brunel confidently predicted that the line would open from Bristol to Taunton and Exeter to Cullompton in the spring of 1838, and the intervening 18 miles by the end of 1839. The meeting elected sixteen directors, none of whom were on the GWR board. Frederick Ricketts was appointed chairman and Samuel Waring, his deputy. Company secretary was Thomas Osler until May 1837 when he was replaced by J. B. Badham.

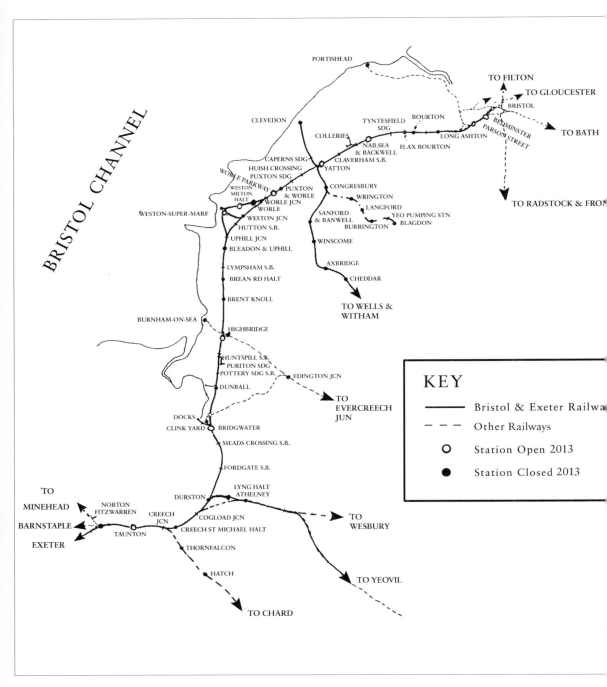

Map of the Bristol & Exeter Railway, Bristol to Taunton.

# Chapter One

# Construction

Initially, to save expense, a temporary terminus was to be opened at Pylle Hill on the Bath Road south of the Avon. Two contracts for the 11 miles to Yatton were let to Hemmings & Ranger and 500 men started work in February 1837. Shortly afterwards two more contracts were let to beyond Bleadon and Uphill.

Some folk were against the railway and tried to upset the detailed survey. This led to an advertisement being placed in the *Bristol Mirror* of 14 January 1837:

> Five pounds Reward. Whereas some evil disposed person or persons have cut and taken away certain ropes affixed to the flag pole on Pile-Hill [old spelling] and pulled up certain stakes placed by the company's engineer for the purpose of marking out the line of the Bristol & Exeter Railway; this is to give notice that five pounds reward will be paid to any person giving such information as may lead to the detection of the offender or offenders.

Railways usually offered landowners a fair price for their property. One parcel of land at Bedminster, with tenements, was first priced by the owner at £2,300, but later he reduced it to £1,400. The B&E, believing this still extortionate, took it to an inquisition at the Guildhall, Bristol, where the Under-Sheriff and Jury's verdict was £760 plus £15 damages.

Similarly, on 14 May 1841, an inquiry was held at Taunton before the Under-Sheriff to assess compensation to be paid to the Reverend Henry Cresswell, Vicar of Creech St Michael, in respect of the vicarage, outbuildings and 9 acres of glebe land which the railway was obliged to purchase. Cresswell had sent in a claim for £4,400 and refused to accept the B&E's offer of £3,150. This proved foolish. The jury awarded him £2,450 for the property plus £200 personal damage.

Unfortunately for the B&E, 1837 was a year of financial depression. All shareholders had paid the deposit, but 990 were in arrears with the first call and 10,298 on the second. In August 1837 the directors provided shareholders with encouraging statistics suggesting that when the railway opened to Bridgwater it would receive a net revenue of over £80,000, sufficient to pay a dividend of 13 per cent on the £35 believed sufficient to cover the cost of opening to that town. They believed that the policy of opening the line in stages was correct in order to keep investment and return in line with each other.

They further observed that the completion of just 10 miles of line would 'enable the Company to bring the products of a vast Coalfield into the City of Bristol',

and that 12 more miles, 'to bring the line close to the mouth of the Axe and the natural Harbour of Uphill, will establish a Line of Communication between the whole of the South of Ireland, including of course the southern coast of Wales, and Bristol and London, of which the most sanguine can scarcely calculate the advantages'. The 'vast coalfield' was at Nailsea & Backwell, and in reality all the pits closed around 1880, while the harbour was never completed.

At the general meeting on 5 March 1839 Chairman Ricketts said that he was 'more and more convinced of the national utility and benefit of these great works. Had it not been for them, their poor population would not be employed.' He also stated that virtually all the land required for building the line between Bristol and Bridgwater had been purchased. £28,434 had been received in late calls.

Some shareholders expressed concern that works were not being extended to Exeter – served by seventeen coaches daily – and said that had they known, they would not have subscribed. With some opposition this meeting adopted that the Bristol & Exeter be built to the broad gauge of 7 feet 0¼ inches.

One shareholder sagely commented that the London & Southampton Railway was seeking Parliamentary powers to change its name to the London & South Western Railway and he foresaw that should it wish to extend to Exeter, this would indeed be a good title. In due course it did rival the B&E.

Meanwhile the remaining contracts for the line to Bridgwater had been let in the spring of 1838. At the general meeting on 5 March 1838 it was revealed that eighty-eight shares were still in arrears of the second call and 2,365 outstanding on the third. Following this meeting at Bristol, between sixty and seventy shareholders proceeded in carriages to Flax Bourton to view progress on the line. William Gravatt, the residential engineer, welcomed them and they were drawn by a locomotive in wagons at 12–14 mph. Afterwards they dined at the Angel, Flax Bourton.

On 11 June that year Parliamentary powers were given to build short branches to Nailsea, Weston-super-Mare, and the mouth of the Axe, where it was expected that a large harbour would be established at Uphill. Burnham-on-Sea was also to be served by a branch. Apart from that to Weston-super-Mare, all these proved abortive.

Due to easy levels, construction costs proved less than half those of the GWR. The *Railway Magazine* paid the B&E a glowing tribute: 'We have before us the last Report of the Directors, with a map and section prefixed, and with an Appendix containing full tables of the traffic, which we consider most convincing, and altogether forming the best manual of a railway we ever saw.'

Excavations sometimes turn up artefacts of historical interest. At Long Ashton the foundation wall of an ancient village was discovered and also Roman domestic utensils and numerous coins of Constantine and Severus.

On 13 August 1839 some of the directors laid the first stone of the Parrett Bridge, and the same month they reported that the contractors were behind with their work and the completion of Ashton and Uphill cuttings deferred. They had abandoned the idea of a terminus at Pylle Hill, believing it imprudent to postpone making a junction with the GWR. Five locomotives had been ordered from Sharp, Roberts & Co. In December 1839 a new temporary section of road was used while the bridge was erected at Pylle Hill to carry the Bath Road over the railway.

The timber Somerset Bridge over the River Parrett. (*Author's collection*)

At the general meeting in March 1840 it was reported that the unfavourable weather since the previous meeting had retarded construction: floods had delayed work on river bridges over the Avon, Yeo, Axe and Brue; furthermore, pressure on the financial resources of the country were causing problems. The company was particularly troubled by the large number of shares being put in the hands of 'irresponsible shareholders' who had taken up shares merely for speculation and had no funds available to pay calls, and the B&E was unable to borrow money until £50 had been paid on each £100 share. Brunel made a revised estimate of £720,000 to £780,000 for laying a single line and £800,000 to £820,000 for double track.

On 14 August 1840 an agreement was made to lease the Bristol to Bridgwater line to the GWR at a rental of £30,000 per annum plus ¼d a mile for each passenger or ton of goods, the directors undertaking to open the line to Bridgwater by 1 June 1841. This lease meant that it obviated the need for the B&E to purchase locomotives and rolling stock.

At the general meeting on 2 September 1840 Frederick Ricketts announced that the problem of arrears was being tackled. 1,055 shares had been forfeited and over 2,700 more would be. Bad shares would be sold to those holding good shares and this would raise between £30,000 and £40,000. The difference between the £40 possible for a share – had all the calls been paid – and that actually received would be borne by the B&E. Total receipts to 30 June had been £541,704 and expenditure £516,939. The editor of the *Bristol Standard* of 10 September 1840 wrote enthusiastically, 'Traffic on the Exeter line will repay – well repay – the cost.'

A special meeting held on 29 October 1840 authorised new shares being issued in lieu of those forfeited by non-payment of calls. These new shares were offered

to existing shareholders at 40 per cent discount *pro rata* to the number of shares held.

In September 1840 Brunel reported that the abutments of the bridge over the New Cut, Bristol, were complete, its centres erected and the arch in progress. The Axe Bridge was finished and the bridge over the River Parrett in an advanced state. Three quarters of Flax Bourton Tunnel was complete and, depending on the weather, the line would be ready for laying the permanent way in January and February. The survey of the line between Bridgwater and Taunton was concluded. By early November the New Cut Bridge was nearing completion and the line almost ready for the permanent way. The longitudinal timbers were on hand as were the immense wrought iron tanks for kyanising – the process for wood preservation before the use of creosote. The B&E was constructed during the period when kyanising was falling out of use and creosote becoming popular.

On 4 March 1841 it was reported that for the first time all shares were in the hands of responsible names and, as considerably more than £750,000 (half the capital) was paid up, the company could now borrow money on debentures without needing to make further calls. It had not been permitted to borrow until half the share price, that is a total of £50, had been paid by calls. Brunel said that Flax Bourton Tunnel and the bulk of Ashton Cutting was complete; Uphill and Puriton cuttings were finished, but masonry had been delayed by severe frosts. The aqueduct at Long Ashton was sufficiently complete to allow the removal of the temporary water course. Permanent way was being laid and timber for the track

Advertisement in the *Bath & Cheltenham Gazette*, 9 March 1841, seeking tenders of loans on debentures.

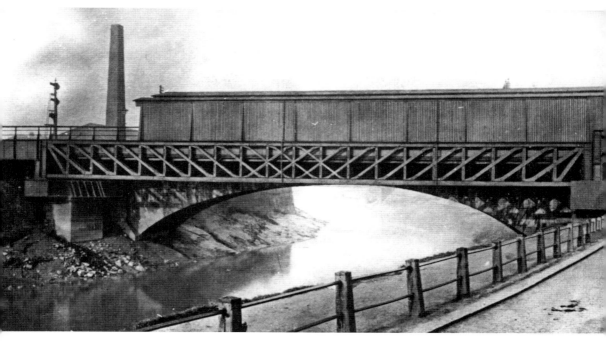

The bridge over the New Cut, view downstream. The steel girder bridge was added to support the platform extension. (*Author's collection*)

beyond Puriton had been landed at Highbridge, at the River Axe for that towards Highbridge and material had been landed at Bridgwater.

One shareholder joyfully exclaimed, 'The sun now shines upon us; our difficulties have vanished as at the touch of a magician's wand, and we may regard the future with a feeling of equanimity and serenity of confidence. Our railway when complete will be without equal; it will be the ambition of the world; no line will be able to compete with it for smoothness and steadiness, so straight and level is its course.'

Uphill Cutting was through marl covered by blue lias and limestone, and its excavation had improved the knowledge of geologists. It had been found necessary to alter the course of the River Axe for 1½ miles to accommodate the railway.

On 28 April 1841, disaster struck and Temple Meads station narrowly avoided being burnt to the ground. Between the passenger station and the river, timber was stacked for the B&E's construction. At approximately 8.00 p.m. the accidental ignition of a tank of creosote set the pile ablaze. The 'varying colours of the flames and the immense volumes of fiery smoke poured from the principal stack' attracted crowds of sightseers as the burning mass occupied at least 2 acres. Brunel directed that the three sides of the stack not facing the river be removed to stop the fire spreading and that the trees should be cut down in Pipe Lane, situated almost immediately north of the passenger station. These precautions had the desired effect and saved the nearby sawmills of Mr Kidd and the numerous courts and alleys in the densely populated district of Temple Back. Fortunately the wind was blowing from the direction of the station, so the terminus was not threatened. A

party of seamen from the brig HM *Savage*, seeing the flames' reflection in the sky, immediately lowered a launch and, accompanied by their chief officer, pulled up to the Cattle Market and performed a great service removing logs, thus preventing further loss.

After destroying £5,000 worth of timber, the fire eventually died down at 2.00 a.m. As it was insured, the B&E shareholders did not have to bear the loss. The total value of the timber was £30,000, but eight trow-loads had already been sent down the line and, only twenty-four hours earlier, more timber had been placed in tanks of sulphate of copper, which was used as a preservative – and, on this occasion, worked in more ways than one.

Bristol Temple Meads platform tickets.

# Chapter Two

# Navvies

As a navvy's job was dangerous, accidents were inevitable. On 31 May 1839 a boy aged eleven died at Bristol Infirmary from a leg fracture incurred whilst working on the railway. The navvies raised a subscription to have his body conveyed to his parish church at Flax Bourton, and on 5 June, 200 navvies wearing white rosettes followed his corpse to the burial.

On 29 August 1839 James Evans was blasting rock when fire accidentally fell into a bag containing 1½ lb of gunpowder. It exploded and he was taken to Bristol Infirmary with fatal injuries.

On 4 August 1840, navvies were blasting rock at Pylle Hill when a fuse was lit and the charge exploded before one labourer could escape. He was blown about 25 feet into the air and killed.

Sometimes construction caused mishaps to non-railway personnel. Building the bridge over the New Cut just south of Temple Meads, two piles had been driven into the riverbed to support the arch centring and these piles were not marked with buoys. At high water these piles were concealed 3 feet below the surface.

On 21 February 1840 the barge *David*, drawing 4½ ft, was navigating the waterway with a load of coal and struck these piles. When horses tried to drag the vessel off, the ropes broke. When eventually removed, she was so injured that she had to spend five weeks in dock. Her owner, Mr Wall, was awarded £140 damages.

As much of the country passed through was flat, bridges over the line required ramps. In order to obtain material for these, 'borrow pits' were dug. These often filled with water and created swimming pools for the local youths. There was one such pond near Nailsea.

On 15 August 1840 Michael Pascoe, aged sixteen, son of a collier and a non-swimmer, unaware of a 12-foot drop from the shallow portion, stepped out of his depth and struggled for air. Henry Weymouth, seventeen, son of a schoolmaster and also a non-swimmer, tried to rescue him but he, too, got into difficulties. Both drowned.

The church was anxious to assist the spiritual welfare of navvies and in 1838 the Reverend John Campbell MA was appointed missionary chaplain to the B&E navvies by the Bishop of Bath & Wells. The B&E directors and the Pastoral Aid Society 'contributed liberally to his support. The men have received the chaplain in the most cordial manner', said the *Bath & Cheltenham Gazette*.

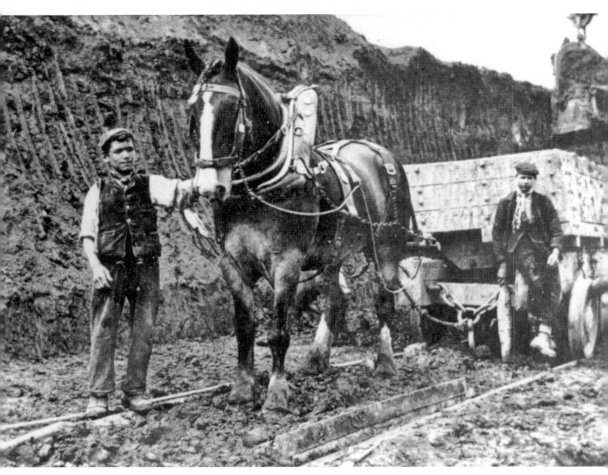

Navvies at work making a cutting. This view was in later days, when a mechanical excavator was used. (*Author's collection*)

Navvies were relatively well-paid and tended to spend too much money on beer. On 30 June 1839 Richard Rowe and others were drinking at the Long Ashton beer house. They left at 10.00 p.m. to have a fight outside. Richard Rowe and two others then returned, found it closed, knocked on the door and asked for more beer. Informed by Charlotte Weaver, the servant, that it was after hours, that no more would be sold that evening and the door would not be unlocked, they threatened to kick it in.

The landlord, Harwidge, was in the Bristol Infirmary with a broken arm, having been previously assaulted by navvies. Mrs Harwidge came up behind the closed door and advised the men to go home. Mrs Harwidge and Charlotte, alarmed by the navvies threats, called on her nineteen-year-old son Lewis Harwidge for protection. Alarmed, he ran and fetched a pistol. Intending to scare the navvies away, he opened the kitchen shutter and poked the pistol out. It discharged accidentally.

As soon as it went off Lewis said to a servant, 'Bless me, how glad I am that I have not hurt anyone, for I might have killed myself or the poor man, as it went off unawares.' Charlotte asked, 'Be you sure no one is hurted?'

Actually the contents of the pistol had entered the right eye of the navvy Richard Rowe. Charlotte looked out, saw Rowe lying on the ground, went out and dragged the corpse into the beer house.

The small pocket pistol was faulty – the hammer would not remain in position as there was no catch to the cog and thus would not stay at cock or half-cock.

The inquest returned a verdict of manslaughter against Lewis who was committed for trial. Lewis escaped, but gave himself up two days later.

At the trial on 10 August at the Crown Court, Bridgwater, many people gave him an excellent character and the jury acquitted him.

Rowe was buried in Long Ashton churchyard on 3 July, the funeral being attended by over 300 navvies. 'They all expressed great dissatisfaction at the [inquest] verdict and used many threats of personal violence to the Harwidges and of the destruction of their house.'

When the B&E was under construction an ugly situation developed over wages, and 200 to 300 men were on the verge of mutiny. As Brunel's appeals were in vain, he sent for magistrate Thomas Tutton Knyfton of Uphill Castle. One contemporary account said,

> Without loss of time Mr Knyfton started for the scene of action and taking the Riot Act in his hand, passed into the thick of the crowd where he was greeted with menacing language and uplifted pick axes.
>
> With calmness he talked to the men telling them the law was stronger than force, and that all would be well if they acted in the spirit of their contract; if otherwise a troop of Cavalry from Horfield Barracks would probably be marching on Uphill.

The navvies saw sense and returned to work.

While the line was being built, Brunel and his family spent some time in Swiss Villa, Locking Road, Weston-super-Mare. Now demolished, for many years it was the home of Sir John Eardley-Wilmot, one of the prime movers of the Brean Down Harbour scheme.

# Chapter Three

# Opening to Bridgwater

It was intended that the public opening be on Monday 31 May 1841, but Sir Frederick Smith, who inspected the line on behalf of the Board of Trade, asked for postponement as he found several deficiencies in the permanent way and fences. It was intended that the ceremonial train for directors and shareholders would still run on this date, but as the *Bristol Standard* reported, 'One of the engines [*Javelin*] having been exercised without permission on the previous day and coming into contact with a truck, the line became obstructed, so that the excursion was postponed to Tuesday.'

Apparently on 30 May the driver of Sun class 2-2-2 *Javelin*, built at Bristol by Stothert, Slaughter & Co. and intended to haul the first train the following day, contrary to orders, took his engine down the line and, as no train was expected, a trolley fouled the line near Brent Knoll. *Javelin* was derailed and *Fire Ball* sent to re-rail it.

On 31 May, thousands gathered on Pylle Hill and more along the route to see the first train, while the platform at Bristol was 'crowded to excess'. Then a notice from the directors was posted in the carriages that an unexpected obstacle had obliged postponement until 1 June.

That day the special, consisting of four first and four second class coaches – with rather less than the 400 passengers it would have carried had it run the previous day – left from a temporary wooden platform at Temple Meads behind Fire Fly class 2-2-2 *Fire Ball*, which previously had drawn the first train between Bristol and Bath. The Fire Fly class was a slightly larger version of the Sun class.

With Brunel and Gravatt on the footplate the train left for Bridgwater at 9.46 a.m., crowds cheering, with the passengers responding. Although the slopes of Pylle Hill were lined with spectators, there were less than the previous day. *Felix Farley's Bristol Journal* commented, regarding Flax Bourton Tunnel, that it presented 'from either end one of the most beautiful vistas imaginable' and that the 110-yard-long tunnel was precisely as long as the train.

There was a stop for 8 minutes at Backwell to take on water and the first train arrived at Yatton at 10.25 a.m. where it was greeted by a rural band playing 'See the conquering hero comes'. The 12-mile journey from Bristol had taken 45 minutes. It stopped for only 1½ minutes and was welcomed by the villagers of Banwell at 10.42, where an old woman exclaimed, 'Lord help we! What shall we see next?' After 1½ minutes it made a 7½-minute journey to Weston Junction. Exclusive of stops, the 18½ miles had taken 56 minutes.

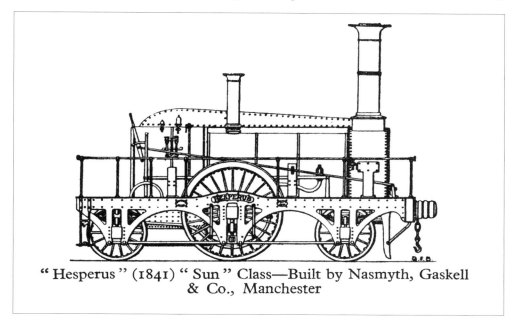

**" Hesperus " (1841) " Sun " Class—Built by Nasmyth, Gaskell & Co., Manchester**

*Hesperus*, a Sun class 2-2-2 and sister engine to *Javelin*, intended to haul the first train between Bristol and Bridgwater.

Pylle Hill left, the goods depot right, and a railway wagon on fire near Victoria Park. (*H. C. Leat, Bristol Photographic Society, per M. J. Tozer*)

It continued on through Uphill cutting and north of Highbridge, where the Bristol to Bridgwater road crossed the B&E; the *John O'Groat* coach was drawn up for its driver and passengers to view the superseding mode of transport. The train called at Highbridge at 11.21 for a one-minute stop and arrived at Bridgwater at 11.40, where it was welcomed by a crowd of over 4,000 and the band of the West Somerset Yeomanry playing 'See the conquering hero'. Exclusive of stops, time for the 33 miles was 1 hour and 54 minutes, giving an average speed of about 17 mph. With a road connection, the opening of the line had brought Taunton to within six hours of London instead of the twenty hours necessary for the 150-mile road journey.

Breakfast for around 300 guests was held in a partly completed hotel near the station, the walls of the hotel being only a few feet high and covered with sheeting to make it tent-like. As less attended than would have appeared the previous day, there was plenty for everyone. 'Tea, coffee, lamb, fowls, tongue etc. formed staple commodities; besides which there was a copious supply of cake, biscuits, blancmange, almonds and raisins etc., etc. and of champagne, claret and sherry there was also a supply which greatly exceeded the demand,' reported the *Bristol Journal*. Toasts were drunk, speeches made and the return train left at 2.20 p.m., arriving in Bristol at 4.06.

The Board of Trade's requirements having been met, the line opened to the public on 14 June 1841. The previous evening a train of twenty-five empty carriages left Bristol drawn by four engines. The first public train left Bridgwater at 6.00 a.m. and was due to arrive in Bristol at 7.18, but actually arrived three minutes early. As the B&E station at Bristol had yet to be completed, all trains had to reverse between the Harbour Bridge Junction and the GWR terminus. Eight trains ran each way daily and were well-filled. The *Bath Chronicle* commented that 'traffic will no doubt rapidly increase when the beauties of the line, and the ease and luxury of the railway, become more extensively known'. Frequent coaches linked Bridgwater with Exeter. The Weston-super-Mare branch also opened on 14 June.

On 13 June a number of coach horses arrived at Bridgwater from the east, having been made redundant by closed road services caused by the opening of the GWR. The *Estafelte* – the North Mail – ceased to carry the post from 29 August as mail was carried by rail. One of the early uses of the line was in September, when it was used to carry detachments of the 11th Regiment between Bridgwater and Bristol *en route* to Newport, where they were to be stationed.

The first through train between Paddington and Bridgwater ran on 30 June 1841, taking four hours to Bristol and another hour and a half to Bridgwater. No through train could run sooner as the line between Chippenham and Bath was incomplete.

On 15 July 1841 the first cattle from Bridgwater Market reached Bristol by means of the new railway.

Brunel and Gravatt had not always seen eye to eye and on 23 July 1840 Brunel sent Gravatt a letter accusing him of betrayal. Initially he addressed him as 'My Dear Gravatt' but then struck through 'My Dear'! Then on 4 June 1841 Brunel wrote to Gravatt, 'How could you leave me uninformed of the deplorable state of the bridge near the New Cut?' And on 16 June, 'If you will retire without raising a question as to the cause, I will be silent.' Gravatt refused.

This led to a particularly lively episode in the general meeting on 2 September 1841; in fact, the *Bristol Journal* commented that it was 'conducted with greater excitement than we witnessed at any respectable meeting'. Gravatt read a statement against Brunel and this led to a three-hour altercation. Gravatt eventually resigned.

Frederick Ricketts revealed that the company was in a much rosier financial position. Up to 31 August, over £130,000 had been subscribed to the company's debentures and the sum received for forfeited shares was over £83,030. Brunel presented good and bad news. Works between Bridgwater and Taunton were proceeding and the two heaviest contracts were in a forward state, but bridges between Bristol and Bridgwater had caused problems, some arches had been built a foot too low and this was remedied by a foot being removed from the ground below the ballast. Some other bridges had given way through being built on peat. With a deep surface of clay, they had stood for some time, but had finally yielded to weight.

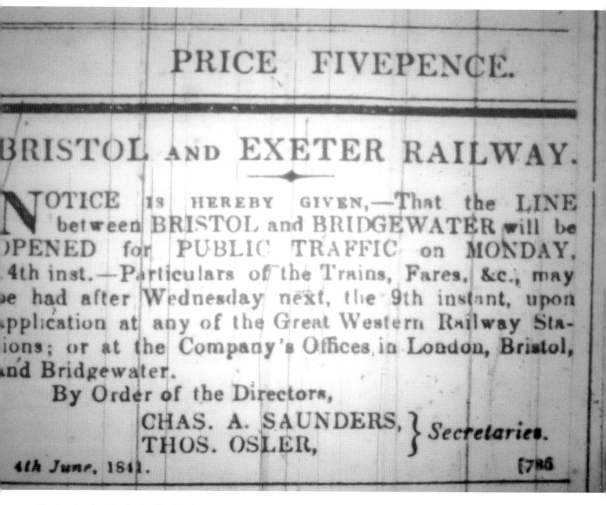

## PRICE FIVEPENCE.

## BRISTOL AND EXETER RAILWAY.

NOTICE IS HEREBY GIVEN,—That the LINE between BRISTOL and BRIDGEWATER will be OPENED for PUBLIC TRAFFIC on MONDAY, 4th inst.—Particulars of the Trains, Fares, &c., may be had after Wednesday next, the 9th instant, upon application at any of the Great Western Railway Stations; or at the Company's Offices in London, Bristol, and Bridgewater.

By Order of the Directors,

CHAS. A. SAUNDERS, } Secretaries.
THOS. OSLER,

4th June, 1841. [786

Notice in the *Bath & Cheltenham Gazette*, 22 June 1841, of the opening of the B&E between Bristol and Taunton.

The *Railway Magazine* of September 1841 said of the B&E, 'Three years back, insolvent, unable to open the smallest fraction, with 4,000 unproductive shares – at present 33 miles opened, let to a good tenant, at a good rent and toll, loans and debentures coming in daily, certainty of opening to Taunton next summer, and a good balance in the banker's hands, and lastly, no call made for a year past, and no immediate necessity for one.'

On 11 September 1841, following the arrival at Bridgwater of the 4.00 p.m. from Bristol, after passengers had left, the engine drew forward with some coaches for about 150 yards to a crossover and then backed them to the Up platform.

Between the station and crossover was a level crossing. As the engine was returning on the Down line tender-first to collect the remaining stock, it struck the *Exquisite* stagecoach, laden with passengers for Exeter.

The front part of the coach was smashed to pieces and freed the horses, who were unhurt. Passengers were thrown down and six injured, one having his head jammed under the tender wheels and could not be extricated until the engine was reversed, the *Bath & Cheltenham Gazette* reporting that 'another inch and his skull would have been cracked'. Johns, the coach driver, was also hurt. Ann Gove, aged seventy-two, a fruit seller who had just crossed the railway on foot, was struck by the toppling coach and received fatal injuries. The engine driver was blameless.

Bridgwater platform ticket.

# Chapter Four

# Opening to Taunton

Contracts for the 11½ miles between Bridgwater and Taunton were let in the spring of 1841. The only major work was Somerset Bridge, a mile south of Bridgwater, where the line crossed the River Parrett. Here Brunel designed a 100-foot-span masonry arch with a rise of only 12 feet and therefore nearly twice as flat as his most criticised bridge at Maidenhead. Somerset Bridge was begun in 1838 and finished in 1841. In August 1843, when it had been used for over a year, Brunel reported to the directors:

> With regard to Somerset Bridge, although the Arch itself is still perfect, the movement of the foundations has continued, although almost imperceptibly, except by measurements taken at long intervals of time; and the centres have, in consequence, been kept in place. Under existing circumstances, it is sufficient that I should state in compliance with a Resolution of the Directors, measures are being adopted to enable us to remove these centres immediately, at the sacrifice of the present Arch.

Six months later the directors informed shareholders that 'a most substantial Bridge has been built over the River Parrett without the slightest interruption to the traffic'. Between the original abutments Brunel had substituted a timber arch which did duty until 1904, when it was replaced by a steel-girder bridge.

On 26 May 1842 the trow *Defiance* was lying at Somerset Bridge over the River Parrett, discharging Kyan's patent liquid for pickling timber for use on the B&E, when Jeremiah Webber went on board in a state of intoxication. The captain ordered him below, but he disobeyed and fell overboard, striking his head as he fell. He met his death by drowning.

The line was extended from Bridgwater to Taunton on 1 July 1842, when 150 directors and shareholders left Temple Meads at 9.00 a.m. behind Fire Fly class 2-2-2 *Castor*, decorated with flags. The *Somerset County Gazette* reported that hundreds of folk came into Taunton from the country for the opening of the railway. By 11.00 a.m. thousands of well-dressed people congregated near the works.

> At a quarter past eleven o'clock, a long train of carriages were seen advancing a short distance from the terminus, and in another moment a splendid engine named the 'Castor', with a long train of carriages, 'pulled up' before the station house.

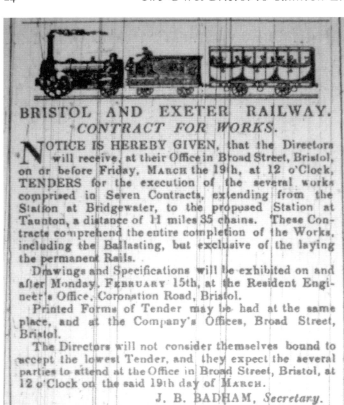

**BRISTOL AND EXETER RAILWAY.**
*CONTRACT FOR WORKS.*

NOTICE IS HEREBY GIVEN, that the Directors
will receive, at their Office in Broad Street, Bristol,
on or before Friday, MARCH the 19th, at 12 o'Clock,
TENDERS for the execution of the several works
comprised in Seven Contracts, extending from the
Station at Bridgwater, to the proposed Station at
Taunton, a distance of 11 miles 35 chains. These Con-
tracts comprehend the entire completion of the Works,
including the Ballasting, but exclusive of the laying
the permanent Rails.

Drawings and Specifications will be exhibited on and
after Monday, FEBRUARY 15th, at the Resident Engi-
neer's Office, Coronation Road, Bristol.

Printed Forms of Tender may be had at the same
place, and at the Company's Offices, Broad Street,
Bristol.

The Directors will not consider themselves bound to
accept the lowest Tender, and they expect the several
parties to attend at the Office in Broad Street, Bristol, at
12 o'Clock on the said 19th day of MARCH.

J. B. BADHAM, *Secretary.*

*Bristol and Exeter Railway Office, 30, Broad Street ;
5th February 1841.*                              [220

Advertisement in the
*Bath & Cheltenham
Gazette,* 11 March
1841, for contract to
build the line between
Bridgwater and Taunton.

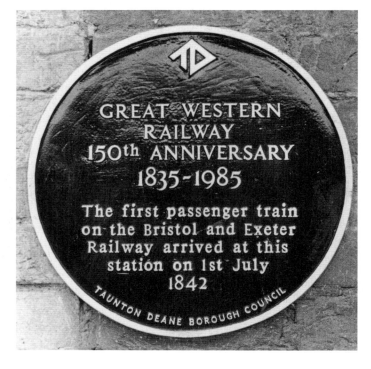

Plaque on Taunton
station marking the
150th anniversary of the
arrival of the Bristol &
Exeter Railway. (*Author's
collection*)

Following the train's arrival, 200 breakfasted in the new hotel adjacent to Taunton station.

The B&E was not strongly in favour of broad gauge, and at a meeting on 28 February 1861 the chairman, J. W. Buller, announced that laying down standard gauge over part or all of its system had been considered, but it had not yet been decided whether the return was commensurate with the expense. In 1867, when the Somerset & Dorset Railway sought powers to build a branch to Bridgwater, to counteract this proposal the B&E undertook to lay standard gauge rails along the main line from the Somerset & Dorset Railway at Highbridge to Bridgwater Docks, on to Durston and the Yeovil branch, where it linked with the standard gauge London & South Western Railway. In November 1867, a daily return goods ran from Yeovil to Bridgwater and the following year a standard gauge passenger and mixed train ran from Yeovil (Pen Mill) to Bridgwater and Highbridge.

The work of putting in mixed gauge was hurried, due to the Royal Agricultural Show traffic coming to Taunton in July 1875, to thus avoid standard gauge/broad gauge transfer. On 30 May 1875 a double-headed standard gauge trial train ran from Bristol to Taunton and returned.

Negotiations for the GWR taking over the B&E were opened when the B&E manager sent this letter to his contemporary at Paddington:

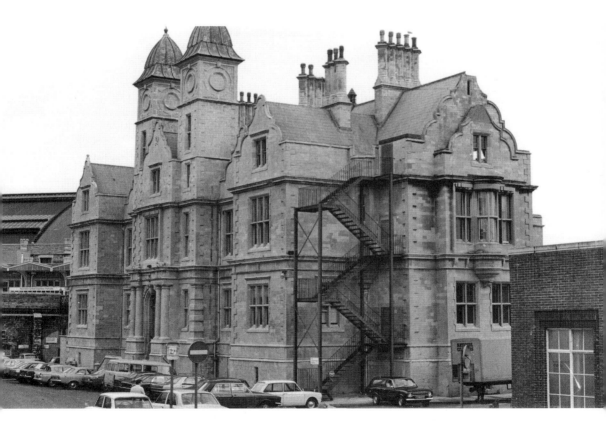

The Bristol & Exeter Railway office block at Temple Meads, seen on 29 May 1980. Designed by F. C. Fripp, this Jacobean-style building was completed in October 1854. (*Author's collection*)

Bristol
23rd September 1875

My dear Sir,
At our Board Meeting yesterday there was a long discussion as to our present and future prospects, one section of our Board having strong Midland proclivities, another section, and, I am happy to say, the largest, having Great Western proclivities.

The matter was put to an end by my saying that if the question was postponed until after our conference at Paddington on the 5th proximo I believed that I should be enabled to place before them something like a tangible proposition. Now you must be prepared to do something, and I have a scheme in my mind that I believe will enable you to hold your present position in the West at a very small risk, and under the worst circumstances entailing only a comparatively trifling loss. I will meet you on Monday the 4th of October to discuss this question if convenient and you think it desirable, and I am sure it is needless for me to assure you that next to the interests of my own Company, I desire to act in a friendly and loyal spirit to yours.

If you think right, pray show this letter to your Chairman.

I must add that I am now sure a change in our position is inevitable and that it will take place at this or any short period.

I am,
Very truly yours,
J. C. Wall
J. Grier, Esq.,
Paddington

The two boards met on 11 October 1875 when a Provisional Agreement was made for the lease of the B&E by the GWR, at a rent of 6 per cent on ordinary capital for the first seven years, and afterwards for 6½ per cent in perpetuity. The B&E thus passed into GWR control on 1 January 1876 and amalgamated with it from 1 August 1876 by Act of Parliament.

B&E finances had always been consistent, its dividend only having fallen below 4 per cent in 1849 and 1850 and 6 per cent only exceeded in 1872 and 1873, so shareholders were well-satisfied with the GWR's offer. In fact to pay this sum the GWR temporarily had to reduce its own dividend.

For every £100 B&E 4% stock shareholders received £80 GWR 5% rent charge stock
£100 B&E 4½% stock shareholders received £90 GWR 5% preference stock
£100 B&E 5% preference stock shareholders received £100 GWR 5% preference stock
£100 B&E ordinary stock shareholders received £120 GWR 5% preference stock
Plus a certificate declaring after 31.12.82 he will be registered for £10 additional stock for every £100 stock

The object in granting the £10 certificate was to provide for the extra 0.5 per cent dividend (making it 6½ per cent) that the stock carried seven years after amalgamation.

# Chapter Five

# The Weston-super-Mare Branch & Loop

Initially Weston-super-Mare was served by a 1½-mile-long single track branch from Weston Junction, following what is now the alignment of Winterstoke Road to a terminus at Alexandra Parade. Powers for building the line were by an Act of 11 June 1838. The single platform had a stone, single-storey, Gothic-style building with clock tower, designed by Brunel.

Initially passengers travelled to and from the junction in small, open-sided coaches drawn by three horses, the GWR supplying the animals at first and then the B&E from 30 April 1849. Against a headwind, a journey could take half an hour and on such occasions some passengers preferred to walk.

An accident happened in 1847, which was not a solitary occurrence.

> On Wednesday evening last, as the last train was proceeding along the branch line from Weston to the junction of the Great Western Railway to meet the two o'clock Down train and the half past five Up train, at a quarter of a mile from the station, one of the horses, suffering from a diseased heart, fell upon the rails, and the carriage passed over it causing immediate death. The train was thrown off the line and the passengers finished the journey on foot.

From the beginning of 1848, a locomotive worked a morning train from Weston to Bristol and a corresponding return in the evening. From 1 April 1851 horse traction entirely ceased.

Circa 1850 the branch was operated by *Fairfield*, the first workable steam rail motor. 40 feet in length, it was carried on six wheels, the two driving wheels being 4 feet 6 inches in diameter and the others, which were wooden, 3 feet 6 inches. The boiler was set vertically and it consumed 14.8 lb of coal per mile. It was painted sky-blue.

Trips were frequently run from the excursion platform, Pylle Hill, Bristol, to Weston-super Mare; in August 1857 one was advertised for 2s 6d first class and in a 'covered carriage' for 1s 6d, or passengers could travel to Highbridge to watch the Burnham Regatta at the same price. On 25 August 1857 the railway carried about 3,000 passengers to Weston-super-Mare for the horse races.

When the branch was doubled on 20 July 1866, the branch was cut back to a large new train-shed-style terminus in Locking Road, designed by Francis Fox, the B&E's engineer. Erected by Brock of Bristol at a cost of £10,000 the two platforms

The 1.20 p.m. Paddington to Penzance express, double-headed by 3001 class 4-2-2, *c.* 1900, passing the site of Weston Junction. Notice the water tower above the first coach. (*M. J. Tozer collection*)

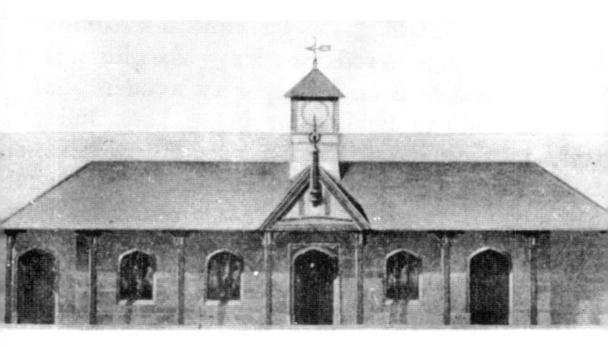

A drawing made in 1841 of the original Weston-super-Mare station in what is now Alexandra Parade. (*Author's collection*)

Three coaches drawn by three horses leave Weston-super-Mare station in 1846. (*Author's collection*)

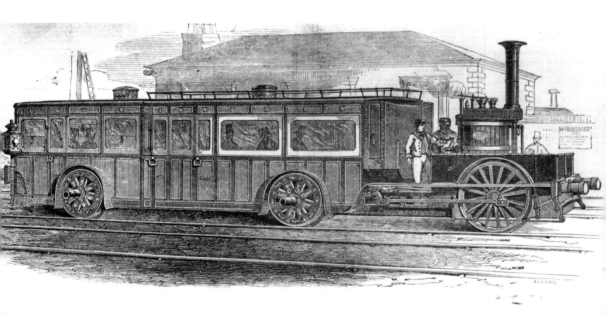

*Fairfield*, the first workable steam rail motor used on the Weston branch, *c.* 1850. (*Author's collection*)

## BRISTOL & EXETER RAILWAY.

# CHEAP EXCURSION

TO

# WESTON.

On MONDAY, MAY 31st, 1869,

## A CHEAP EXCURSION

WILL RUN AS UNDER.

FARES TO AND FRO,
on this occasion,
COV. CARS.

| LEAVING | A.M. | |
| --- | --- | --- |
| Exeter − − − − | 8. 0 | |
| Hele and Bradninch | 8.23 | |
| Collumpton − − − | 8.35 | **1s. 6d.** |
| Tiverton Junction − | 8.44 | |
| Tiverton − − − − | 8. 0 | |
| Wellington − − − | 9. 7 | |

Arriving at Weston about 10.30 a.m.   Returning from Weston at 6 p.m.

The Tickets are not transferable, and are not available by any other train or for any other Station

### NO LUGGAGE ALLOWED.

By order,

# HENRY DYKES,

Terminus, Bristol, May 17th, 1869.                    SUPERINTENDENT.

1

Exeter: Printed at the "Flying Post" Office, Little Queen Street.

*Left:* Poster to advertise a Whit Monday excursion to Weston-super-Mare on 31 May 1869.

*Below:* 57XX class 0-6-0PT No. 7718 outside Weston-super-Mare goods shed, August 1947. The building once formed the town's second passenger station. (*M. J. Tozer collection*)

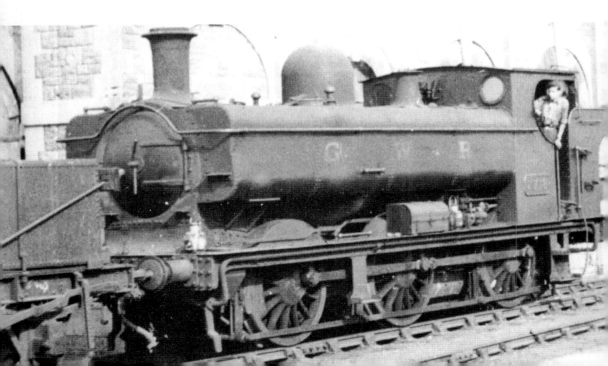

were each 420 feet in length, while the building was 243 feet long and 100 feet wide.

To cope with the growing number of day trippers and holidaymakers, an excursion platform was also opened at Locking Road in 1866. Nearby was an excursion hall, open free to all ticket-holders. Here a cup of tea or coffee could be either bought at a reasonable price, or made with ingredients brought from home.

The excursion station was rebuilt in 1907, the width doubled, a bay platform laid, and three shelters provided. It was enlarged to four platforms on 8 April 1914, offering a direct exit into Locking Road. It had its own ticket office. The station was chiefly used in the summer months, finally closing on 6 September 1964. The excursion platforms were nearer the sea than those of Weston General, and its platforms rather stark, but there was no need to provide protection against the winter weather. In its heyday, on a Bank Holiday Monday the GWR and LMS (the latter's engines worked through to Weston-super-Mare) brought in excess of 38,000 passengers, and the normal two-road station could not have coped with such numbers.

In later years, mail for Weston dropped by the 8.10 p.m. from Paddington was worked in from Weston Junction at 1.10 a.m. by 'Post Office Trolley'. Certainly the GWR service timetable for October 1886 (after the opening of the standard gauge-only loop line) mentions that the 'Trolley' worked over the old Weston branch line from a point near the gasworks sidings to a siding at the old Weston

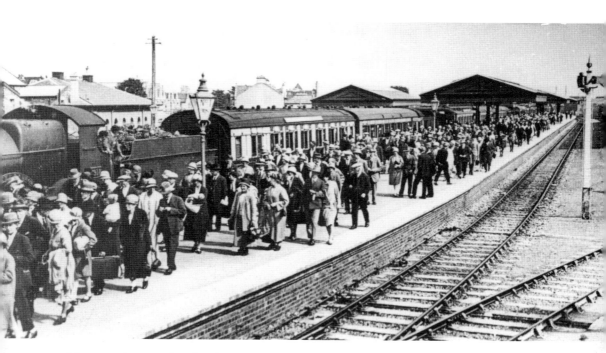

4-4-0 No. 3818 *County of Radnor* has just arrived at the Locking Road excursion platform No. 2, *c.* 1924. (*Author's collection*)

Junction. Joseph Glossop, who operated a horse bus in Weston, hired a grey carthorse to the railway to draw a van carrying Weston-super-Mare mail bags to and from the Up and Down broad gauge night mails. With the abolition of broad gauge, the mail trains necessarily became standard gauge and so could use the Weston-super-Mare Loop.

An Act for laying a loop line was obtained on 19 July 1875 and then the B&E was taken over by the GWR. That company immediately served notices on landowners whose property was required to be taken. £14,500 was paid in January 1877 for 37 acres. Probably due to the GWR's financial problems, the building contract was not let to W. Mousley of Clifton, Bristol, until January 1882, but then work began immediately. Chief engineer was Francis Fox, with J. Lean the resident engineer. As railway and roads were on the same level, the four bridges of brick arches faced with Doulting stone required long road embankments. Material for these was brought by engine and tip wagons from a sand cutting at Weston. Ballast was obtained from a limestone quarry on land opened at Ashcombe, Weston-super-Mare.

The new passenger station built by J. Hartley, Birmingham, was a long, low, Gothic-style building designed in 1876 by Francis Fox. Its skyline was very efficiently broken by the height of the towers above the bridge staircases. Both bridge and stairs were wide to cope with hordes of excursionists. The platforms had ridge-and-furrow awnings on decorative latticed girders supported on attractive columns, the cast-iron work painted to represent bronze. Adjoining the 270-yard-long Up platform were first, second and third class waiting rooms, a booking office refreshment room and a kitchen. Furniture in the first class room was new, whilst the others had newly upholstered and varnished furniture from the old station. The 1866 station was used for band concerts before being converted for goods use.

The Down platform could only be approached by footbridge, there being no carriage drive that side. Its only offices were cloakroom, ladies' waiting room and general waiting room. Screens at the platform ends gave shelter from the wind. The station and its approach were lit by Sugg's lamps.

At the Worle end of the loop, 'a pretty little station' was built by H. W. Pollard of Bridgwater. Nearer the village than the old station, the *Western Daily Press* reporter suggested that the district would be better served if the old station, Puxton, were removed to Huish. Worle closed on 2 January 1922, but the building remained intact until the mid-1960s.

Although the permanent way was complete and ready for the Board of Trade inspection on 1 November 1883, it was not opened until 1 March 1884. As the loop line had only standard gauge, this meant that passengers travelling from London by express were usually required to change at Bristol, though sometimes a standard gauge relief was provided to serve the resort direct.

Weston Milton Halt opened on 3 July 1933, was refurbished and had a new car park constructed in 1983. In GWR days the halt was staffed from 5.45 a.m. until 9.30 p.m.

In the interests of rationalisation, although Weston-super-Mare station retained double track, serving two through platforms, the rest of the Weston Loop was

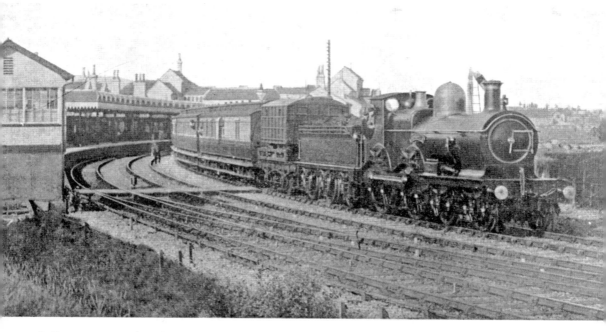

A Down express leaves Weston-super-Mare behind a Badminton class 4-4-0. Notice the pantechnicon on a carriage truck behind the tender. (*Locomotive Publishing Company*)

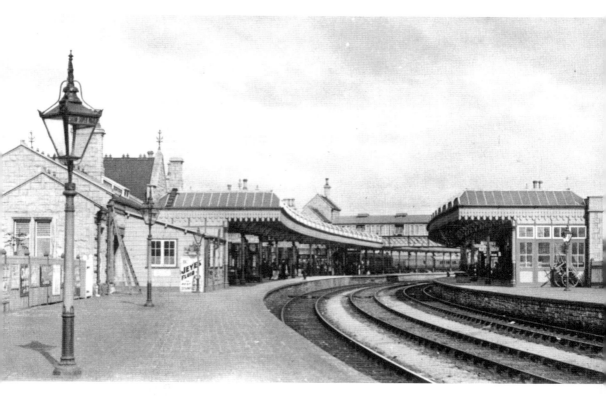

The 1884 Weston-super-Mare station view Up *c*. 1905. Notice the ornate lamp on the left, with 'Weston-super-Mare' on the tablet, and the windscreen protecting the Down platform. (*M. J. Tozer collection*)

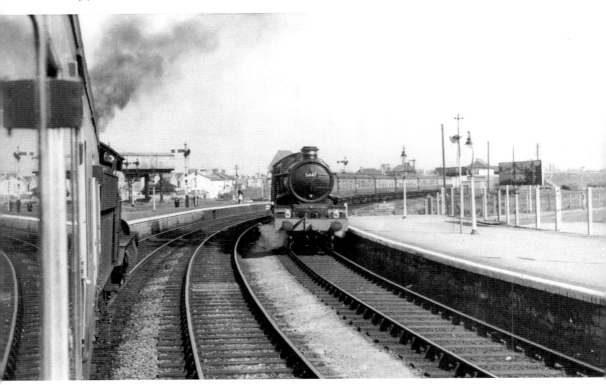

Castle class 4-6-0 No. 5047 *Earl of Dartmouth* enters Weston-super-Mare with a Down express, 4 March 1961. (*R. E. Toop*)

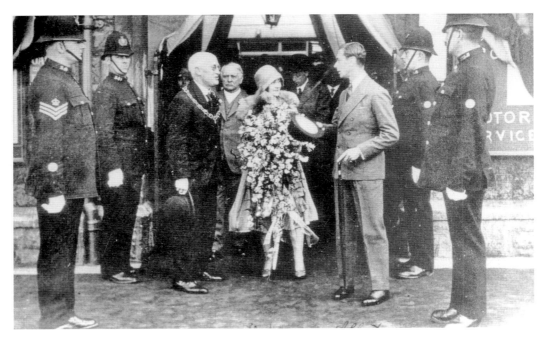

The Duke and Duchess of York (later King George VI and Queen Elizabeth) leave Weston-super-Mare station on 6 July 1928 to open a hospital. (*Author's collection*)

The disused Worle station in 1934, view Down. (*Locomotive & General Railway Photographs*)

Weston Milton, view Up, 26 August 1983. The line was singled on 31 January 1972. (*Author's collection*)

singled from the station to Uphill Junction on 12 October 1969 and to Worle Junction on 31 January 1972. The redundant Down platform at Weston Milton was removed to form the Lympstone Commando station on the Exmouth branch.

From 1883, a siding to the gasworks led from the Down Main line at the Bristol end of the Down passenger platform. Traffic for the siding was propelled up to the gate. Initially wagon movements within the works were probably by horse, but from 1918 a 0-4-0ST was used and then a 4wDM by F. C. Hibberd. Traffic ceased in May 1968. The Weston-super-Mare & District Electric Supply Co. Ltd had its private siding from 1927 until 1959.

At the time of writing two schemes are under consideration. The first is to reinstate the Up bay platform at Weston-super-Mare. While this currently has track, it is served by a ground frame and is used only for stabling tamping machines when engineering work is taking place in the vicinity. Only accessed from the run-round loop to the east of the station, this loop was last used regularly by locomotive-hauled trains from Paddington before HSTs were introduced. Trains had to set back out of the station, the engine ran round and then propelled back into the platform. For passenger use a connection leading onto the main line would be needed, as the present connection is by ground frame release facing west, rather than east towards Bristol. The signalling would need upgrading to passenger standards.

With the aim of enhancing capacity on the Weston Loop, plans are advanced to re-double the track at Worle Junction and restore double track for approximately a mile towards Weston Milton. This will have the significant performance benefit of enabling Down trains via Weston-super-Mare to stand beyond Worle Junction, (if an Up train was occupying the single line), and thus allow a following fast train to Taunton to continue along the main line without delay. Although it would be good to restore double track all the way to Weston-super-Mare, the cost of reinstating a Down platform at Weston Milton and slewing the track where the single line has been moved into the centre of the formation would mitigate this.

# Chapter Six

# Brean Down Harbour of Refuge

In December 1840 the Bristol General Navigation Company launched the steam packet *Taff* to run between Uphill and Cardiff, but eight months later negotiations for operating the service were cancelled. In July 1854 the prospectus of the Weston-super-Mare Pier, Steam Ferry & Railway Company was issued, proposing to lay a ¾-mile-long link line with the B&E. This too was abortive.

As early as 1841 Captain Evans, later made an admiral, had extolled to the Select Committee of the House of Commons the virtues of Brean Down Harbour as a potential deep sea port. In 1862 the Brean Down Harbour & Railway received its Act. The company's prospectus claimed,

> Brean Down occupies the finest situation in the country for a trans-Atlantic port. The track for vessels being in direct line to New York would avoid the circuitous and sometimes dangerous detour by the Irish Channel, and the serious delay often caused by the bar at the mouth of the River Mersey. The saving in time by the Brean Down route between America and London would be nearly a whole day. The distance from London to Brean Down is only 140 miles compared with 200 miles from Liverpool to London. Brean Down Harbour will also furnish an excellent landing place for cattle and other livestock from the South of Ireland. The proximity to the Welsh Coal fields will afford ample facilities for a cheap and expeditious supply of the best steam, coal for the steamers using the harbour.

A further Act of 1865 gave powers to construct a railway 3¼ miles in length to connect with the B&E.

The beginning was hardly auspicious. Lady Wilmot was to lay the first stone on 5 November 1865 and the previous day the paddle steamer *Wye* left Bristol conveying the party to the scene but, owing to a dense fog, roamed the Bristol Channel all night. Then, following the ceremony, while a champagne luncheon was being consumed in the Town Hall, Weston-super-Mare, the foundation stone, attached to a gaily painted buoy and a small flag embroidered with the initials 'BDH', floated off down the channel, its cable being of insufficient length. Owing to constructional and financial difficulties the scheme made little progress and the great storm of 9 December 1872 carried away the stone pier, causing the project to be abandoned.

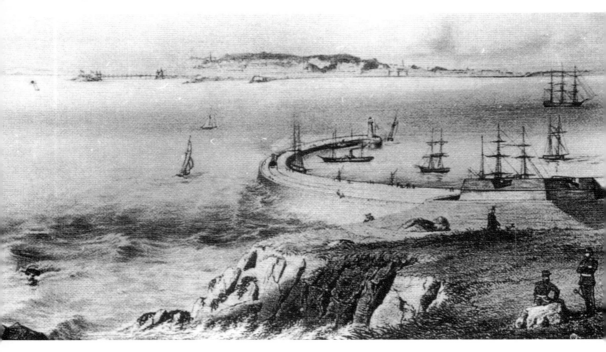

Brean Down Harbour of Refuge, as planned in 1864. (*Author's collection*)

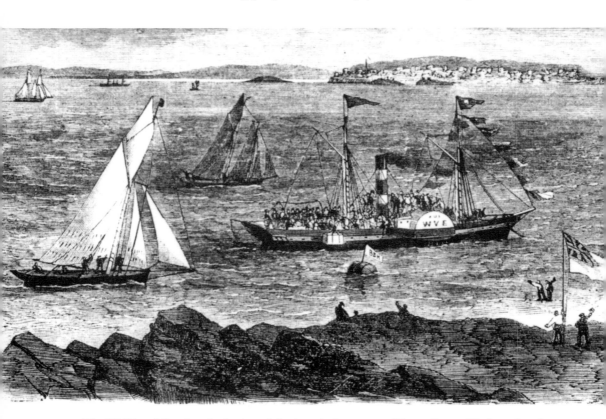

The PS *Wye*, following the laying of the foundation stone of Brean Down Harbour breakwater in November 1864. The stone is marked with a flagged buoy 'BDH'. (*Author's collection*)

# Chapter Seven

# Dunball Wharf Branch

Although the 792-yard-long Dunball Wharf line was authorised in the 1836 B&E Act, lack of finance left no cash available for its construction. As the need for the line was still felt, in 1844 the B&E directors laid a private horse-worked tramway from the main line to the wharf. It was principally used for coal traffic. At this date there was no through rail communication between South Wales and the West of England because until the Severn Tunnel was opened in 1886, rail traffic had to travel via Gloucester.

The opening of this tramway meant that coal could be shipped from South Wales and the Forest of Dean to Dunball and then distributed onwards by rail. Some ship owners actually diverted their vessels to Dunball from Bridgwater Docks, which was then without rail communication.

This meant that the railway was now competing for coal traffic with the Bridgwater & Taunton Canal and the Grand Western Canal. Consumers benefited as the cost of rail transport for coal from Dunball to Tiverton fell from 4s 9d a ton in 1851, to 1s 3d a ton the following year.

In 1867 the B&E was authorised by an Act of Parliament to buy and extend Dunball Wharf and convert the horse tramway into a locomotive-worked branch. Once the rebuilding was complete, the first steam-hauled trains ran over the mixed gauge branch in November 1869. The extension of Dunball Wharf itself was completed in 1874.

Between 1876 and 1881 the wharf dealt with about 100,000 tons of traffic annually, but after this date quantities declined, especially following the opening of the Severn Tunnel, when so much of the South Wales trade, hitherto carried by sea, was transferred to rail. Nevertheless, a daily coal train still ran from Dunball to Exeter and remained broad gauge until final conversion in May 1892.

In more recent years the wharf dealt with timber, sand, gravel, cement and molasses. There was also J. Bibby's animal feedstuffs distribution depot and an Esso petroleum depot to offload supplies brought by barge across the channel from the Milford Haven refinery.

Speed over the branch was restricted to 5 mph and special regulations were in force for crossing the A38. A man with a red flag was required to bring road traffic to a halt and loads were limited to a maximum of twenty-five wagons when the engine was propelling its train. A weighbridge was provided for ascertaining the weight of the railway wagons and their contents.

Dunball, view Down *c.* 1895. The line to the wharf on the right, and the ground frame hut, left. (*Author's collection*)

A United Molasses rail tank wagon at Dunball Wharf, 1 June 1966. (*Author's collection*)

This short but busy branch line was only capable of taking the smallest GWR shunting engines, either a four-wheeler, or a very light six-coupled locomotive such as a 1361 class 0-6-0ST or 1366 class 0-6-0PT which was stabled at Bridgwater.

One of the interesting engines which worked the branch was 0-6-0ST No. 2194, *Kidwelly*, inherited by the GWR when it took over the Burry Port & Gwendraeth Valley Railway. Another locomotive seen on the line was 0-4-0ST No. 1338, built by Kitson's for the Cardiff Railway and the only one from this company to stray so far from home under GWR ownership. It could proudly proclaim that, when withdrawn in September 1963, it was the last Cardiff Railway engine remaining in British Railways' service. The Dunball Wharf branch itself closed on 22 April 1967.

---

### DUNBALL POTTERY GROUND FRAME

The Ground Frame operating the connection from the Down Main Line to the Down Siding is controlled by Huntspill Signal Box and is worked in accordance with the "**Instructions for Working Ground Frames operated by Interlocking Lever at Signal Box and Key Release Instrument at Ground Frame.**"

Telephone communication is provided between the Ground Frame and Huntspill Signal Box.

The gate, when not in use, must be kept padlocked across the line.

The key of the padlock is kept in the cupboard containing the Key Release Instrument to which it must be returned after use.

---

### DUNBALL

#### Bristol Road Level Crossing

Before movements are made over the public road the Working Foreman or Dunball Porter must station himself on the roadway and exhibit a red flag in such a position as to warn road users approaching the crossing in either direction. When he is satisfied it is safe for the movement to commence, he must give an " All Right " signal to the Guard or Shunter in charge, who must not allow the public road to be fouled until this signal is received. The Working Foreman or Porter must remain at the crossing until the public road is again clear.

No engine, except No. 1338 (0-4-0T) and engines of the 1361 (0-6-0T) Class and 1366 (0-6-0T) Class, must shunt beyond the stop board on the wharf side of the public roadway and not more than 25 wagons must be propelled over the crossing at a time. No engine may work over weighbridge weighing line.

Except when it is necessary to shunt over the public road the Level Crossing gates and wheel stops must be kept padlocked across the rails, the keys being kept in Dunball Signal Box. The Working Foreman or Porter, whoever is in attendance, will be responsible for locking and unlocking the gates and wheel stops and immediately shunting operations are completed the keys must be returned to the Dunball Signalman.

No shunting is permitted over this crossing except in daylight and clear weather.

#### Hand Points from the Dead End Shunting Spur into Sidings East of Signal Box.

The hand point leading into the Sidings East of the Signal Box must always be set and padlocked for the Wharf Siding, except when it is required to be used for shunting purposes. The key of the padlock must be kept in the Signal Box.

---

### BRIDGWATER

#### Shunting Operations

Telephone communication is provided between the East and West ends of the Yard, and the Shunters at each end must come to an understanding with each other in order to avoid conflicting movements.

A ground frame is situated near the West end of the Up Platform, the lever of which, when reversed, bolts in the normal position the points leading from the Carriage Siding to the Up Main Line. When not in use the ground frame must be kept padlocked in the normal position and the key kept in the Ticket Office.

---

Instructions for working at Dunball from *Sectional Appendix to the Working Time Table and Books of Rules And Regulations, Exeter Traffic District, March 1960.*

# Chapter Eight

# World War Two

In 1941 a bomb dropped on the main line between Yatton and Huish Crossing between the Up and Down main lines, closing all four roads for about twenty-four hours. Trains were diverted and at least one express travelled via Witham and Yatton. The following day, Up and Down loops were used by passenger traffic proceeding slowly past the crater.

Weston-super-Mare was raided 28/29 June 1942. On 29 June, bombs fell near five of the six road bridges in the borough. The station itself was never quite out of action, though an unexploded bomb caused the suspension of the issue of tickets for a while. Glass was broken in the station windows and nine coaches and nine kitchen cars were damaged in the sidings. The East and West signal boxes were damaged and hand-signalling was instituted.

On the second raid, the Down waiting room went up in flames and eight coaches, a kitchen car, and three wagons were damaged, as was the goods shed. An unexploded bomb by Uphill Junction signal box blocked traffic on the loop, so through trains called at Puxton & Worle until 3 July 1942 when single line working was introduced.

Slight bomb damage was caused to Highbridge station on 18 May 1943 and three trains in the vicinity were machine-gunned, only breaking the side light of a coach on the 9.50 p.m. Paddington to Penzance express. On 27/28 March 1944, an unexploded bomb dropped near Hutton signal box, and for five hours all trains were diverted over the Weston-super-Mare Loop.

In preparation for D-Day in 1944, certain strategic locations were guarded in case they were destroyed by enemy agents anxious to delay the invasion. Somerset Bridge, Bridgwater, was one such guarded installation, and Cogload flyover another.

The GWR had its own Home Guard company at Taunton, separate from other civilian companies. A light anti-aircraft troop armed with a lighter type of quick-firing gun was attached to this GWR company for station defence purposes.

The bombing of Bristol had its effect on Weston-super-Mare as some made it a dormitory town in order to escape severe air raids.

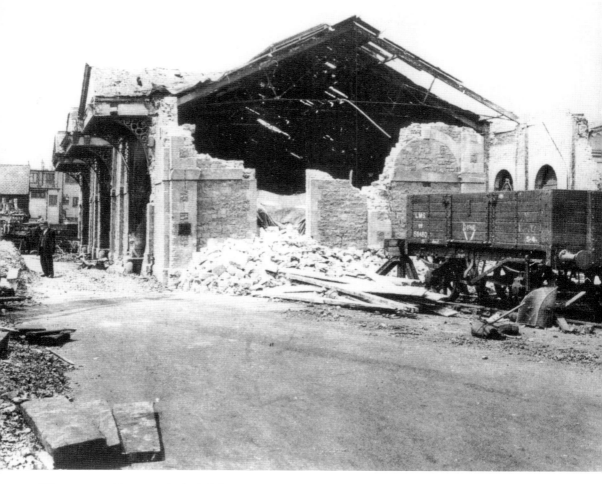

Weston-super-Mare goods shed, following an air raid on 28/29 June 1942. (*Author's collection*)

# Chapter Nine

# Description of the Line

Temple Meads station had to be constructed 15 feet above ground level to give clearance to waterborne traffic passing under the Floating Harbour Bridge immediately east of the station. Temple Meads, in the 1830s, consisted of open fields, a cattle market, and cholera burial ground.

The fact that trains at Temple Meads used a first-storey level allowed Brunel to design the station like a Tudor mansion. Behind the splendid Bath-stone façade facing Temple Gate were GWR offices. Flanking it were two gateways, the one on the left giving access to the departure side, while that on the right led from the arrival side.

On the ground floor of the departure side of Brunel's building were the booking offices. Passengers used stairs to approach the platforms, but luggage was raised by hydraulic lift. The train shed was truly impressive: its cantilever roof had a span of 72 feet, unsupported by any cross time or abutment. Each principal beam met its counterpart in the centre of the roof, the weight carried on octagonal columns. From a practical point of view, the octagonal columns were rather close to the platform edge and offered little clearance when coach doors were opened, but matters were improved when the broad gauge was abolished and platforms could be widened.

When the B&E opened to Bridgwater on 25 May 1841, it used this GWR terminus, which proved unsatisfactory as it involved the time-wasting procedure of backing trains into or out of the station. The Bristol & Gloucester Railway, opened on 8 July 1844, also used Temple Meads. The station thus became rather overcrowded, but matters were eased the following year when the B&E opened its own terminus at right angles to that of the GWR. Brunel set it at this angle in order to avoid purchasing expensive house property.

A contrast to its GWR neighbour, the B&E station was a simple, single-storey wooden building set on brick vaults, its overall roof lacking the height of its GWR companion, but spanned two platform roads and three centre tracks for stabling coaches. Due to its design and being sited near the Cattle Market, it quickly became known as the 'Cow Shed'. An access road was provided from Bath Parade, quite separate from that to the GWR terminus.

Goods and passenger vehicles could be transferred one at a time by turntable, but it was a lengthy business, so in 1845 the two lines were joined by an 'express curve' with a narrow platform on the Up side. Down through expresses ran round

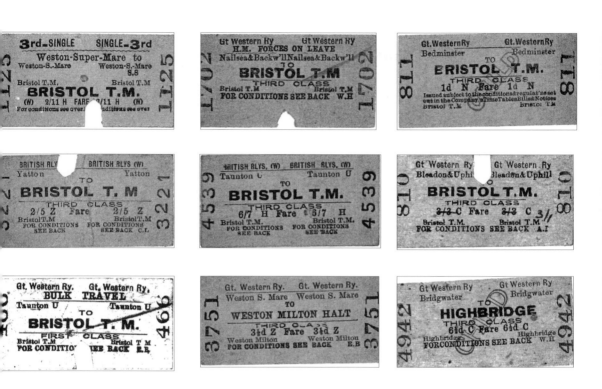

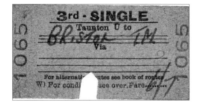

A selection of tickets issued.

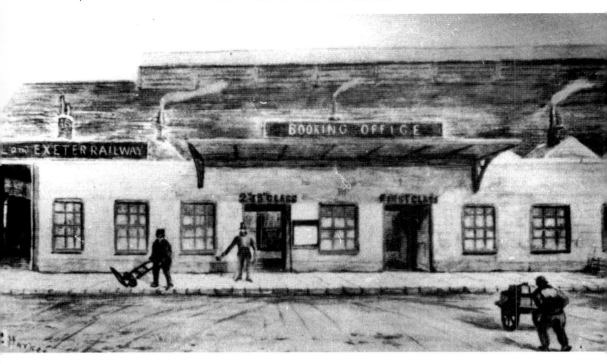

A contemporary painting by Harker of the 'cow shed', the Bristol & Exeter Railway's terminus at Bristol. Second and third class passengers entered through the doorway centre left, while first class passengers used that on the centre right. (*Author's collection*)

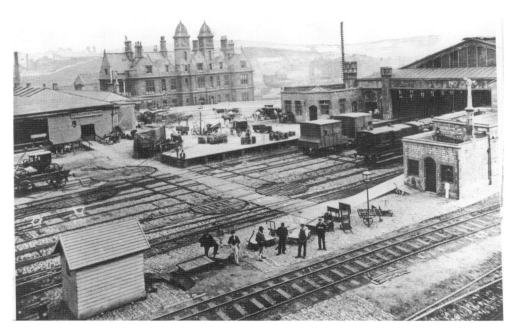

Temple Meads in the 1860s: the GWR train shed right, the B&E offices centre left, and the B&E terminus left. Notice the cabs waiting outside. Most of the railway wagons are mixed gauge. Several carriage and wagon turntables are in evidence for transferring stock to different roads. Two GWR horse boxes stand beyond the coaches. (*Author's collection*)

this junction curve and reversed into the B&E terminus, while Up through trains, after calling at the B&E express platform on the Up curve, then went forward before backing into the GWR terminus.

These movements caused a loss of time and offered a chance of accident. A joint B&E, GWR and Midland Railway station was proposed and referred to the engineers of the respective companies. Francis Fox of the B&E submitted a scheme, which, after modification, was adopted. As traffic necessarily had to continue to run without interruption during works, completion took a long time.

Sir Matthew Digby Wyatt, a friend who had assisted Brunel with the 1854 Paddington station, was architect for the Temple Meads enlargement and carried out the work most skilfully, blending the old and new superbly. The unpretentious wooden B&E terminus was demolished and a great curved train shed with a span of 125 feet was erected on the site of the former B&E express platform. At least one fatality occurred during the station improvements. When a portion of the footbridge being erected fell, it killed one man and injured others.

A wide, gently rising carriageway approached the architecturally pleasing main entrance on the Up side, with offices and a 100-foot-high clock tower of Draycot stone approximately on the site of the former B&E terminus. The approach road to the Down side curved around the B&E office block and passed under the line. The green-and-gold exterior canopy to the station was virtually identical to that which Francis Fox designed for Weston-super-Mare.

Each of the three companies had its own booking hall within the Great Hall, passengers entering through separate doors: the MR on the left, the B&E centre and the GWR right, a scroll above each bearing the appropriate initials.

The new Down through platform, the first section of the new station, was brought into use on Monday 6 July 1874 and the whole extension completed on 1 January 1878. There were seven platforms: No. 1, the Down main, 804 feet in length, and Nos 2 and 3, each of 429 feet. No. 2, an island platform, was used mainly by terminating MR trains and passengers could walk straight across the platform to a Down GWR train to continue their journey. No. 3 was the GWR Up main; No. 4 the MR departure platform, and No. 5, the lengthened southern platform of the original terminus, was used for New Passage, or later for South Wales trains. Platform 7 was for the arrival and departure of Clifton Down and Avonmouth trains.

Improvements were certainly needed. For instance, on 14 August 1876 the 9.00 a.m. standard gauge Swindon to Taunton train entered Temple Meads and struck eight broad gauge coaches, laden with passengers on an excursion to Weston-super-Mare, which was waiting for an engine. There was no derailment and little damage to stock, but thirty passengers were injured. Captain Tyler, in his report to the Board of Trade, said that it was poor practice to allow an excursion train to be loaded on a line where another train ran in, but admitted that limited accommodation forced the use of one platform for two trains:

It is evident that the accommodation provided in the station as it is now being completed, is insufficient for safe or convenient working. It is a daily and even hourly occurrence that trains are delayed outside this station in consequence of the

Francis Fox, engineer to the Bristol & Exeter Railway. (*Author's collection*)

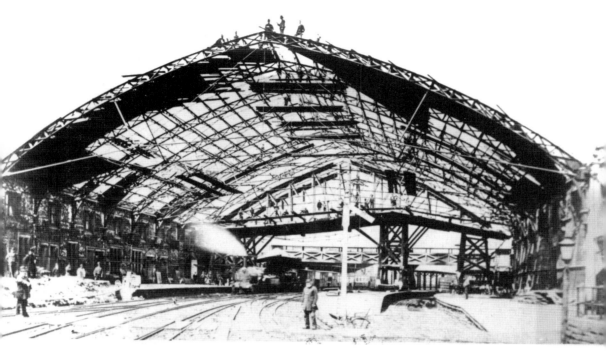

View Up of Francis Fox's large train shed, under construction at Temple Meads, August 1876. The ironwork was provided by the Central Iron Works, Cheltenham. (*Canon Brian Arman collection*)

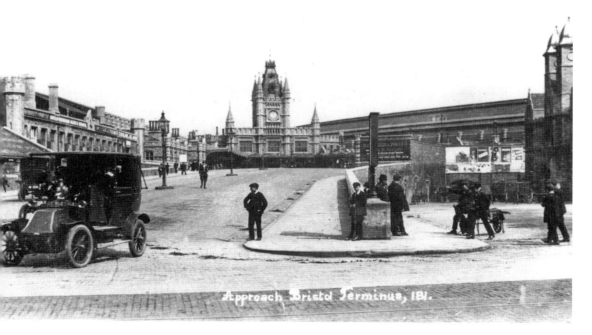

A taxi at the foot of the approach to Temple Meads station, *c.* 1912. On the left is Brunel's terminal train shed, with an advertisement above the windows for Anglo-Bavarian Ales & Stout. On the right is Wyatt's through train shed, while the B&E offices are on the far right. (*M. J. Tozer collection*)

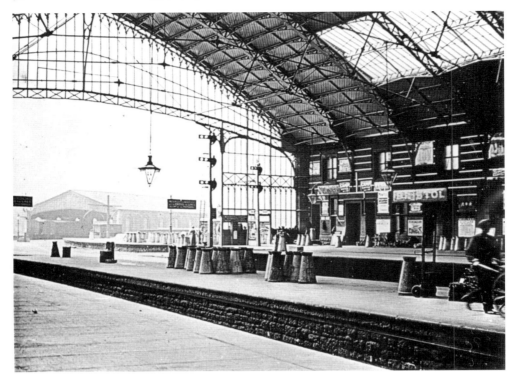

The Down end of Wyatt's train shed, *c.* 1895, with the B&E carriage shed centre left. (*H. C. Leat, Bristol Photographic Society, per M. J. Tozer*)

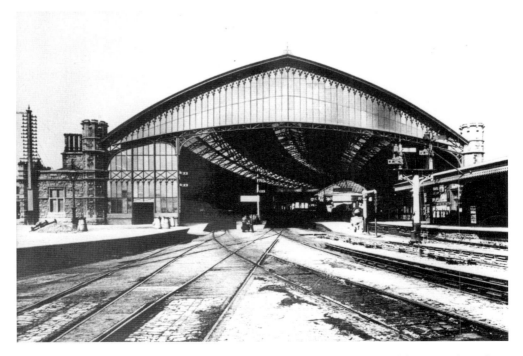

View of the south end of Wyatt's train shed *c.* 1900. The surface is paved between the rails to facilitate horse shunting. (*Author's collection*)

inconvenient arrangements under which the various trains in shunting are backed or otherwise taken in and out of it.

One improvement brought into use on 2 October 1892 was a widened bridge over the New Cut so that No. 1 platform could be lengthened and a Down bay provided. By the 1920s, busy times could see trains held in block from Highbridge, waiting for a platform at Temple Meads, and often they had to stand outside the station for an hour. On summer Saturdays between 1920 and 1930, it was not unknown for local trains to take two hours to travel the last mile to reach a platform, and on at least one occasion, the time was three hours and twenty minutes. The joint companies could not be blamed for this state of affairs, as there was no room for expansion except over the cattle market sited on the inside of the curve, and this was owned by Bristol Corporation, which was not anxious to sell.

In 1929 unemployment stood at over 1 million and the Development (Loans, Guarantees & Grants) Act of 1929 allowed the government to guarantee and pay the interest for two, three, or four years on the capital expended on a redevelopment scheme. The GWR was one of the first railway companies to seize advantage of this scheme and by the late autumn of 1929 had proposed a capital expenditure of £4½ million, offering direct employment for 200,000 man-months. Bristol was part of this scheme, the work including the enlargement of Temple Meads passenger station, quadrupling the line between Temple Meads and Portishead Junction, reconstruction and enlargement of the Bath Road locomotive depot, and the provision of additional sidings.

P. E. Culverhouse was the architect, and the main contractors, Shanks & McEwen of Glasgow, commenced work in 1930. Temple Meads was more than doubled in size, the number of platforms increased from nine to fifteen, covering much of the cattle market. The collective length of the platforms at the enlarged station totalled 2 miles. The new buildings were faced with white or brown Carrara glazed bricks, imitating marble and set on a grey concrete plinth. The work was completed in 1935.

With the abolition of many stopping trains in the 1960s, the platforms in Brunel's train shed became surplus to requirements, and on 12 September 1965 the shed was closed to rail traffic and became a car park the following year. When signalling in the Bristol Panel Box area takes place, it is likely that Brunel's train shed will again be used for trains. There are also suggestions for restoring passenger signalling to the old parcels platform (Platform 2) as a west-end bay for stopping services towards Taunton (and also for Portishead should this branch be reopened).

Unlike most stations, Temple Meads had a superintendent rather than a stationmaster, the difference being that the former was responsible only for railway operation and the fabric of the building; other duties normally undertaken by a stationmaster were covered by separate posts such as goods superintendent, guards' inspector, parcel agent and passenger manager. As Temple Meads was a joint station, the post of superintendent was filled alternately by a man from the GWR and MR, or later the LMS.

After crossing the bridge over the New Cut was Bath Road locomotive depot and the B&E's locomotive works. Then Pylle Hill goods depot was on one side

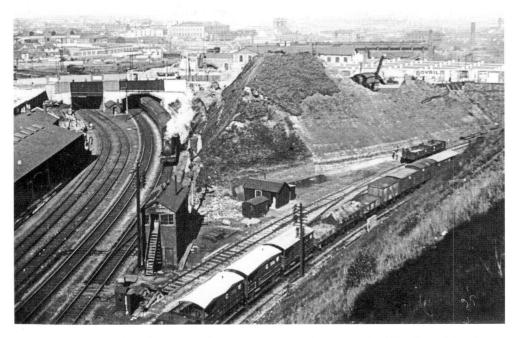

View north from Pylle Hill, 8 September 1932, showing the Bristol Avoiding line, right, that to Temple Meads, left, and Bath Road shed beyond the centre mound. Pylle Hill Junction signal box closed on 26 May 1935. (*H. C. Leat, Bristol Photographic Society, per M. J. Tozer*)

Diesel-electric No. 46006 at Pylle Hill Junction, 21 August 1980, *en route* from Malago Vale carriage sidings with empty coaching stock to form the 13.48 to Birmingham. (*Author's collection*)

View of Pylle Hill goods depot from the cab of a Class 08 shunting engine, 20 May 1966. (*W. F. Grainger*)

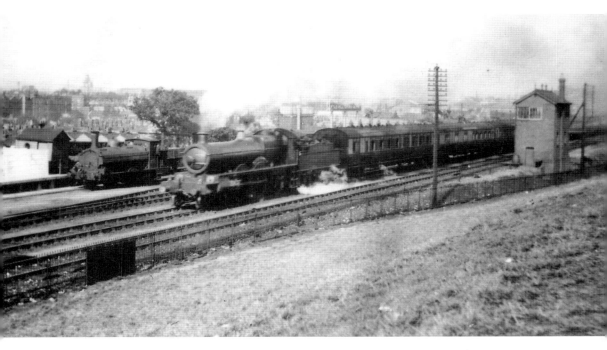

Saint class No. 190 *Waverley*, as a 4-4-2, passes Pylle Hill goods depot in 1908 with an express to Penzance. No. 190 later became No. 2900 and a 4-6-0. Beyond is 850 class 0-6-0ST No. 872. Pylle Sidings signal box closed on 1 May 1932. (*Canon Brian Arman collection*)

and Bristol West Junction, with the Bristol Relief line opened 10 April 1892, on the other. This useful route allowed through trains not requiring a platform to avoid passing though the passenger station. The excavation of Pylle Hill Cutting provided spoil to raise the land to form a basis for goods sheds and offices on one side of the line and an engine shed and locomotive works on the other. The inward and outward goods sheds, opened 1 May 1850, were on each side of the Bath Road over the bridge. Until then, B&E goods traffic had been dealt with by the GWR staff at the GWR goods station. Pylle Hill Goods Depot closed 4 December 1991.

On 28 August 1852, B&E labourers working near the foot of Pylle Hill discovered a skeleton. When the cutting had been originally excavated, two of three skeletons had been found nearby together with cannon balls and fragments of weapons. They were believed to have been associated with the Civil War.

The B&E provided a cheap return excursion from Bristol to Weston-super-Mare for 1s 6d return, these passengers using special platforms at Pylle Hill, Bedminster and Weston-super-Mare. B&E fares were generally higher than on most other railways, being 2¾d and 2d a mile respectively for first and second class. Third class fares were the Parliamentary penny a mile.

The first station at Bedminster, opened in June 1871, was approximately sited on the footprint of Pylle Hill excursion platform, which closed on Whit Monday 1871. B&E platforms were generally short and varied in height from 1 feet 9 inches to 2 feet 9 inches; they also ended in steps rather than ramps. The B&E eventually recommended that all platforms be raised to the standard height of 2 feet 9 inches, have a length of 500 feet, and that ramps replace steps.

Bedminster closed 27 May 1884 when another station opened on a site to the west and approximately on the site of the ticket platform where Up trains had stopped for ticket examination. Bedminster was extended in 1908, necessarily rebuilt slightly to the east when the line was quadrupled; the new station opened 30 April 1932. At one time very busy with commuters on weekdays and trippers at weekends, today it is but a shadow of its former self.

Malago Vale Colliery Sidings opened 15 August 1879, and when the colliery closed, were used by a brickworks, but were out of use by July 1918. On the opposite side of the line, Malago Vale Carriage Sidings came into use on 10 April 1932, closed in 1988 and the track was lifted in 1991. When necessary, and only in clear weather, an empty train could be propelled over the Down Relief line from the sidings to Parson Street Junction signal box. The guard, or shunter, was required to ride in the leading vehicle and keep a sharp look-out and be prepared to hand signal to the driver. The train had to carry the proper head lamp and was not to exceed 10 mph, or 4 mph through facing points and crossovers.

Parson Street opened 29 August 1927 as the two-road Parson Street Platform, to serve a developing suburb. It was rebuilt when the line was quadrupled, the new station, minus the suffix, opening 21 May 1933. The 1930s-style booking office was on Parson Street road bridge. It is the principal station for Ashton Gate football ground. A short tunnel to the west of the station was removed during quadrupling.

The line capacity from Temple Meads to Parson Street is to be enhanced by restoring the four tracks as far as Parson Street, extending the old Down Relief from

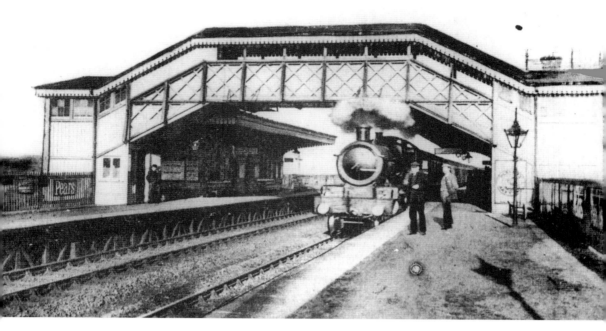

A Down express passes through Bedminster *c.* 1920 in double track days. (*Author's collection*)

Bedminster, view Up on 21 August 1980 after quadrupling. The platform on the left is an island, with the two Up roads on the far side. (*Author's collection*)

Malago Vale Carriage Sidings, Bristol, 30 May 1980. (*Author*)

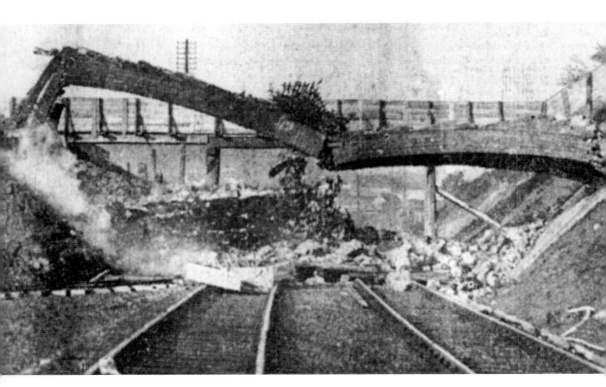

Bartlett's Bridge, between Bedminster and Parson Street stations, being blown up on 26 April 1931 to enable the line to be quadrupled. (*Author's collection*)

Bedminster, currently used only as a turn-back for empty trains coming out of Temple Meads or St Philip's Marsh Depot. The restored Down Relief and the existing Down Main would become the Down and Up Main respectively, while the present Up Main would become the Down Relief. The Up Relief would retain its designation.

Beyond, at Parson Street Junction, the line formerly to Portishead, but now only to Portbury, branches to the north. Bristol West Depot extended on each side of the main line. Although much was taken out of use in the 1970s, part of the Up side became a Freightliner Depot, but this closed in May 1992 and the site mothballed. Then, in June 2009, Freightliner Limited began discussions with the Hillebrand Group, the world's leading logistics company for the wine and spirits trade. Trans Ocean, a Hillebrand subsidiary, transported in bulk from round the world and needed to deliver it to Europe's largest bottling plant at Avonmouth.

At this South Liberty Lane terminal, two sidings of nineteen and twenty wagon lengths were cleared plus a run-round loop. The deadline of 1 June 2010 was met and now the rail port handled a total of twelve trains weekly, four originating from the Port of Tilbury as well as a service from both London Thamesport and the Port of Felixstowe. Initial investment in the site was approximately £750,000 and it is upgraded as business grows.

At the west end of the former extensive yard was West Depot Junction with the Portishead branch, this forming the third side of the triangular junction. This curve closed 6 December 1971. Beyond was South Liberty Colliery Sidings opened in 1873 and when the colliery closed, the site was used by a brickworks.

Ashton station closed in January 1856, but seventy years later, Long Ashton Platform opened on 12 July 1926 on approximately the same spot. It lost its suffix on 23 September 1929 and closed on 6 October 1941. Tickets were issued by an agent, while guards were required to collect tickets from alighting passengers and hand them in at the next station.

Flax Bourton Tunnel, 110 yards in length, was unlined with ends of blue brick. Bourton station opened in the cutting just west of the tunnel, and there were no goods facilities. It was renamed Flax Bourton on 1 September 1888. As needs pressed for freight handling, a new station opened 400 yards west on 2 March 1893. It closed to passengers on 2 December 1963 and goods on 1 July 1964.

Tyntesfield Sidings opened on 21 September 1958 as part of a strategic fuel reserve, with underground pipes to tanks at Portishead and Redcliffe Bay. They received no regular traffic and closed in May 1981.

Nailsea station changed its name to Nailsea & Backwell on 1 May 1905. It closed to goods on 1 July 1964, but passenger trains, including HSTs, continue to call. Platforms were originally of timber and those on the Up side of the footbridge were set lower. About twenty-four fire buckets were required to be kept filled and clean. With modernisation, the B&E buildings were demolished. This proved an error as the buildings stabilised the embankment and thousands of pounds had to be spent stabilising it. Recently the station has been repaired and redecorated, much of the work being carried out by offenders under the probation service's Community Payback Scheme. To the west, sidings for Nailsea Colliery opened around 1875 and the rails lifted about 1930. The light railway enthusiast, Arthur Cadlick Pain, was engineer to the Nailsea Tramway from 1875–7. Other

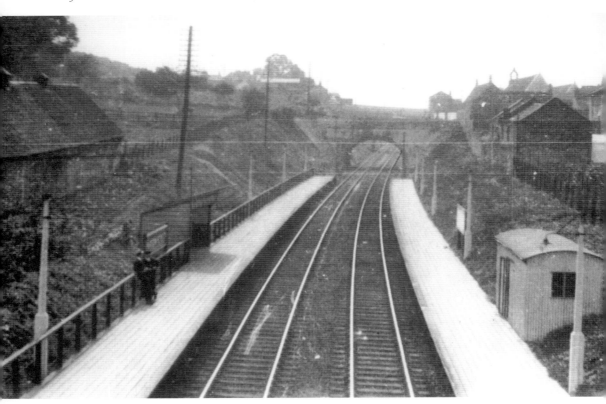

Parson Street before quadrupling, view Down. (*Author's collection*)

Two Down ex-GWR diesel railcars call at Parson Street, *c.* 1954, following quadrupling. (*M. J. Tozer collection*)

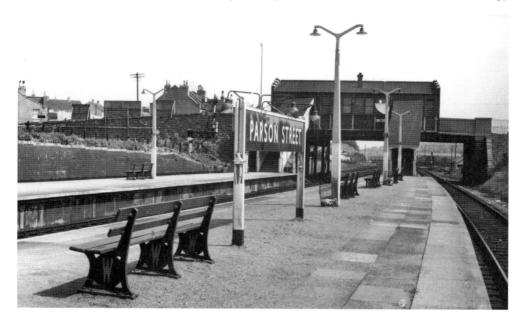

*Above:* Parson Street view Up *c.* 1960. Notice the booking office set on the bridge. (*Author's collection*)

*Right:* The uninviting entrance to Parson Street station, 21 August 1980. (*Author*)

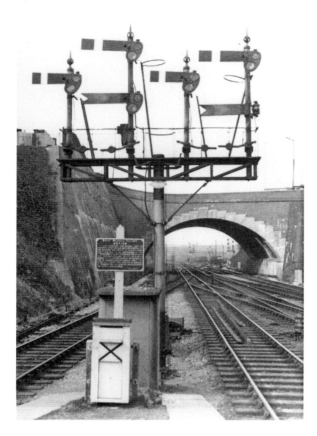

*Left:* View down from the end of Parson Street, 21 March 1970. The line to Portishead curves right beyond the bridge, with the West Depot in the fork. (*Derrick Payne*)

*Below:* Bristol West Depot, seen from Bedminster Down Road bridge, 21 August 1980. (*Author*)

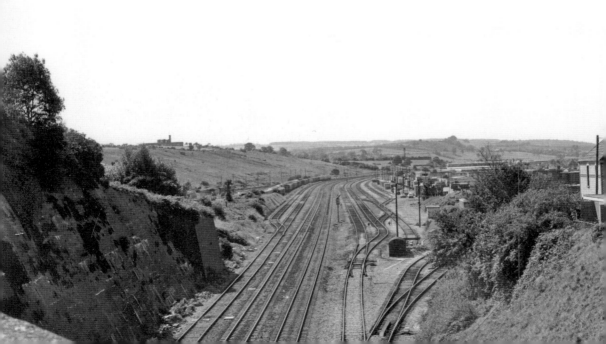

A Sparrow's crane lifting a Rail Mail
container at the Freightliner Depot, 29 July
1980. (*Author*)

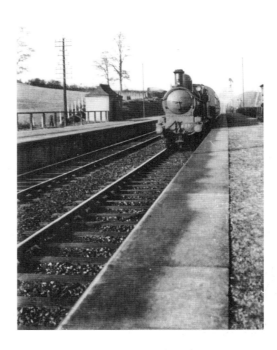

Dean Goods 0-6-0 No. 2381 enters Long
Ashton Halt with a passenger train.
(*Author's collection*)

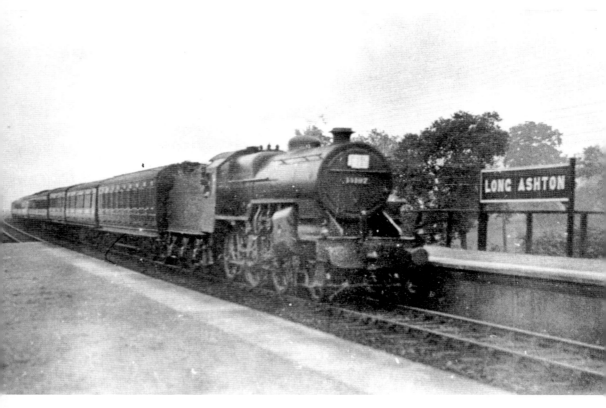

LMS 2-6-0 No. 13197 works an Up LMS excursion from Weston-super-Mare through Long Ashton Halt in the early 1930s. (*Author's collection*)

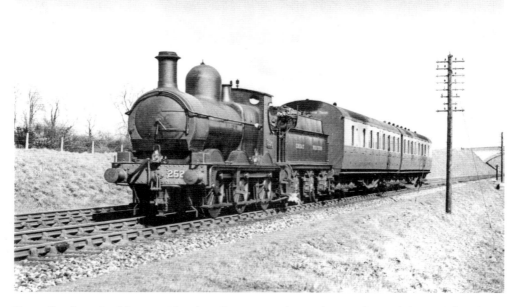

Dean Goods 0-6-0 No. 2526 heads a Down stopping train near Long Ashton Halt. (*G. H. Soole*)

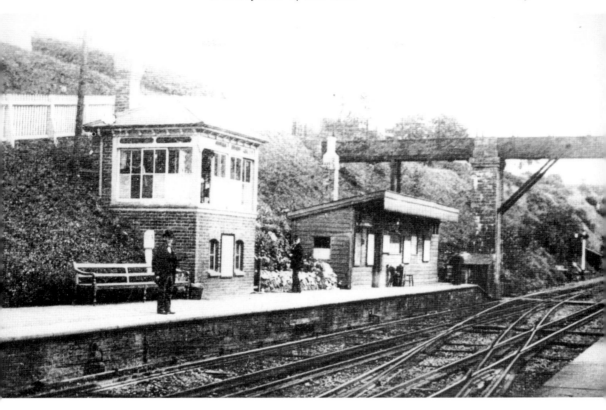

The Up platform of the 1860 Flax Bourton station, showing the B&E signal box. The station office is of timber and there is an unusual timber bridge supported on brick pillars. The track is mixed gauge. (*M. J. Tozer collection*)

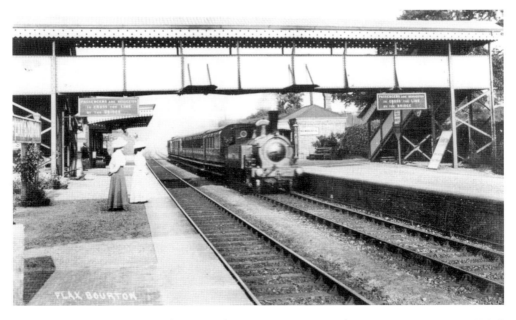

A Metro class 2-4-0T passes the 1893 Flax Bourton station with a Down train *c.* 1910. (*M. J. Tozer collection*)

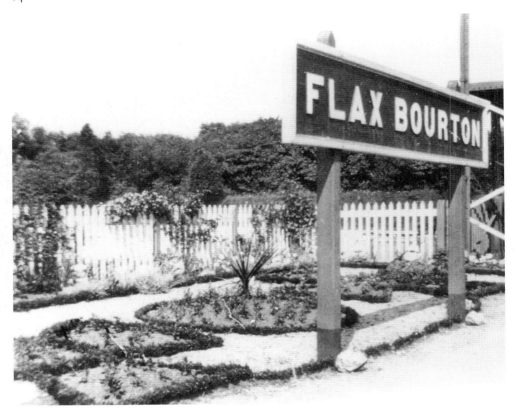

The running-in board and attractive garden on the Up platform, Flax Bourton. (*Author's collection*)

The Ministry of Fuel & Power's Tyntesfield Sidings, view west, 14 June 1988. (*Author*)

rail-served collieries nearby were Young Wood, closed in 1880, and from here ran a tramway to Whiteoak Colliery, closed the same year.

Before reaching Yatton are Claverham Loops offering an opportunity for fast trains to overtake slower ones.

Yatton, formerly the junction of the Clevedon and Cheddar Valley branches, closed to goods traffic on 29 November 1965. Its Brunel buildings still stand, with a Tudor-style flat all-round awning on the Down side, while the Up has an Italianate hipped roof and Tudor details. Yatton West signal box was built of red brick to a B&E design. Extended in 1897, latterly it had 130 levers and was manned by two men and a booking boy. The station garden was reinstated for the Millennium. The end of the Cheddar Valley walk is off the west end of the Down platform. To the west was Huish Crossing Loop, taken out of use on 24 January 1972.

Puxton Sidings ground frame was brought into use 1970/1 to give access to fly ash sidings bringing material for the construction of the M5. Fly ash was tipped into a field and this caused the ground to rise. One train arrived daily and, at the contractor's expense, BR provided a man to contact the signalmen on either side to warn when vehicles required to cross the main line.

Banwell was renamed Worle on 3 August 1869, Puxton on 1 March 1884 and Puxton & Worle on 1 March 1922 – the closure date of Worle station on the loop line. Puxton & Worle closed to passengers on 6 April 1964 and goods on 10 June 1963. Milk traffic was dealt with at the London Co-operative Creamery Siding between 1935 and 1966, the tank wagons usually being picked up by the 5.55 p.m. Wellington to West Ealing milk train.

Worle Parkway opened on 24 September 1990, having been built at a cost of £700,000. Due to it being erected on marshy ground, lightweight construction materials were used.

At Worle Junction the line bifurcates: one route is the Weston-super-Mare Loop (see page 32) and the other the main line to Taunton.

Weston Junction had a Down platform while an island platform served the Up main line and the branch to Weston-super-Mare. As there was no existing community, cottages were built nearby for the company's servants. It closed 1 March 1884 when the loop line replaced the terminal branch.

Just beyond, extensive sidings were opened on 9 October 1940 to serve Bristol Aircraft Company's 'shadow' works, while a passenger platform for workers was opened on 16 April 1941. Shunting within the works was carried out by two Ruston Hornsby 4wDM locomotives. All were taken out of use on 7 June 1964. In the post-war period, in order to keep the workforce employed, BAC manufactured aluminium pre-fabricated houses and schools. At least a hundred of the latter were sent to Victoria, Australia, the total cost being only £2,600. They travelled by rail from Weston-super-Mare to Avonmouth. The Weston Loop rejoins the main line at Uphill Junction.

A Grade II single-span flying bridge at Uphill has a span of 110 feet and is 60 feet above the line. It used less masonry than an ordinary bridge since it was supported without abutments by the cutting sides, and as it was built before the cutting was excavated to its full dimensions, no expensive centring was required. At the time of its construction it was reputed to be the highest and widest single-span brick bridge in the country. It was known as Devil's Bridge, after 'Devil'

Payne, a cantankerous landowner who possessed the land needed for the railway and who held out for a high price.

Bleadon & Uphill opened in 1871 as Uphill, the name being lengthened the following year. The station was unstaffed from 2 November 1959 and closed on 5 October 1964. It had no goods facilities, only a siding north of the station serving a quarry. From Bleadon the line is almost completely straight to Bridgwater.

The 400-foot-long timber platform Brean Road Halt opened on 17 June 1929 at a cost of £1,487. It closed on 2 May 1955. In addition to passengers, it dealt with milk and general produce. Guards of Down trains conveying milk were required to take the consignment notes to Brent Knoll and carry Up notes to Weston-super-Mare.

The buildings at Brent Knoll station were of timber due to the marshy ground. The station exemplified the two types of Brunel roofs: a steep Tudor-style gabled roof and a hipped roof with sloping ends instead of vertical gables. The station was unstaffed from 1 October 1964, closed to goods on 6 June 1963 and to passengers on 4 January 1971, though in its final years only one morning and evening train called daily.

Highbridge station was noted for the fact that, immediately north of the platforms, the Somerset Central Railway (later the Somerset & Dorset Railway) crossed the main line on the level. To the north of the passenger station was quite an extensive goods yard and, until 6 September 1965, a siding served a brick works. The number of wagons on a transfer trip between the two railways was not to exceed twenty-two and a tail lamp was required to be fixed to the rear vehicle. Before a passenger train was allowed to pass to or from the Somerset & Dorset line, the Highbridge Crossing signalman was required to obtain an assurance from the man at the points that all which were not bolt-locked from the box were properly secured with clips. GWR passenger stock of 70 feet or more in length were banned from using the crossover road.

The station enjoyed a number of names: it became Highbridge West on 5 May 1950; Highbridge & Burnham-on-Sea on 30 June 1962; reverted to Highbridge on 6 May 1974 and became Highbridge & Burnham on 17 May 1991. The concrete footbridge, which originally also linked the GWR platforms with those of the Somerset & Dorset, still remains.

Following closure of most of the Somerset & Dorset in 1966, Highbridge to Bason Bridge was retained for milk traffic, while on 26 April 1971 a temporary road-stone terminal was opened when the M5 was being constructed. A trial run was made on 19 April 1971, and from 26 April two trains ran daily, increasing to three on 3 May. The line closed on 3 October 1972, the creamery having closed the previous day. Highbridge itself closed to goods on 2 November 1964.

At Huntspill the extensive Puriton Royal Ordnance Factory Sidings were brought into use on 19 May 1940. The site had several advantages: the methanol, TNT and anthracite required for production could be obtained from South Wales, the GWR provided a rail link and Dunball Wharf a sea link. Although water was available from Durleigh Reservoir, this proved insufficient, so a new drainage channel, Huntspill River, was cut in the flat countryside. The factory went into production in August 1941 and employment was at its peak in March 1943, when there were 2,816 workers. In May 1945 the factory produced 200 tons of RDX weekly.

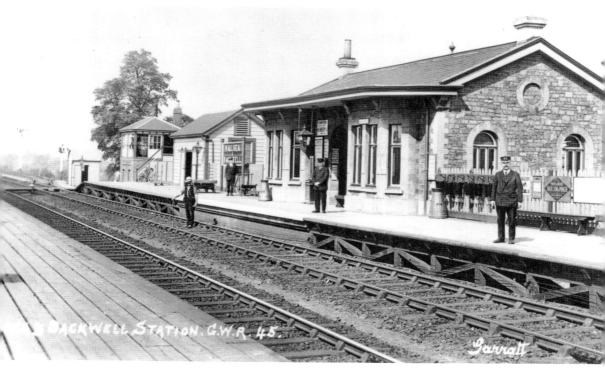

Nailsea & Backwell, view Down, 1920. As it stands on 'made' ground, for lightness the platform is principally of timber. Behind the stationmaster is a row of fire buckets. A permanent way man wearing a straw hat stands in the Up road, while the signalman has all his windows open and leans out, duster in hand. He has arrived on a bicycle, which leans against the cabin steps. A goods shed stands between the signal box and the main building. (*Author's collection*)

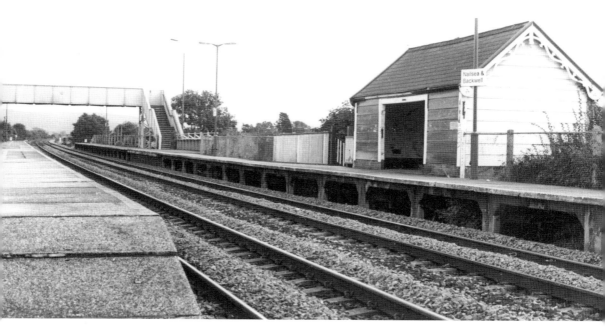

Nailsea & Backwell view Up, 12 October 1991. (*Author*)

Nailsea & Backwell view Down, 12 October 1991. (*Author*)

The cycle shed and unattractive stairway at Nailsea & Backwell, 30 May 1992. (*Author*)

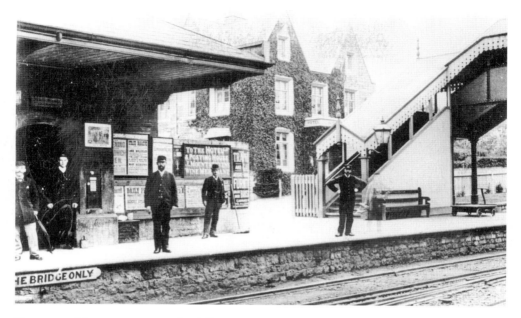

Yatton, 20 May 1892: notice the different styles of uniform, the mixed gauge track, and the back of the seat near the footbridge steps bearing the legend 'Yatton Station'. Railway servants cross over the track from one platform to another using the step on the far left, but passengers are requested to use the bridge. The GPO box in the wall enjoys three collections daily. To the right of this box is a receptacle for used books and magazines, but the name of the charity cannot be discerned. (*Author's collection*)

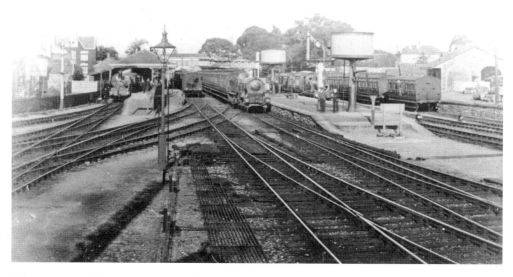

A busy scene at Yatton, *c.* 1908, with a passenger train at all four platforms. A 3001 class 4-2-2 heads a Down main line train; a 517 class 0-4-2T stands in the Down bay platform with a Cheddar Valley, or Wrington train. On the left is an Up main line train and one to Clevedon. (*M. J. Tozer collection*)

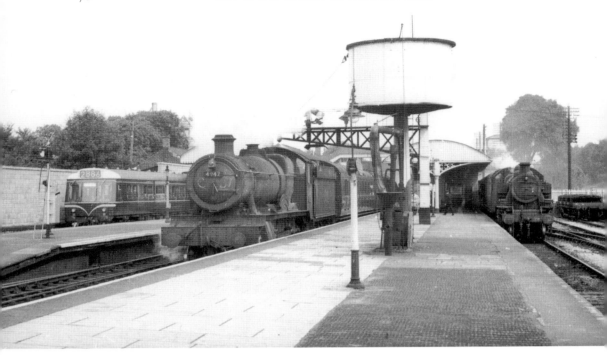

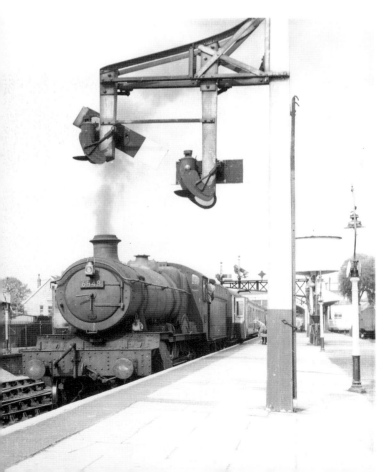

*Above:* Yatton, 20 August 1960:
4-6-0 No. 4947 *Nankoran Hall*
is in charge of the 9.40 a.m.
Swansea to Weston-super-Mare,
Ivatt class 2 2-6-2T No. 41249,
the 1.27 p.m. Yatton to Wells,
while a DMU works the 1.30
p.m. Saturdays-only to Clevedon.
Swansea to Weston-super-Mare
is only 50 miles by sea, but 103
miles by rail. (*R. E. Toop*)

*Left:* 4-6-0 No. 6848 *Toddington
Grange*, of 88D Merthyr shed,
heads a Down train at Yatton.
The signals are suspended in order
that their sighting is not blocked
by the footbridge. (*W. H. Harbor*)

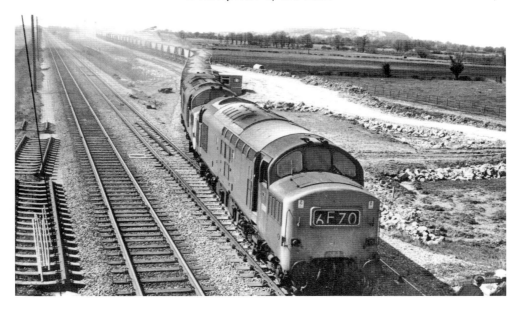

Type 3 English Electric diesel-electric No. 6981 and No. 6875 back into West Huish fly ash sidings on 20 April 1970, with a train from Aberthaw. The pulverised ash is for use in constructing the M5. The view was taken from Puxton signal box. (*Revd Alan Newman*)

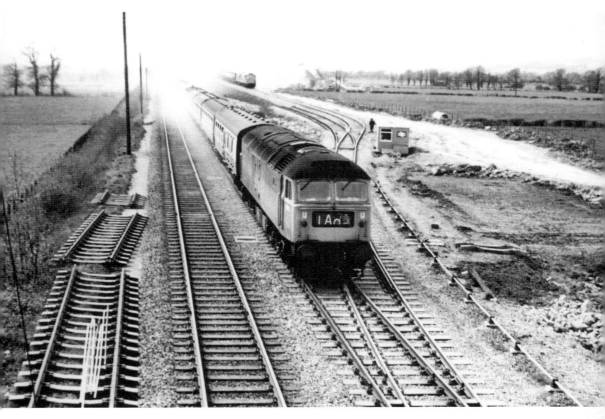

Brush Type 4 diesel-electric No. 1644 passes the fly ash sidings with the 13.50 Weston-super-Mare to Paddington, 20 April 1970. (*Revd Alan Newman*)

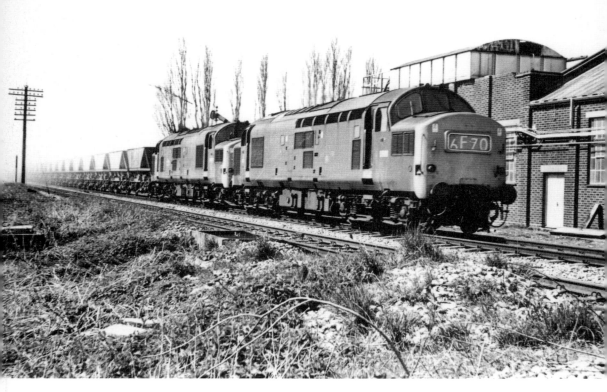

Type 3 diesel-electric No. 6981 and No. 6875, with a fly ash train from Aberthaw, passes the creamery at Puxton, 20 April 1970. (*Revd Alan Newman*)

Worle Parkway, view Up, 11 March 1992. (*Author*)

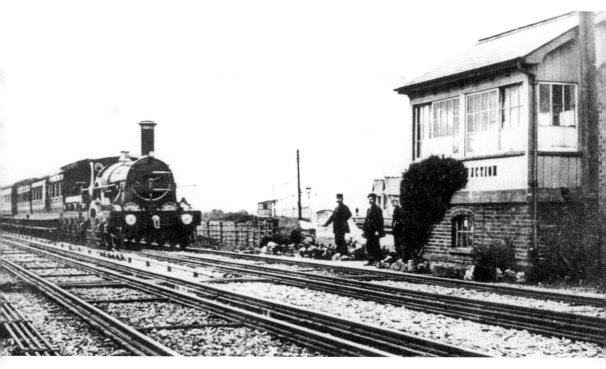

The Up Cornishman passes Worle Junction signal box, 3 May 1892. Worle station on the Weston-super-Mare Loop can be seen immediately to the left of the signal box. The track is mixed gauge. (*Revd A. H. Malan*)

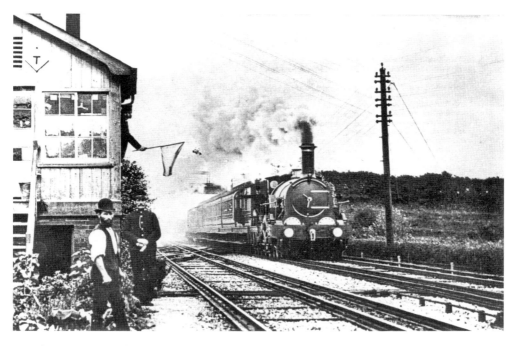

Broad gauge 4-2-2 *Inkerman*, with Driver G. Eggar, passes Worle Junction with the second part of the Down Flying Dutchman, 3 May 1892. The signalman displays a white flag to indicate a clear road. (*Revd A. H. Malan*)

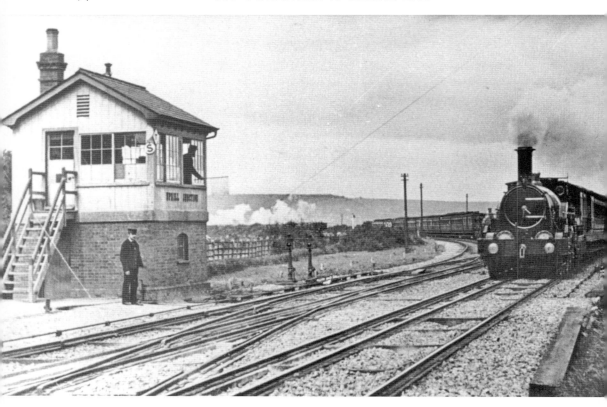

The Down Cornishman passes Uphill Junction, 4 September 1891. A Down train from Weston-super-Mare waits for it to pass. (*Revd A. H. Malan*)

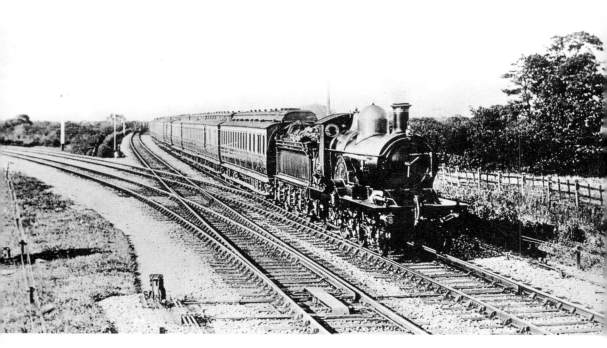

3001 class 4-2-2 No. 3060 *Warlock*, at Uphill Junction with a Down express. In March 1909 it was renamed John G. Griffiths. (*Author's collection*)

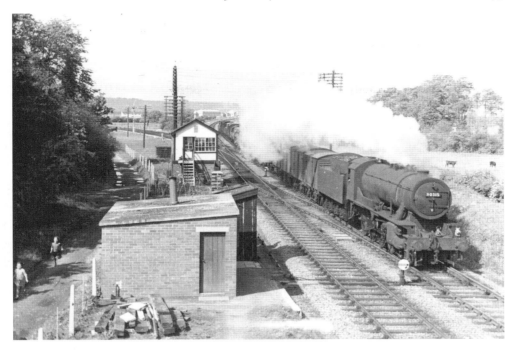

WD 2-8-0 No. 90315 passes Uphill Junction with a Down goods, 18 May 1957. (*R. E. Toop*)

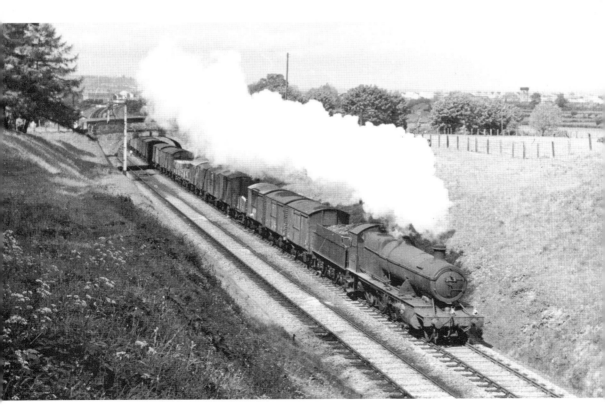

28XX class 2-8-0 No. 2875 passes Uphill Junction with a Down goods, 18 May 1957. (*R. E. Toop*)

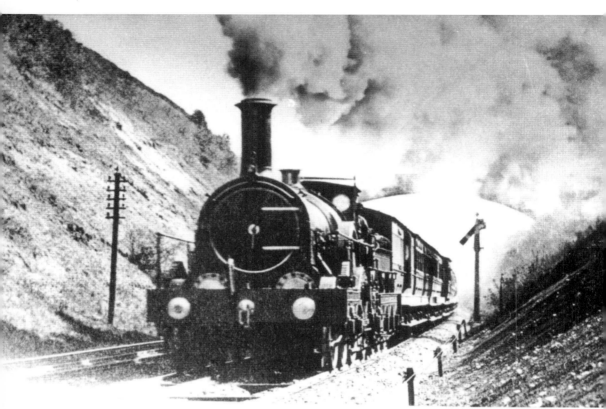

Broad gauge 4-2-2 *Balaclava* passes under Devil's Bridge, Uphill, with the Up Flying Dutchman, 19 May 1892. (*Revd A. H. Malan*)

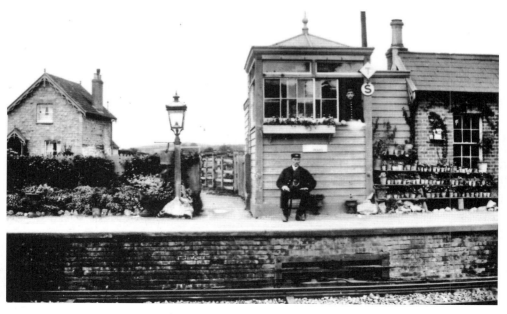

Bleadon & Uphill, 31 August 1891. Notice the shelves of potted plants on the right and the stationmaster's house on the left. (*Author's collection*)

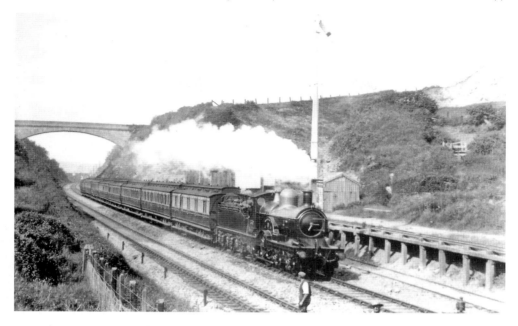

3011 class 4-2-2 *Kennet*, built in April 1892, heads a Down express through Bleadon & Uphill *c*. 1900. Devil's Bridge is in the background. Notice the tall signal with a long ladder for the lamp man to climb. A narrow gauge quarry railway serves the loading platform of the ballast siding. *Kennet* was withdrawn in June 1908. (*Canon Brian Arman collection*)

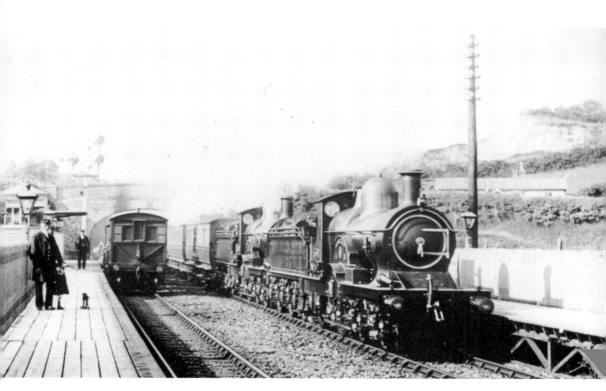

3001 class 4-2-2 No. 3077 *Princess May* pilots No. 3065 *Duke of Connaught*, of the same class, on a Down express at Bleadon & Uphill. Notice the toy wooden horse on the Up platform. (*Author's collection*)

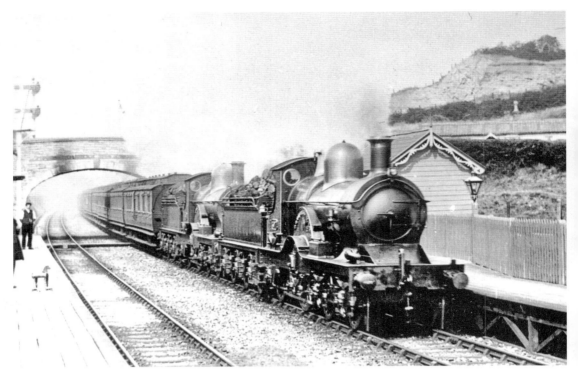

3001 class 4-2-2 No. 3011 *Greyhound* and No. 3020 *Sultan* pass Bleadon & Uphill, *c.* 1900. A porter holds the hand of a child with a wooden horse. (*Author's collection*)

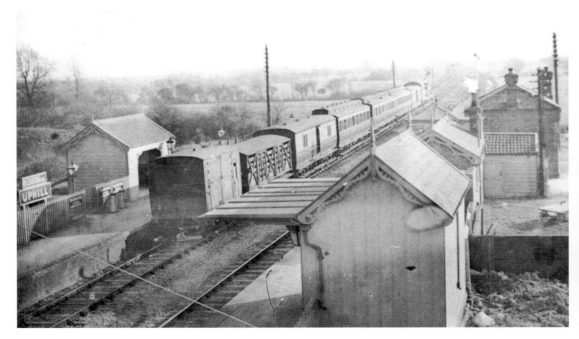

A Down train leaves Bleadon & Uphill. On the left, the original name board 'Uphill' had 'Bleadon &' added above when it was renamed in 1872. The last vehicle is a horse box and the penultimate, a ventilated van for conveying milk churns. (*Author's collection*)

The railway museum at the former Bleadon & Uphill station. Seen here on 13 April 1971 is GWR 0-4-0ST No. 1338, ex-Cardiff Railway, and latterly a shunter at Bridgwater Docks. (*Revd Alan Newman*)

The timber-platformed Brean Road Halt, view Up 1948. Note the experimental flat-bottomed track on the Down line. Beyond the halt can be seen Lympsham signal box opened 19 May 1921 and closed 21 December 1958. (*Locomotive & General Railway Photographs*)

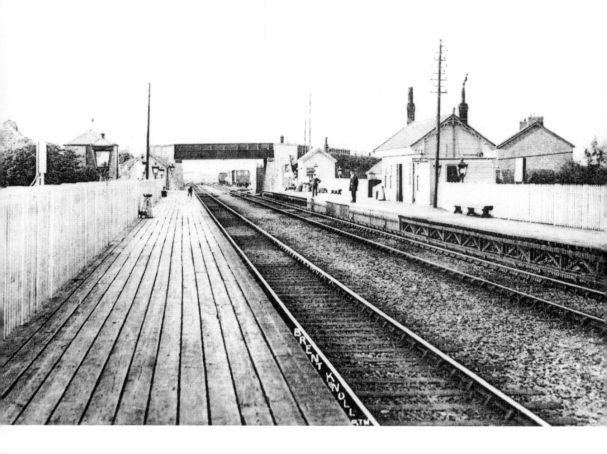

# B & E R

## To

# Highbdge.

*Above:* Brent Knoll, view up. Most of the platforms are timber, the only solid portion being in front of the station building. (*Author's collection*)

*Left:* Highbridge luggage label.

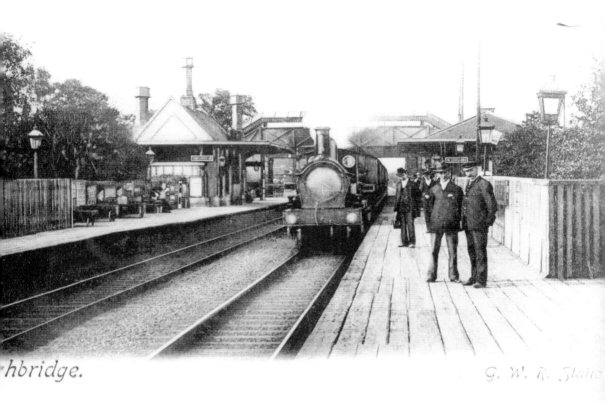

A 2-4-0 heads a Down train at Highbridge *c*. 1910. (*Author's collection*)

A Wilts United Dairy's Albion lorry and churns by the Up platform, Highbridge, 2 February 1928. The signal box is in the background. (*Author's collection*)

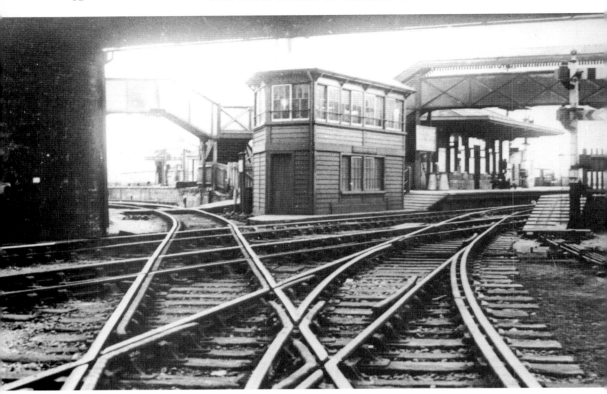

The junction at Highbridge, *c.* 1920. The GWR passes from left to right, the Somerset & Dorset line to Burnham-on-Sea is behind the photographer, and the line ahead leads to Evercreech Junction. (*Author's collection*)

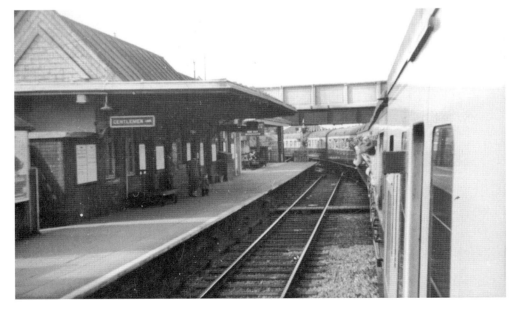

On 28 April 1957 a Railway Correspondence & Travel Society special at Highbridge runs from the GWR Down Main to the Somerset & Dorset, *en route* to Burnham. (*Dr A. J. D. Dickens*)

Messrs Courtaulds' siding, Bridgwater, view Up, 22 February 1990. (*Author*)

open, with a 50-ton crane for dealing with Hinkley Point nuclear power station containers, which travel by rail from Bridgwater to Sellafield and are handled by Direct Rail services. The UKF fertiliser traffic ceased many years ago, although the sidings still remain. In the 1950s, the goods department at Bridgwater employed about fifty men and twenty clerks, the goods agent there being graded higher than many of the divisional staff.

One Bridgwater porter was dismissed by the B&E for being absent when a slip coach arrived (slips were inaugurated at Bridgwater in 1869). He was expected to be on duty for fourteen hours each day, apart from the thirty minutes allowed for lunch. His union tried to uphold his case for reinstatement, but the B&E was reported as saying it did not intend and 'never did intend, to be interfered with or dictated to by a self-appointed authority, who might wish to – for the purpose of being clothed with brief authority – and choose to interfere in some matter in which they were not concerned'.

Between the passenger station and the goods yard, the Docks branch curved away from the Up line. Opened by Bridgwater Corporation in 1845 as a horse tramway known as the Communication Works, it was leased to the B&E in August 1859, purchased by that company in 1863, and four years later was converted to mixed gauge and worked by locomotives. In 1871 it was extended to the Docks.

Between 1971 and 1973 the construction of the M5 necessitated rebuilding the standard gauge line on a new alignment with severe gradients either side of the viaduct over the motorway, requiring the introduction of more powerful locomotives. Its first engine was an Andrew Barclay 0-4-0ST, but subsequent locomotives 0-4-0DMs.

Following the factory's closure in 2008, the track has been lifted. Sedgemoor District Council has recently consulted the public on its plan for an energy park to include what will become the West Country's largest solar farm, and the feasibility of reopening the branch from the main line is being investigated. If it were rebuilt before the opening of the energy park, it could be used for transporting contaminated material from the site. The initial report states that the earthworks are basically in good condition, but that the bridge over the M5 would probably have to be strengthened to meet modern axle load requirements, while the expense of reinstating the junction at Huntspill with associated modern signalling would be significant. Pottery Siding, a short distance west along the main line, was taken out of use in 1968.

Dunball station opened in 1873 where the line crosses King Sedgemoor Drain, and it was this feature which led to the timber platforms being staggered. It became a halt when staff were withdrawn on 6 November 1961. Passenger closure came on 5 October 1964 and goods on 2 November 1964. Opposite the Down platform, sidings led to Dunball Wharf on the River Parrett. Until it was removed on 16 November 1958, a siding crossed into a cement works on the east side of the main line. The wharf line closed on 22 April 1967. There was a First World War munitions factory at Dunball Pottery Sidings, served by a workers' train from 26 July 1916. London & South Western Railway C14 class 2-2-0T No. 738 was purchased by the Ministry of Munitions in November 1917 for £1,050 for use at the works.

When Dunball Cutting was being excavated, a deposit of blue lias was found, valuable for cement-making. Mr Board started the works, which was served by a siding. Approaching Bridgwater, the British Cellophane Company sidings were just south of the bridge that carried the Somerset & Dorset's Bridgwater branch over the main line. When the factory was being built in 1935, the local authority was most encouraging, as it was in a depressed area due to the closing of the Somerset & Dorset Railway's locomotive works at Highbridge in 1929, and the decreased trade in bricks and tiles.

The standard gauge sidings serving the cellophane factory were first shunted by Peckett 0-4-0ST No. 1904, purchased new in 1936; Andrew Barclay 0-4-0ST No. 1286 of 1914, bought in 1950, and 0-6-0DM, ex-BR D2133, obtained in 1969. The factory is now closed.

Bridgwater is one of the oldest surviving B&E stations. Designed by Brunel, it is Grade II listed. It has large, single-storey matching buildings on both platforms. The Up platform building has Georgian-style windows, its low, pitched roof hidden behind a parapet. The platform canopies are supported on decorated pillars. A glazed screen protects passengers from the prevailing wind. On the Down platform is a large shelter. General goods facilities from the extensive yard north of the station were withdrawn in November 1965, but the yard is still

## SOMERSET AND DORSET TRAINS CROSSING GREAT WESTERN MAIN LINES.

When Up or Down Somerset and Dorset Trains require to cross the Main Lines at Highbrid the Trains are signalled from the S. & D. "A." or "B." signal boxes as the case may be on a bell fix in the G.W.R. Signal Box as under :—

| UP TRAINS.<br>Signals from S. & D. "A" Box. | Beats on Bell. |
| --- | --- |
| Up Passenger Train to Burnham | 2 Beats. |
| Up Goods Train, or Light Engines to Burnham or to S. & D. Goods Yard | 4 Beats. |

| DOWN TRAINS.<br>Signals from S. & D. "B" Box. | Beats on Bell. |
| --- | --- |
| Down Passenger Train from Burnham | 2 Beats. |
| Down Goods Train or Light Engines from Burnham or S. & D. Goods Yard | 4 Beats. |
| Transfer Trains S. and D. to G.W.R. | 5 Beats. |

Before permission is given for S. & D. Trains to cross, the signalman in the G.W.R. Box place the Up or Down Main Line Signals to danger, and then give the required permission by pull over the necessary lever or levers for an Up or Down Train, and taking off the slots, which enable the signalman in the S. & D. Box, "A" or "B," as the case may be to lower his Start Signal to allow the Up or Down S. & D. Train to cross over the G.W. Main Lines.

Extract from the *Appendix to the Service Time Tables*, May 1909, giving instructions for crossing Somerset & Dorset Railway trains over the GWR main line at Highbridge.

When GWR trains or engines were in the reception sidings, the factory engine was required not to carry out any movement between the single line and the reception sidings unless a clear understanding had been made between a member of the factory staff and a railwayman. When the workers' passenger train was required to run between the reception sidings and the factory site, the factory inspector acted as pilot man, wearing a standard pilot man's armlet. Before taking the train forward he was responsible for seeing that the factory's locomotives and all wagons were secured clear of the lines over which the passenger train was to run. He was also responsible for seeing that the points at the marshalling yard were clipped and padlocked for the safe passage of the train. On arrival at the factory marshalling yard, the engine was uncoupled and returned to the reception sidings, after which the factory engines could be released. A similar system was operated for taking passenger coaches from the factory to the reception sidings. Speed was limited to 10 mph in daylight and clear weather, and 5 mph during darkness, falling snow, or when passing over the weighbridge.

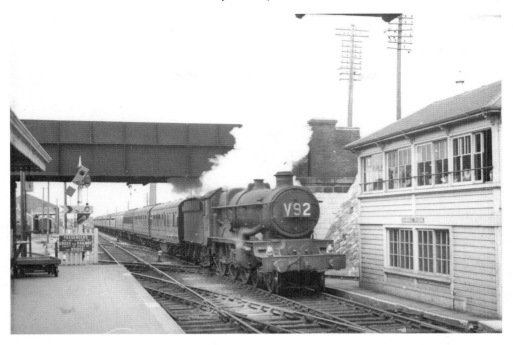

4-6-0 No. 4098 *Kidwelly Castle* at Highbridge heads a train of ex-LMS coaches to Paignton, 24 June 1961, on the Somerset & Dorset crossing. (*R. E. Toop*)

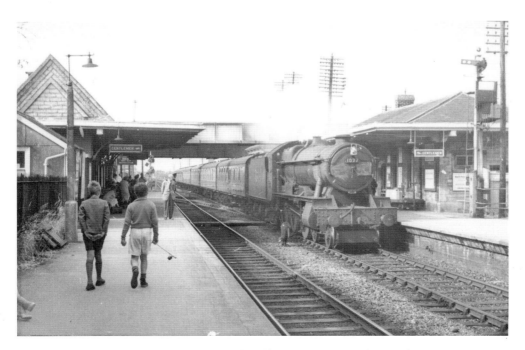

At Highbridge, 4-6-0 No. 1027 *County of Stafford* works a Temple Meads to Taunton train, 24 June 1961. (*R. E. Toop*)

This entailed a bridge having to be built across the River Parrett and, to avoid interfering with river traffic, one span was made telescopic.

The bridge consisted of three sections. When a vessel required to pass, the man in charge of the bridge was required to fix stop blocks across the rails, place the signals at each side of the bridge in the Danger position, and then close the gates. The first bridge section was then moved sideways on wheels; the second section, which spanned most of the river, was then moved sideways into the space vacated by the first section, thus clearing the river. The third section remained fixed. The two movable sections were shifted by a stationary steam engine. Due to the upper berths of the river falling out of use, it is believed that the bridge, still *in situ* today, has not been opened since June 1957. It is designated an Ancient Monument.

The opening of the Docks branch ended the practice of coal being carried to Taunton by the Bridgwater & Taunton Canal and then distributed onwards by rail, as it could then be delivered direct from Bridgwater by rail without any additional transhipment. At one time Bridgwater became the fifth-ranking port in Britain for the import of coal, trade trebling in the decade ending in 1874. One coal merchant distributed by rail 40,000 of the 60,000 tons he imported.

The peak period for Bridgwater Docks was 1880–5, when an average of over 3,600 vessels, mostly schooners and ketches, arrived annually with coal, timber, grain and sand; they left carrying bricks and tiles. The opening of the Severn Tunnel in 1886 reduced coal imports at Bridgwater. By the late 1920s, only about 530 ships used the docks annually.

A shunter and two hand-signalmen, each with a red flag, were required to accompany every trip over the Dock line.

The Somerset & Dorset Railway's Edington Junction to Bridgwater North branch closed to passengers on 1 December 1952, but before it closed entirely on 2 October 1954, a new chord line was opened on 27 June 1954 in order to give access to the former S&D yard from the Bridgwater Docks branch. This chord was severed on 2 January 1967, shortly before the Docks branch closed in April 1967.

The B&E did not encourage standard gauge traffic, because standard gauge wagons required at the Docks had to be ordered up to a week in advance, and no matter how much traffic there was between Bridgwater and the Somerset & Dorset at Highbridge, only one standard gauge train ran daily.

South of the passenger station were the carriage and wagon shops founded by the B&E, initially for repair, but from 1848 the majority of the company's rolling stock was built there. It was one of the town's major employers. In 1934 the works changed solely to tarpaulin sheet examination, and during the Second World War all types of military canvas, varying from tents to stretchers, were repaired. Eventually returned to peacetime use, these works in Colley Lane caught fire on 25 August 1947. Approximately 1,500 sheets and hundreds of pulley blocks were lost in the blaze and the works never reopened.

South of the town the line crosses the River Parrett by Somerset Bridge. The low-lying length between Bridgwater and Durston was subject to flooding.

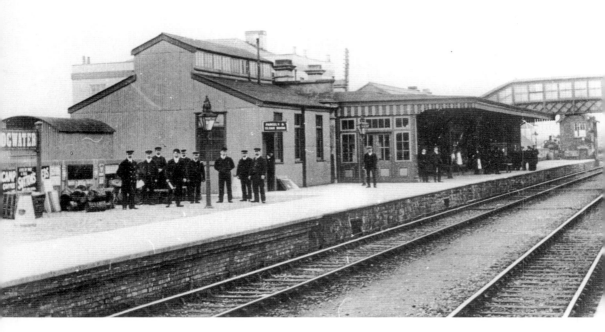

Bridgwater view Up, 1897. Notice the change in platform facing from stone to brick, indicating where it has been extended. (*P. J. Squibbs collection*)

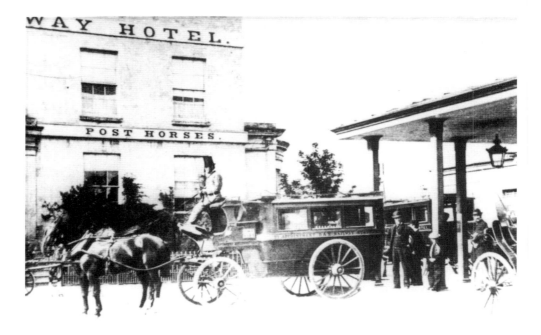

A horse bus to the town centre stands outside Bridgwater station, 1865. A notice below the windows reads, 'By appointment B&E Railway Station.' (*Author's collection*)

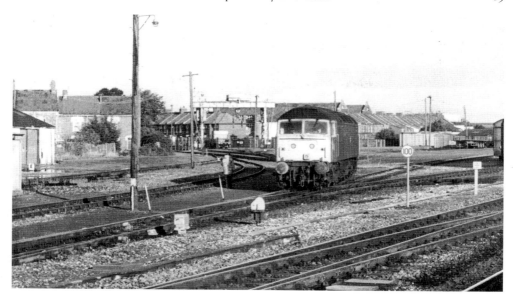

No. 47323 at Bridgwater, 29 October 1990. The line to the left formerly led to the docks. (*Author's collection*)

## Working of Slip Coaches.

Points at which Slip Coaches must be detached at Stations where they are regularly Slipped are as under :—

| Station. | Up or Down Train. | Point at which Slip must be detached. |
|---|---|---|
| Bridgwater | Down | Opposite Down Distant Signal for the East Box. |
| Do. | Up | Opposite Up Distant Signal fitted with Slip Arm, for the West Box. |
| *Taunton | Down | Opposite Canal Bridge, 890 yards from Footbridge Taunton Station. |
| **Do. | Up | At Fairwater Bridge, 982 yards from the Footbridge, Taunton Station. |
| ***Norton Fitzwarren | Up | Opposite the Up Distant Signal for Norton Fitzwarren Box, 1,153 yards from Box.—(Slips off Up Ocean Special Mail Trains only). |
| ****Exeter A | Down | On Exwick Level Crossing. |

\* Slip Guard to satisfy himself that the Down Distant Signal for East Station Box is standing at " All right " before slipping.

\*\* Slip Guard to satisfy himself that the Up Distant Signal for West Junction Signal Box is standing at " All right " before slipping.

\*\*\* Slip Guard to satisfy himself that the Up Distant Signal for Norton Fitzwarren Box and the Arm above it which is the Starting Signal for Victory Siding Box are standing at " All right " before slipping. Slip to be stopped Dead just inside the Up Home Signal for Norton Box, where an Engine will be attached to work Slip to Bristol.

\*\*\*\* The Slip Guard must satisfy himself that the Down Distant Signal for the West Signal Box is standing at " All right " before slipping.

A Station Master, Exeter, to arrange for a porter to be on duty at the Wicket Gate near the Middle Signal Box at Exwick Crossing to prevent passengers from crossing until the Slip Coach off the Down Limited Express, daily, has passed the Crossing.

See Standard Slip Coach Regulations in the Revised General Appendix to the Book of Rules and Regulations.

Extract from the *Appendix to the Service Time Tables*, May 1909, giving instructions for slipping coaches at Bridgwater and Taunton.

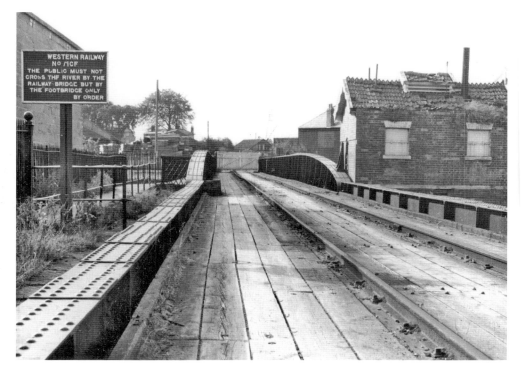

The retracting bridge over the River Parrett on the Bridgwater Docks branch, 8 October 1966. Machinery in the engine house, right, moved the section of rail in the foreground to the right, leaving a space into which the span beyond could be retracted. (*Author's collection*)

View of the bridge looking in the opposite direction, 8 October 1966, showing the space, left, into which the section of the track is moved. (*Author's collection*)

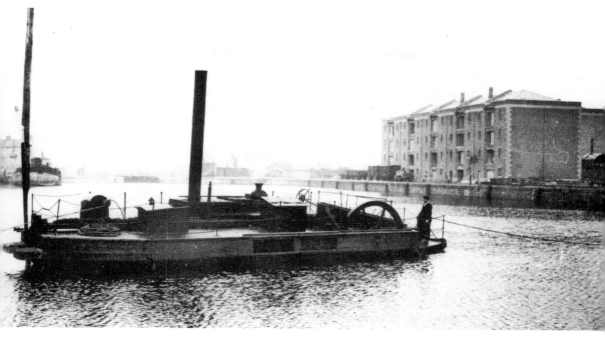

Brunel's mud scraper at work in Bridgwater Docks. (*Author's collection*)

Simplex shunting engine No. 15 at Bridgwater Docks, February 1951. The cab had completely open sides. The locomotive weighed 8 tons and was powered by a four-cylinder petrol engine developing 40 bhp at 1,000 rpm. The chain driver to both axles was through a two-speed gear box. (*Author's collection*)

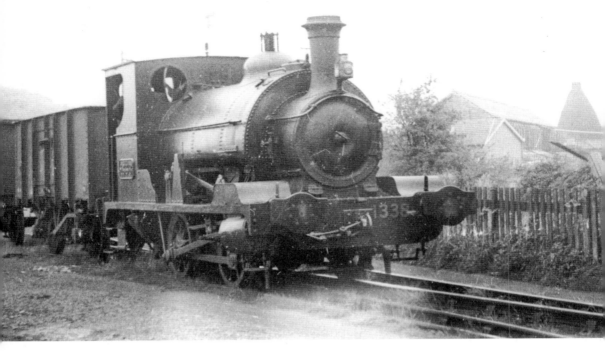

Ex-Cardiff Railway 0-4-0ST No. 1338 (now preserved), shunting on the Bridgwater Docks branch, 13 October 1951. (*Colin Roberts*)

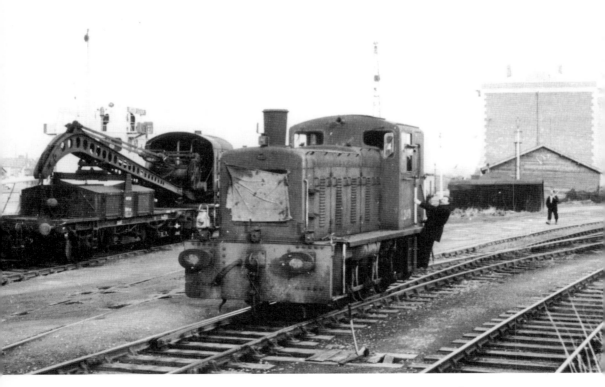

Drewry 0-6-0 shunter D2140 at Bridgwater Docks, 18 January 1965. (*Paul Strong*)

## Dock Line Working

The Railway Bridge over the River Parrett leading to the Dock is fixed in position for railway traffic, but in the event of special arrangements being made to open it for river traffic, the following instructions must be strictly observed :—

Before the bridge is opened and railway communication cut off with the Dock, the man in charge of the bridge must adjust the stop blocks across the rail, place the signals at each side of the bridge in the " Danger " position and then close the gates. This protection must remain in operation until the bridge is again closed and communication restored with the Dock.

To avoid trespass over the Railway Bridge when it is not required for Dock traffic, the gates across the bridge must be kept locked. The keys of the gates must be kept on the Dock Pilot Engine.

The speed of engines and trips must not exceed 5 miles per hour over any portion of the Dock Line.

The following public roads cross this line :

| | |
|---|---|
| Bath Road | West Quay Road |
| Bristol Road | North Gate |
| Church Street | |

A Shunter and two Handsignalmen must accompany every trip over the Dock Line.

The two Handsignalmen, each equipped with a red flag, must be employed when passing over the Bristol and Bath public roads. One must post himself to command the Bristol Road, and the other the Bath Road. Each man must exhibit the red flag to caution persons approaching in either direction, and when it is safe for the trip to cross the public roads, the man standing furthest from the trip must give an " All right " signal to the man nearest the engine, who must pass on the signal to the Shunter in charge of the trip, who must remain with the engine and instruct the Driver. The Handsignalmen must remain at the respective crossings until the trip has passed clear over the crossings.

Except when shunting is taking place, the wheel stops which protect the Bristol and Bath public roads must be kept across the rails. The Shunter in charge will be responsible for seeing this is done.

Before any of the other public roads are fouled, the Shunter in charge of the movement, or a Handsignalman, must post himself in such a position to caution persons approaching in either direction. When it is safe for the train to cross the public road, he must give the " All right " signal to the Driver. The Shunter or Handsignalman must remain at the crossing until the movement has passed clear over the Crossing.

An engine may, if necessary, propel a maximum of six wagons over the public road crossings with the exception of the Bristol and Bath roads, which must be restricted to not more than three wagons. When such working is adopted a handsignalman equipped with a red flag must be provided at each crossing to afford protection of the public roads in either direction and, in addition, the shunter must walk alongside the leading vehicle in order to be prepared to signal the Driver.

During shunting of Sidings adjacent to buildings, coupling and uncoupling of vehicles in motion must only be performed at places where there is sufficient clearance to allow the shunting pole to be used without risk of accident.

**No engine must be taken across any road except in daylight and clear weather.**

**The engine must, in all cases, be brought to a stand before fouling any public road, and when wagons are propelled over the Public Road Crossings, the trip must be brought to a stand before the leading wagon fouls the public road.**

---

## Restrictions on Wagons working in Bridgwater Dock

Wagons with a wheel base exceeding 11 ft. are prohibited from working to the undermentioned firms and traffic must be dealt with at Chilton Street Siding :—

Holmes Sand and Gravel Company and sidings on the North side of the dock.

Instructions for working the Bridgwater Dock Branch given in the *Working Time Table Appendix* for March 1960.

The ex-Somerset & Dorset Railway's Bridgwater North station, 29 August 1956, in goods use following closure to passengers. (*Author's collection*)

The B&E's carriage works, Bridgwater, 1865, with the traverser rails behind the entrance gates. The foreman wears a top hat. (*P. J. Squibbs collection*)

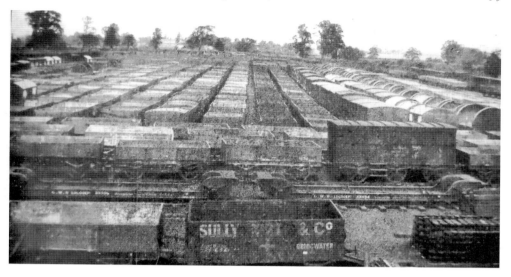

Broad gauge goods rolling stock dumped at Bridgwater following the abolition of the broad gauge on 20 May 1892. 75 per cent of this stock was inconvertible. The total number of broad gauge wagons in traffic at the time of the conversion was 3,351. (*Author's collection*)

Durston station opened 1 October 1853 with the inauguration of the Yeovil branch. The main line has an Up platform, while there is an island on the Down side. The large signal box at its end was unusual in being placed at right angles to the line. In its early years the branch platform was covered by a train shed. The station closed to goods on 6 July 1964 and passengers on 5 October 1964.

At Cogload Junction, the line from Bristol and the direct line from Paddington via Castle Cary join. Originally a flat junction, with the 1930s quadrupling in the Taunton area, on 15 November 1931 it was made a 'flying junction'.

Creech St Michael Halt opened on 13 August 1928 at a cost of £800, but quadrupling soon caused it to be modified. Its two platforms served the relief lines, which formed the outer tracks. It had neat, brick-built waiting rooms. Although designated a 'halt' it was staffed like a station and had carefully tended flower beds. It closed on 5 October 1964.

The main line burrowed beneath the Chard Canal. Brunel constructed a brick invert with retaining walls 660 yards long, in the centre of which was the aqueduct carrying the canal. As the railway descended into this invert from either end, water collected in the dip below the aqueduct and required pumping into surface drains. The B&E purchased the canal in 1867 and dismantled the aqueduct two years later, but the invert was not filled and the track raised until 1895. Shortly beyond, the Chard branch diverged at Creech Junction.

On the approach to Taunton, the GWR's concrete depot could be seen on the Up side. Started in 1898, in 1963 it also took over work formerly performed by the former SR's Exmouth Junction concrete works. It closed in the summer of 1995.

On 20 February 1932, a new brick-built goods shed was opened at Taunton, almost twice the size of the original. The platforms in this two-road shed were connected by movable balanced bridges, and before wagons were moved, the

bridges were required to be lifted clear of the tracks. One of the shed roads was extended beyond the shed to a loading bank that dealt with container traffic, and other heavy consignments requiring the use of a 6-ton crane. The overhead warehouse was equipped with two electrically powered lifts and this accommodation was used for storing animal feedstuffs and a repository for consignments of a variety of commodities.

In the 1930s, the depot operated a two-shift system: early turn 5.30 a.m. until 2.30 p.m. and the late turn 2.00 p.m. until 11.00 p.m. Ideally the early turn discharged all wagons and the late turn loaded them. As Taunton handled many head of livestock, cattle pen accommodation was increased in the 1930s. It was not unusual to see forty to fifty cattle wagons waiting to be cleaned. Coal and coke for industrial and domestic use was important, as were building materials and farm supplies. The various biscuit manufacturers sent small containers to Taunton thrice weekly.

Outwards traffic was wide-ranging, but tended to be connected with agriculture – cattle, sugar beet, butter, eggs, greengrocery and pit props. In 1963 Taunton became a Freight Concentration Depot, the surrounding sub-railhead depots being closed. Despite this economy, lack of traffic caused Taunton to close to freight in 1972.

The passenger station at Taunton is Grade II. Originally it was an example of Brunel's one-sided pattern, with Up and Down stations built on the same side of the main line. The Up station at the Up end of the layout was single-storey, and the Down station of two storeys. Both were executed in the domestic style. As Taunton developed as a junction station, the Up building was demolished and its platform became part of the Down. A new Up platform was built on the other side of the tracks and an overall roof added, spanning 250 feet by 88 feet, all work being completed by 17 August 1868, and that afternoon the directors and officials dined at the nearby Douch's Railway Hotel.

In 1895 the platforms were further extended, giving Taunton the longest platforms on the GWR system. Bay platforms were added to deal with terminating trains. Despite these developments, Taunton remained congested, so to ease the situation a goods avoiding loop was added south of the station, built approximately on the site of the Grand Western Canal, which had been bought by the B&E in 1864.

Cogload Junction to Norton Fitzwarren was a 7½-mile-long bottleneck. The Development (Loans, Guarantees & Grants) Act of 1929, with the aim of relieving national unemployment, provided funds for the improvement of large public works, and the Taunton area qualified. Quadrupling the track necessitated the reconstruction of sixteen bridges and the removal of 140,000 cubic yards of earth. The cost was estimated at £360,000 and Scott & Middleton were the contractors.

With the quadrupling works taking place between September 1930 and April 1932, the passenger station's overall roof was demolished and replaced with four through roads. To economise on maintenance, on 31 March 1976 the island platforms were taken out of use and only passed by non-stop trains, but in 2000 they were restored to passenger use. On 16 March 1983 a new booking office and travel centre opened, the building virtually obscuring the façade of the 1931 booking hall.

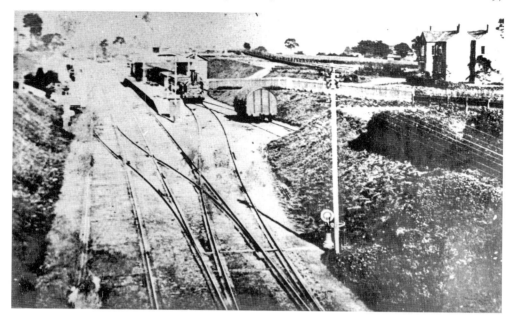

Durston Junction, view Up *c.* 1866. The Railway Hotel is on the right. (*Author's collection*)

Durston from a similar viewpoint, 2 June 1962. Drewry 0-6-0 D2141 (now preserved), with a freight from Yeovil, joins the main line. The 12.30 p.m. Saturdays-only Taunton to Temple Meads DMU stands at the Up platform. (*R. E. Toop*)

4-6-0 No. 4932 *Hatherton Hall* passes Durston with a Down fitted freight, 2 June 1962. (*R. E. Toop*)

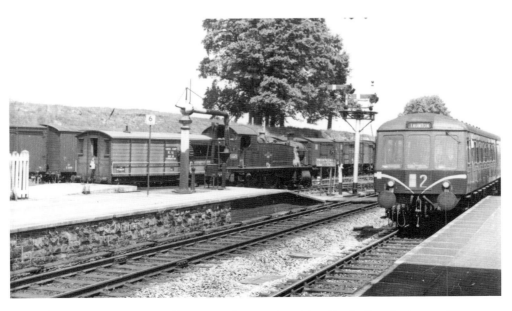

4575 class 2-6-2T No. 5563 at Durston, 2 June 1962, with a Castle Cary brake van. The 12.00 noon Saturdays-only Temple Meads to Taunton DMU approaches. (*R. E. Toop*)

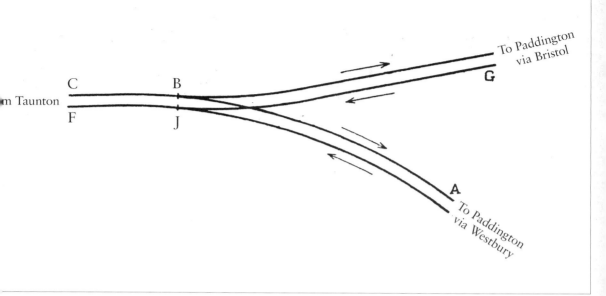

The original flat junction at Cogload.

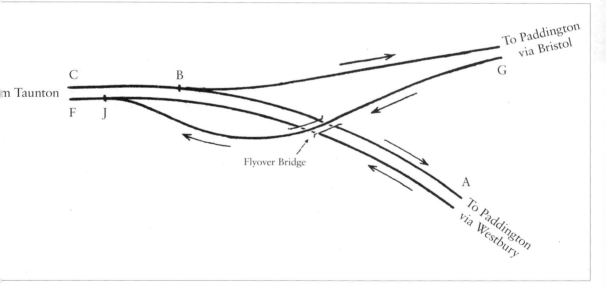

The flying junction at Cogload.

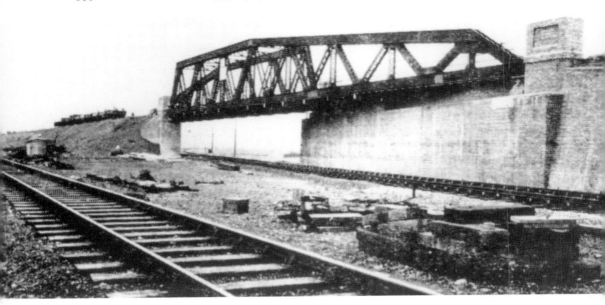

Construction of the flyover at Cogload Junction is almost complete. The bridge will carry the Down line from Bristol over the lines to and from Castle Cary. (*Author's collection*)

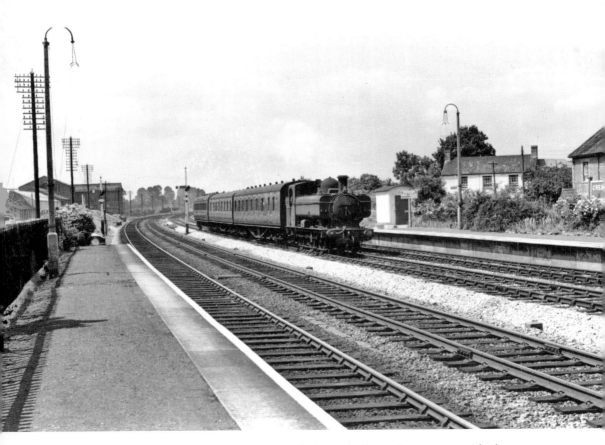

57XX class 0-6-0PT No. 9757 at Creech St Michael, 29 June 1960, with the 12.50 p.m. Taunton to Yeovil Pen Mill. (*D. Holmes*)

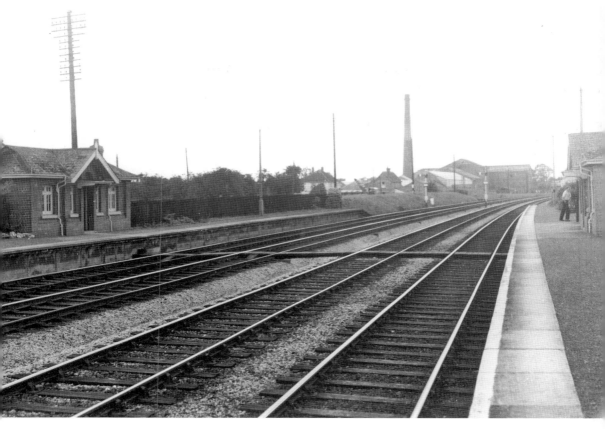

Creech St Michael, view Down, 21 August 1962. The paper works can be seen in the distance. (*Author*)

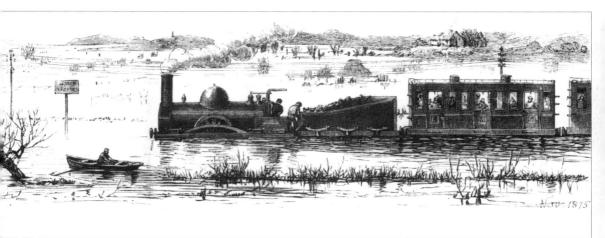

A contemporary sketch, drawn in November 1875, of an express passing through floods at Creech St Michael. (*Author's collection*)

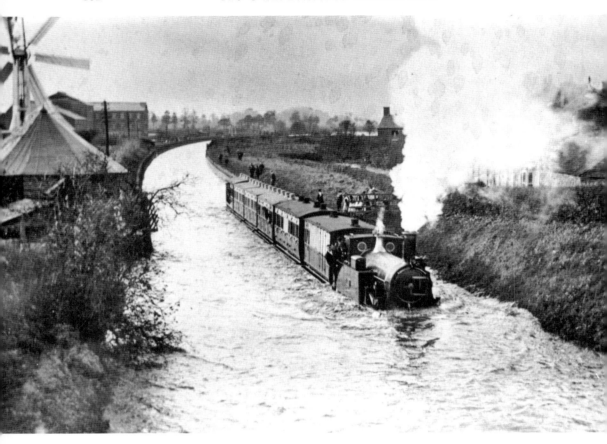

A 2-4-0T, with water to footplate level, passes through the flood at Creech with an Up train *c.* 1887. (*Author's collection*)

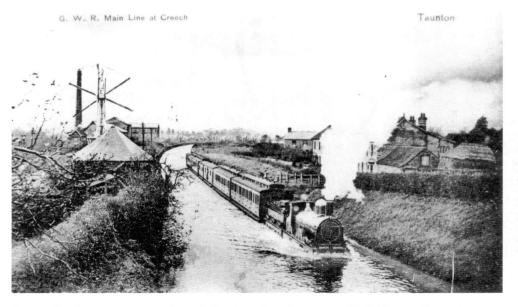

A 2-4-0 heads an Up express through floods at Creech *c.* 1887. (*M. J. Tozer collection*)

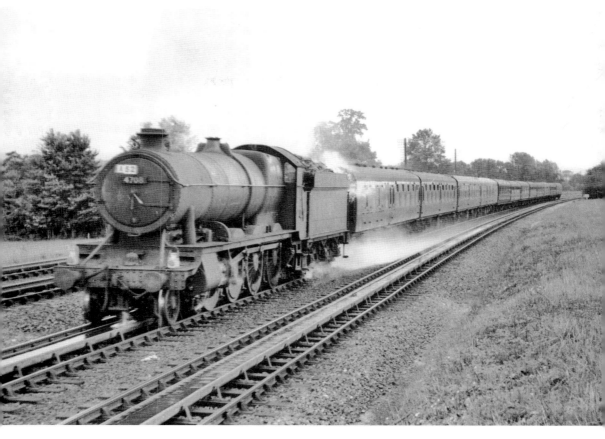

47XX class 2-8-0 No. 4708 picks up water from Creech troughs, heading a Minehead to Paddington express, 5 August 1961. (*John Cornelius*)

4-4-0 No. 3374 *Britannia* crosses the Bridgwater & Taunton Canal at Obridge, 10 March 1902, while making a Plymouth to Paddington non-stop run with King Edward VII and Queen Alexandra, following the launching of the battleship Queen. Notice the royal coat of arms on the smoke box. (*Author's collection*)

Taunton concrete depot, 1 August 1979. (*Author*)

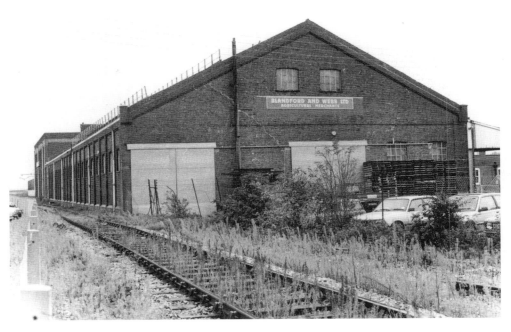

The west end of the former goods shed, 29 October 1990. (*Author*)

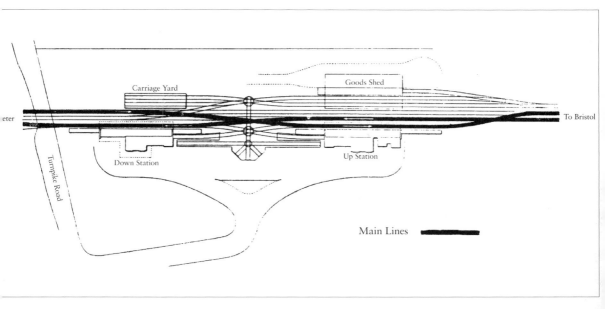

The plan of Taunton station in 1844.

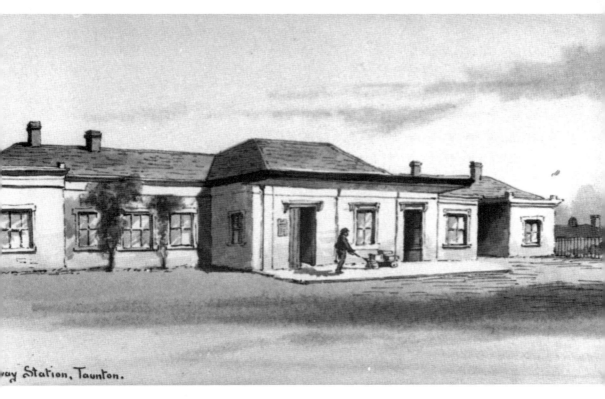

The Up station building at Taunton, 1855, a contemporary watercolour by H. Frier.

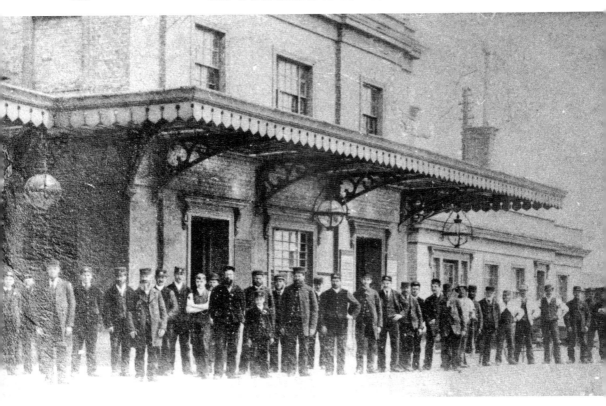

Taunton passenger staff outside the former Down station building, 1885. (*J. F. King collection*)

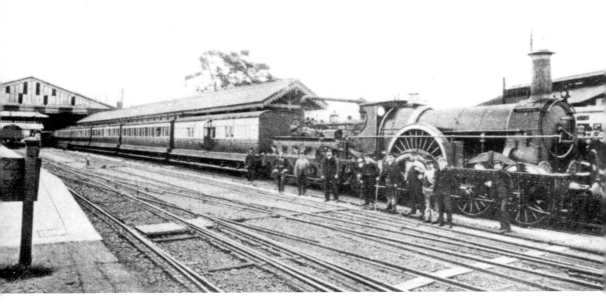

The 4-2-2 *Dragon* at Taunton with the final broad gauge Down Cornishman, 20 May 1892. Notice the platform extension outside the train shed. The engine shed roof can be seen beyond *Dragon*'s chimney. (*J. F. King collection*)

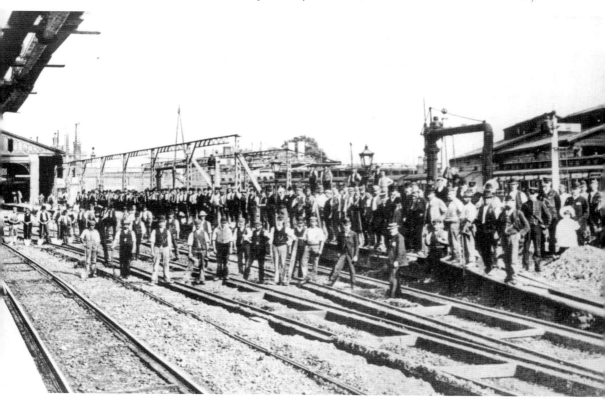

Taunton station in July 1895, with work in progress adding additional bay platforms. Girders for the umbrella roof can be seen. The train shed is on the left and the old engine shed, rebuilt the following year, on the right. (*J. F. King collection*)

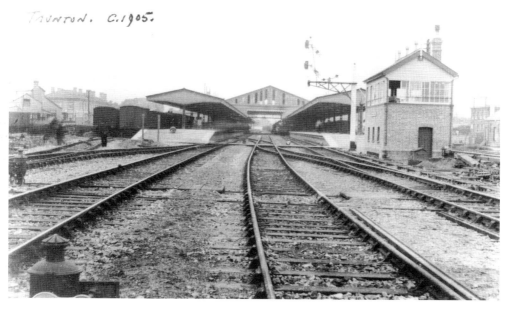

Taunton, view down *c.* 1905. The East station signal box is on the right and the Station Hotel may be seen on the far left. (*Lens of Sutton*)

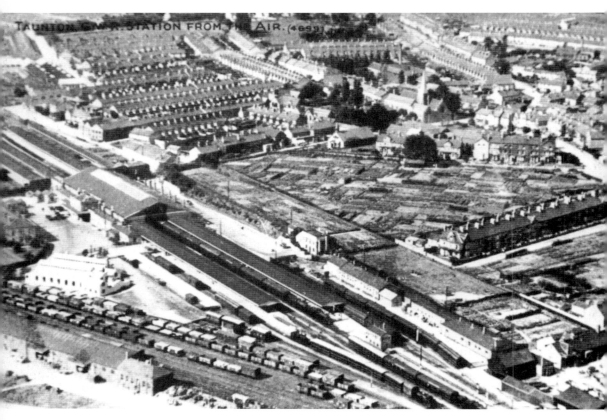

An aerial view of Taunton *c.* 1927. The goods shed and goods loop are at the lower left. (*Author's collection*)

The west end of Taunton station, view south, *c.* 1932. The end of Brunel's train shed can be seen and rebuilding work has just started. (*Author's collection*)

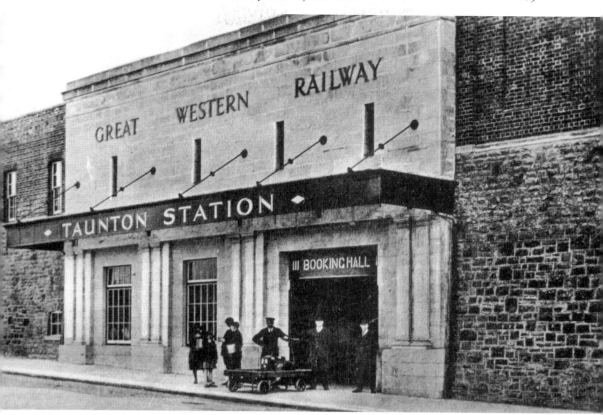

The 1931 booking hall, viewed from the Up-side station approach. (*Author's collection*)

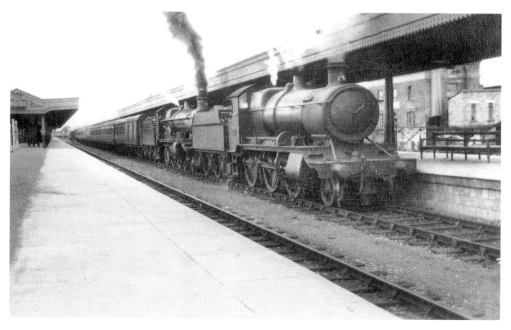

53XX class 2-6-0 No. 6305 and Star class 4-6-0 *Princess Charlotte* at Taunton with an Up train
c. 1935. (*E. J. M. Hayward*)

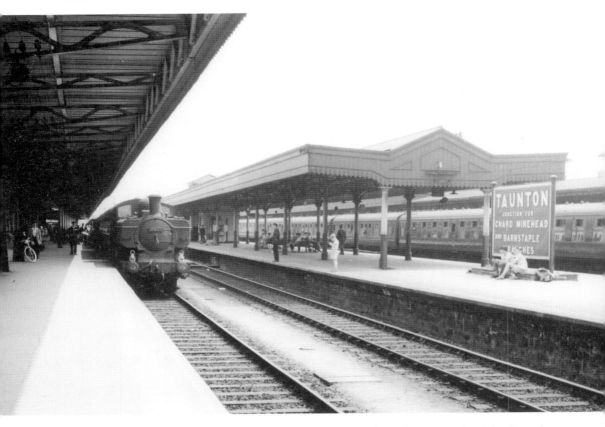

57XX class 0-6-0PT No. 9671 at Taunton *c.* 1950. Ex-LMS coaches are on the right. Some loco spotters are in the sun while others can be seen beneath the canopy. (*Lens of Sutton*)

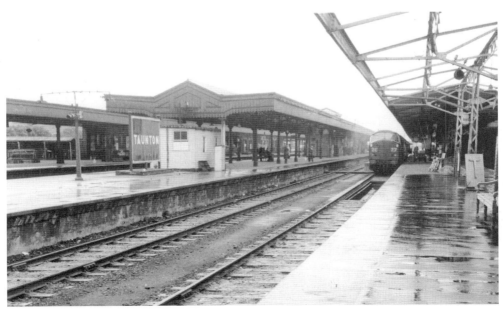

A Warship class diesel-hydraulic calls at Taunton. (*Lens of Sutton*)

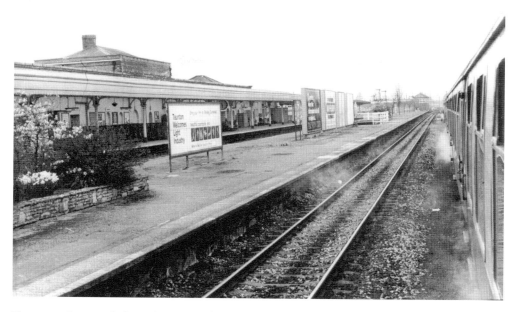

Taunton, view south from the Up platform. At that date, 4 April 1981, the island platform was normally out of use. The large hoardings are an eyesore, only partly ameliorated by flower beds and trees. (*Author*)

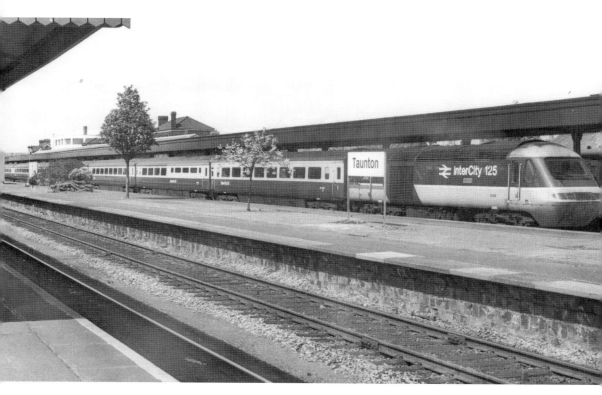

HST power car No. 43126 *City of Bristol*, with No. 43191 at the rear, works the 10.45 Paignton to Manchester Piccadilly, 16 May 1986. (*Author*)

Stairs leading from Platform 2 to the subway. The orange and white tiles give a bright appearance. View taken on 16 May 1986. (*Author*)

Pooley's weighing machine on Platform 1, 16 May 1986. (*Author's collection*)

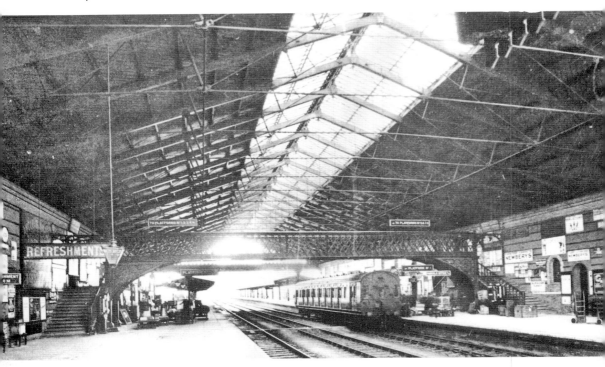

A slip coach in the train shed, Taunton, pre-1931. (*Author's collection*)

**Metro class 2-4-0T No. 3581 at Taunton, 15 May 1937, with a van whose roof board reads, 'Loco, Carriage & Wagon Dept, Taunton.' (***Author's collection***)**

Taunton, view Up from west of the station, 27 April 1963. 4575 class 2-6-2T No. 4593 is at the head of a line of out-of-steam locomotives; a 0-6-0PT with empty coaching stock is on the left; the locomotive shed, centre right; and the goods loop, right. (*R. E. Toop*)

Taunton platform tickets.

# Chapter Ten

# Locomotives &
# Locomotive Sheds

From its opening in 1841 until 1 May 1849, the B&E was worked by the GWR. The B&E's first locomotives for passenger working were twenty 4-2-2 engines, smaller editions of Gooch's Iron Duke class. Goods trains were in the hands of eight Gooch 0-6-0s. The company also owned the steam railcar *Fairfield* (see pages 27 and 29).

In May 1850 James Pearson was appointed locomotive superintendent and designed all the company's engines for the rest of its existence. Locomotive shops for repair and new-build were opened at Bath Road, Bristol, in September 1854. Pearson's first design was for five 2-2-2 back and well tank engines for branch line work. Next followed four 0-6-0s, similar to Gooch's design. Then came eight 4-2-4 well and back express tank engines with flangeless 9-foot-diameter driving wheels. The fastest engines of the era, they consumed an average of under 22 lb of coke per mile. Built in 1853/4, four were replaced or renewed from 1868–73 as coal-burners. The Flax Bourton accident (see page 168) spelt their doom and the remaining three were rebuilt as 4-2-2 tender engines. The first new engine built at Bristol appeared in September 1859, No. 29, a 4-2-4T with 7-feet-6-inch-diameter driving wheels; it was followed by a sister engine in 1862. Altogether, thirty-five engines were built in the Bristol shops: twenty-three for the broad gauge; ten for the standard gauge and two for the 3-foot gauge.

Between 1855 and 1873, twenty-six 4-4-0STs were constructed by outside builders for use on the main line and branches. Around the same period, six more 0-6-0s and two 2-2-2WTs were added to stock. The next engines built at the B&E's works were two 0-6-0STs, one of which could generally be seen at Pylle Hill shunting broad gauge wagons requiring transhipment.

Pearson's first passenger tender locomotives were ten 2-4-0s, which first appeared in February 1870, and all were constructed at Bristol. Two 0-4-0STs were built at Bristol for shunting. Pearson then designed three convertible 2-4-0s, though in fact they had a life of only a dozen years and were never converted. This class was unique on the B&E by having domed boilers.

The first B&E engines appeared in green livery picked out with black, but from around 1860 they appeared in plain black, most with the number and company's initials in brass letters above the driving wheel. The company's initials and the engine number were carried on the front buffer beam, on two separate castings each side of the coupling hook. Hand rails, reversing lever and similar metal features were of polished steel.

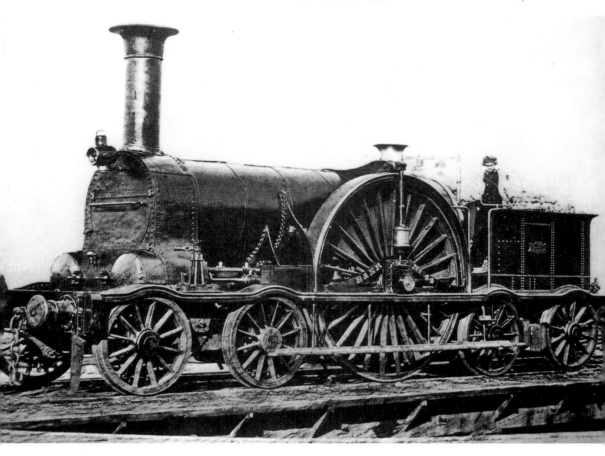

B&E 4-2-4T No. 44 designed for express duty. (*Author's collection*)

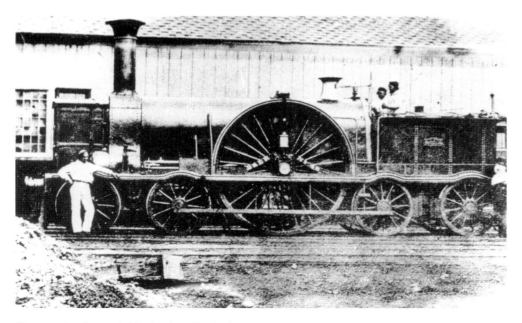

Sister engine No. 46. (*Author's collection*)

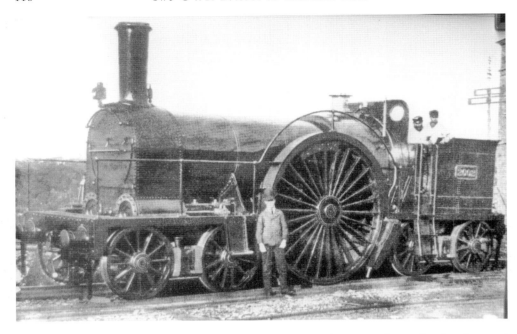

GWR 4-2-4T No. 2002, ex-B&E No. 40. It was converted to a tender engine in 1877 and withdrawn in December 1890. Notice the disc and crossbar signal, right. (*Author's collection*)

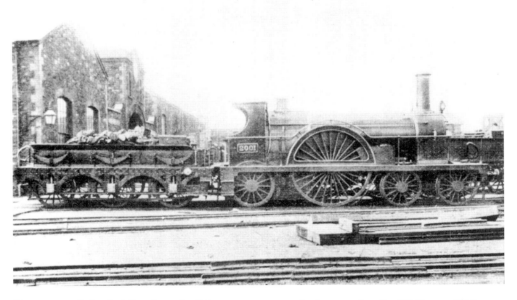

No. 2001 at Bristol, following rebuilding as a 4-2-2 tender locomotive. Ex-B&E 4-2-4T No. 42, it was renumbered and given the number of the withdrawn 4-2-4T No. 2001 when converted to a 4-2-2 tender locomotive in 1877. It was withdrawn in December 1889. (*Author's collection*)

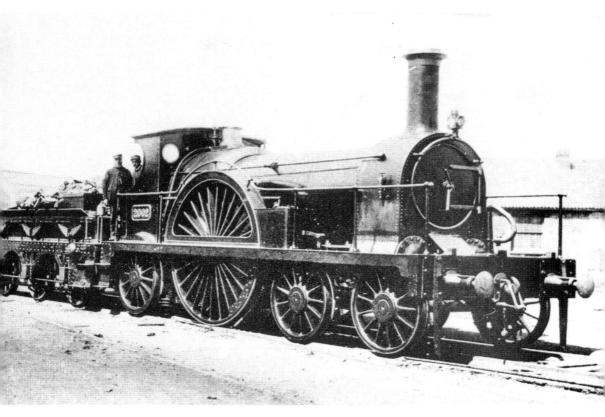

4-2-2 No. 2002 at Bristol. It was ex-B&E 4-2-4 tank engine No. 40. (*Author's collection*)

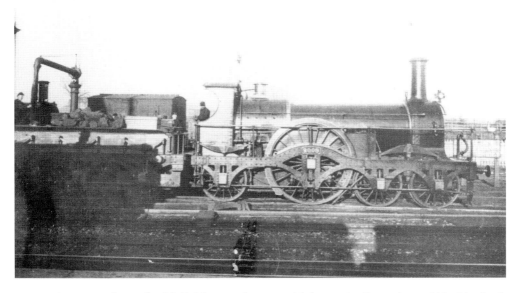

4-2-2 No. 2009, formerly B&E No. 10. It was withdrawn in December 1888. (*Author's collection*)

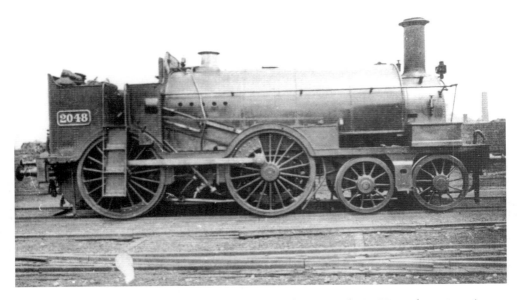

4-4-0T No. 2048 ex-B&E No 85. Built at Bristol by Avonside in November 1872, it was withdrawn in May 1892. (*Author's collection*)

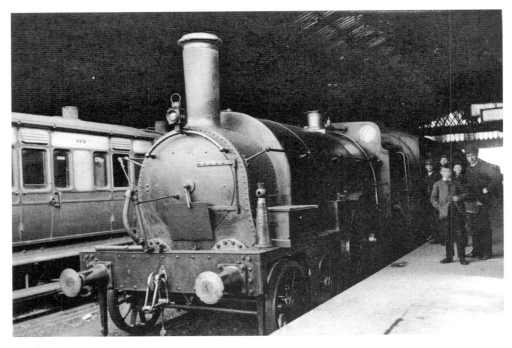

A B&E 4-4-0ST inside the train shed at Taunton, 1885. The cylinder heads can be seen behind the buffer plank. Notice the re-railing jack near the right-hand buffer. The vacuum brake would have been an addition after the original building. (*Canon Brian Arman collection*)

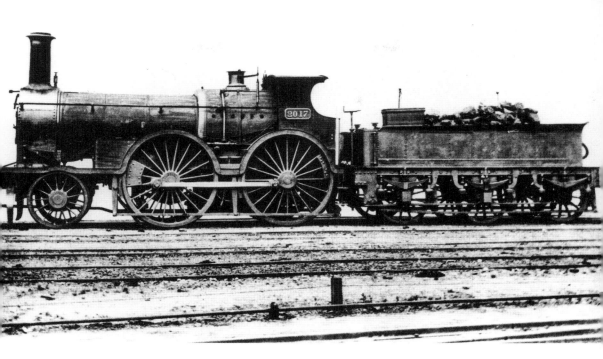

B&E 2-4-0 No. 5 as GWR No. 2017. It was withdrawn in May 1892. (*Author's collection*)

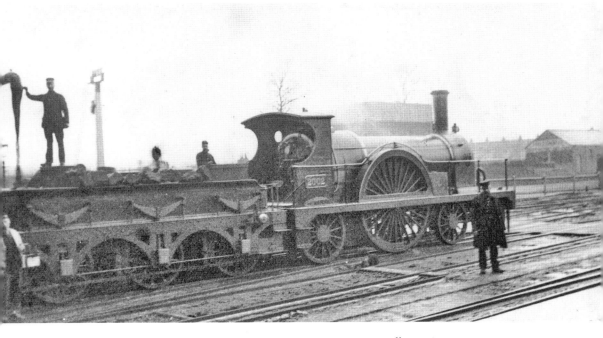

No. 2002 being watered at Taunton, 1885. (*Canon Brian Arman collection*)

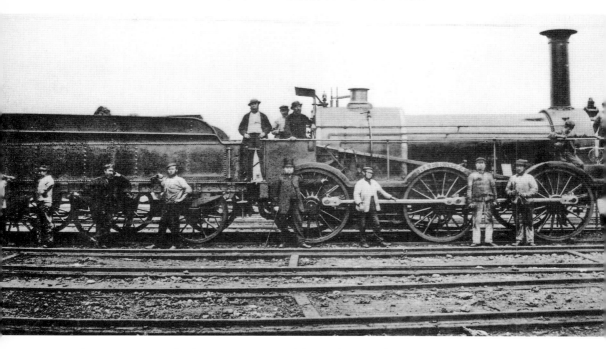

B&E 0-6-0 No. 25 built in 1849 at Bristol by Stothert & Slaughter to Gooch's design. It was withdrawn in June 1884. (*Author's collection*)

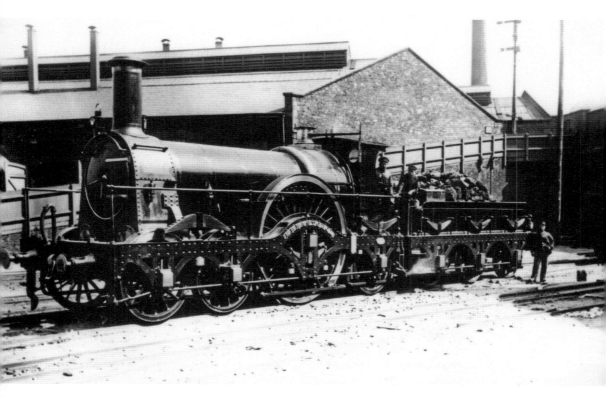

4-2-2 *Sebastopol* at Bristol Bath Road shed *c.* 1890; Bath Road bridge is on the right. The signals are probably for sighting purposes. (*Broad Gauge Society*)

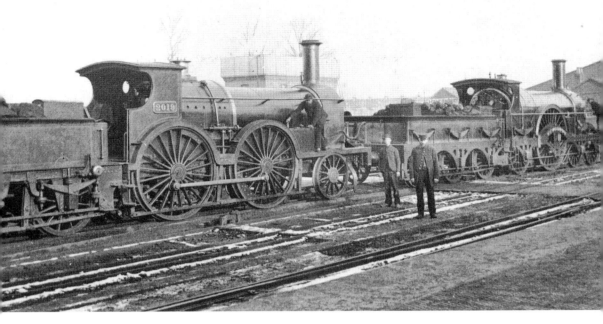

View at Taunton, 1885: 2-4-0 No. 2019, ex-B&E No. 8, built June 1872 and withdrawn in June 1889. Behind is an Iron Duke class 4-2-2. (*Canon Brian Arman collection*)

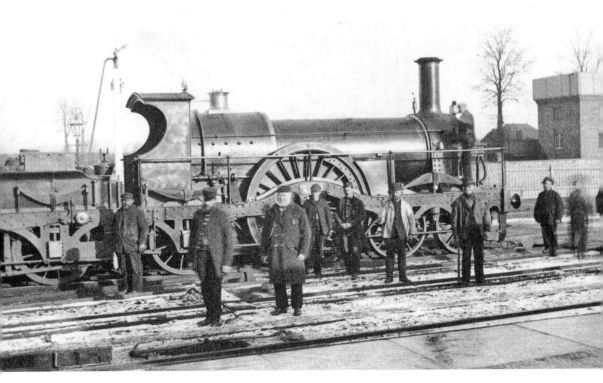

4-2-2 No. 2008 at Taunton, 1885. Originally B&E No. 9, it was rebuilt in March 1865 and withdrawn in December 1888. (*Canon Brian Arman collection*)

In the last six months of 1856, shunting engines at Bristol covered 6,320 miles, and consumed 194 tons 6 cwt of coke at 66.86 lb/mile. Figures for the following six months were 6,160 miles; 209 tons 18 cwt and 76.32 lb/mile.

When the GWR absorbed the B&E on 1 January 1876, it took over 125 locomotives – ninety-five broad gauge, twenty-eight standard gauge, and two 3-foot gauge.

The B&E first required standard locomotives in 1867, when the third rail was laid between Highbridge and Yeovil, and then more were needed in 1875 when mixed gauge was extended between Bristol and Taunton. The first B&E standard gauge locomotives were six 0-6-0s built in 1867/8 and most had a short but varied life. Five were converted to broad gauge 1870/1 because the number of standard gauge trains had decreased, but were reconverted to standard gauge in 1875. They were altered to saddle tank engines in 1878/9. Although most were withdrawn in the 1880s, the oldest, B&E No. 77, became a stationary engine at various locations, the last being Swindon Carriage Department in 1927, where it lasted until being cut up in August 1944.

In GWR days, all standard classes worked over the line, including on at least one occasion 4-6-2 *The Great Bear*, which was not supposed to run south of Bristol.

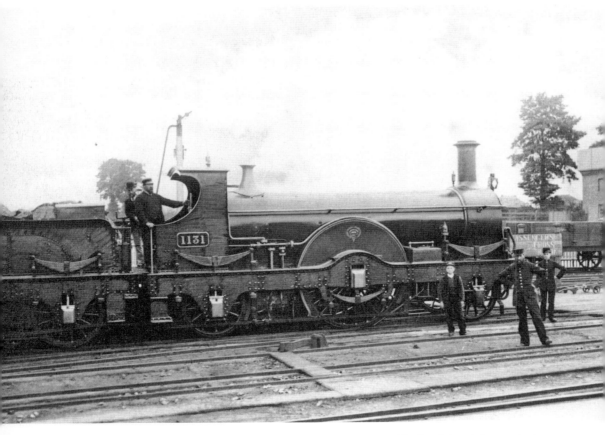

Standard gauge Queen class 2-2-2 No. 1131 at Taunton, 1885. To the right of the smoke box a notice reads, 'Passengers must not cross the line.' (*Canon Brian Arman collection*)

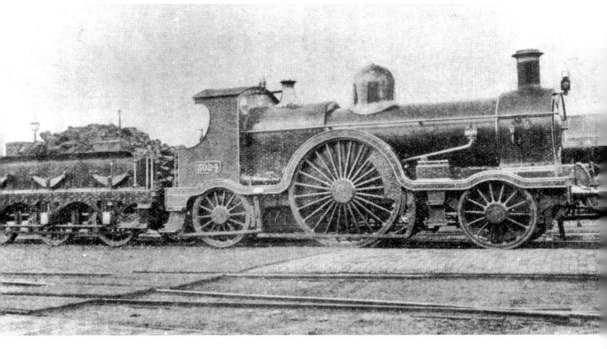

3001 class 2-2-2 No. 3024 *Storm King*. Built as shown here as a broad gauge convertible, in July 1891. It was converted to standard gauge in August 1892 and reconstructed as a 4-2-2 in December 1894 and withdrawn in February 1909. (*Author's collection*)

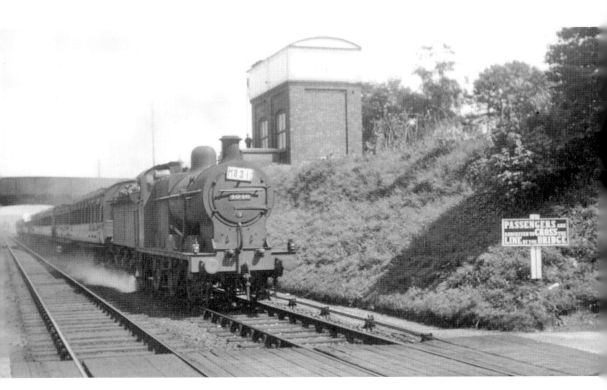

LMS Class 4F 0-6-0 No. 4046, of Gloucester shed, heads an LMS train to Weston-super-Mare through Yatton in the 1930s. (*Canon Brian Arman collection*)

Ex-LNER Pacific No. 22 *Mallard* (now preserved) at Taunton with the 8.30 a.m. Plymouth to Paddington during the Locomotive Exchanges of 1948. (*Tony Harvey*)

'Foreign' engines appeared at Weston-super-Mare. During the summer of 1931, the 12.00 Saturdays-only from Weston to Sheffield was worked throughout by an LMS 4-4-0 Compound, No. 1013 making the first run. Around 1937, half a dozen LMS men were sent to learn the road from Bristol to Weston-super-Mare. One day, three LMS drivers caught an early train to Weston and for the return journey tossed to determine who would travel on the footplate, as the GWR driver would only allow one 'rider'. The other two offered to fire so that the GWR fireman could ride on the cushions, but the GWR driver almost foamed at the mouth: 'A Midland man firing on the Great Western: Never!' In the post-Second World War period Class 5 4-6-0s appeared, and, on at least one occasion, a Patriot. LMS Class 4F 0-6-0s working excursions were only allowed nineteen minutes for the 12 miles from Bristol to Yatton, requiring an average speed of 38 mph.

In the early '30s, Brighton to Weston-super-Mare excursions were hauled by an SR T9 class engine throughout, and included at least one Pullman car in each train; Pullmans were rarely seen on the GWR. An N15X Remembrance class

4-6-0 was lent to the GWR from late 1941 until mid-1943, generally working at Exeter to Swindon goods. It was unpopular.

Unusual visitors to Weston-super-Mare on 30 August 1970 were two six-car diesel-electric multiple units, Nos 1033/5, which had worked through from East Croydon via Redhill and Reading. In 1971 locomotives from the Eastern and London Midland Regions worked through to the West of England with greater frequency each year, whereas in steam days, visitors were rare.

## LIGHT ENGINES, BRISTOL RUNNING & MAINTENANCE DEPOTS TO WESTON-SUPER-MARE.

When a light engine has to run from either of the Bristol Running & Maintenance Sheds to Weston-super-Mare the Running & Maintenance Shed Foreman will advise the Signalman at the Signal Box where the engine enters the main line (St. Philip's Marsh Signal Box and Temple Meads Loco. Yard Signal Box respectively) in good time before the engine starts and the Signalman at the Signal Box must send a Box-to-Box message as far as Weston-super-Mare Signal Box, announcing the approach of the engine, and stating what train it is required to work from Weston-super-Mare. The Running & Maintenance Foreman will supply this information.

## YATTON

### DOWN GOODS LINE BETWEEN YATTON EAST SIGNAL BOX AND YATTON STATION.

This line may be used from the Yatton end for a Passenger train to shunt for more important trains to pass. A Passenger train must never be placed in the Goods Line if there is a train there already nor must any train be allowed to enter the Goods Line after a Passenger train has been placed there until the Passenger train has been again removed from the Goods Line.

### ENGINES REQUIRING WATER.

Drivers of Down Freight trains running via the Down Goods Line, must advise the Signalman at Yatton West Signal Box by means of the telephone fixed in a box near the Down Goods Line Exit Signal when they require to take water at the Down Platform.

### DETACHING VEHICLES FROM TRAINS.

In connection with the track circuiting of the Down Platform Line a "Vehicle on Line" switch is provided which must be operated in accordance with the standard instructions.

After sunset and during fog or falling snow, it will be the duty of the person in charge to inform the Signalman immediately after the departure of all Stopping trains whether vehicles have been detached or not, also whether there are passengers in such vehicles.

Details of locomotive arrangements, Bristol, Yatton and Weston-super-Mare from *Sectional Appendix to the Working Time Table and Books of Rules and Regulations, Bristol Traffic District, March 1960.*

# Chapter Eleven

# Sheds

Initially engines for working B&E trains had been provided from the GWR depot east of Temple Meads station. In May 1849, when the B&E had decided to work its own trains, plans were immediately prepared for a shed to be built south of the station, on the opposite side of the river near Bath Road. The six-road depot, stone-walled with gable slated roof, opened in 1850 and early in 1852 the first part of the locomotive works was opened, both shed and works being enlarged over succeeding years. Following amalgamation with the GWR in 1876, the GWR closed its own broad gauge shed by South Wales Junction, east of Temple Meads, and transferred its stock to the former B&E shed. In 1877 the former locomotive works was converted to a two-turntable roundhouse for standard gauge engines and the GWR transferred its standard gauge stock here. As the number of broad gauge engines decreased, the broad gauge shed became mixed gauge and finally standard gauge in 1892.

Under the 1929 Railway Development Scheme 1931–4, the whole complex was demolished and a new ten-road shed and workshops erected. The new shed, with brick walls and a slated roof, opened in 1934. The four-road repair shop was steel-framed with brick walls and a slate roof. This depot closed to steam on 11 September 1960.

Locomotive allocation 31 December 1947

| 4-6-0 | 1002, 1005, 1007, 1011, 1013,1014, 1028, 2929, 2931, 2939, 2942, 3950 (5955), 4019, 4020, 4030, 4033, 4034, 4035, 4041, 4042, 4043, 4047, 4080, 4084, 4089, 4093, 4096, 4942, 5019, 5024, 5025, 5048, 5074, 5076, 5082, 5083, 5084, 5091, 5949, 6958, 6971, 6972, 7809, 7812, 7814 |
|---|---|
| 2-6-0 | 5325, 5327, 5343 |
| 2-6-2T | 4142, 4143, 4151, 4152, 4155, 4535, 4536, 4539, 4577, 4580, 4595, 5169, 5511, 5512, 5514, 5523, 5527, 5528, 5535, 5536, 5539, 5546, 5547, 5548, 5553, 5555, 5558, 5559, 5561, 5564, 5572 |
| 0-4-2T | 1430, 5803, 5809, 5813 |
| 0-6-0PT | 2072 |

Two B&E 0-6-0s behind hoisting gear. (*Author's collection*)

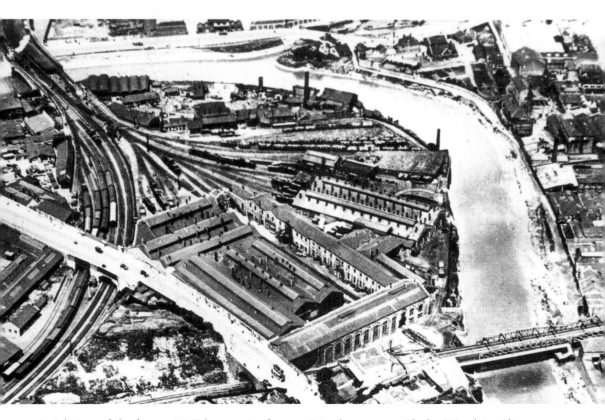

Aerial view of the former B&E locomotive factory, Bristol, *c.* 1930, with the Bristol Avoiding line at the foot of the picture. (*M. J. Tozer collection*)

Yatton had a single-road stone shed with slated roof, opened in 1879 and closed in August 1960. It was solely for the use of branch engines.

Locomotive allocation 31 December 1947

| 2-6-2T | 4563 |
|---|---|
| 0-4-2T | 1415, 1463 |

Weston-super-Mare shed, opened in April 1851, was replaced with a new single-road stone shed with slated roof in 1861. Originally broad gauge, it was converted to mixed gauge in 1875 and closed August 1960.

Locomotive allocation 31 December 1947

| 4-6-0 | 2950, 5096 |
|---|---|
| 0-6-0PT | 7780 |

Bridgwater shed, opened in June 1841, was just temporary, being removed to Taunton where it reopened in June 1842. A single-road brick engine shed opened in 1893 and had been converted from a bay of the carriage and wagon shops for use by the carriage and wagon locomotive and docks engine. It closed in July 1960.

Locomotive allocation 31 December 1947

| 0-6-0PT | 2038 |
|---|---|
| 0-4-0ST | 1338 |

Taunton broad gauge shed opened in June 1842, having been moved from Bridgwater. It had two roads, timber walls, and a slated roof. The turntable was 22 feet in diameter. Situated west of the station, it closed in 1860, was dismantled and yet again re-erected on a new site. It closed April 1896 and was replaced at a cost of £10,500 by a brick-built shed with north-light roof. There were twenty-eight roads, and it could hold twenty-six engines, one on each line with one road for incoming and one for outgoing locomotives. The longest road was too short to hold a King class engine. In 1932 a repair shop of corrugated asbestos was constructed. The shed closed to steam in October 1964. From 1 January 1972, diesel fuelling facilities were withdrawn, and servicing of main line locomotives and DMUs discontinued. The water supply for locomotives and station use came from the Bridgwater & Taunton Canal.

Star class 4-6-0 No. 4033 *Queen Victoria* at Weston-super-Mare, 6 September 1947. The locomotive shed is unusually ornate. (*Locomotive & General Railway Photographs*)

The official inspection of Taunton shed before opening in 1896. Mr Christie, Divisional Superintendent, stands on the plank. (*Author's collection*)

53XX class 2-6-0 No. 7304 in Taunton shed. Between No. 7304 and the locomotive on the left is a stationary boiler fitted with a tall chimney. (*P. Cox*)

## Locomotive allocation 31 December 1947

| | |
|---|---|
| 4-6-0 | 4026, 4056, 4954, 5003, 5077, 5982, 5999 |
| 4-4-0 | 3443, 3444 |
| 2-8-0 | 2814 |
| 2-6-0 | 6305, 6317, 6323, 6328, 6343, 6364, 6372, 6377, 6394, 6398, 7304, 7314 |
| 0-6-0 | 2211, 2212, 2214, 2215, 2261, 2267, 2268 |
| 2-6-2T | 4113, 4117, 4136, 5172, 5501, 5503, 5504, 5521, 5522, 5533, 5542, 5543, 5571 |
| 2-4-0T | 3582 |
| 0-6-0PT | 1760, 1909, 2127, 2708, 2748, 2755, 7421, 9718, 9757 |
| 0-6-0ST | 2194 |
| 0-4-2T | 5812 |
| 2-8-0 WD | 77077 (90546) |
| 4-wheel petrol driven Service locomotives | 23, 24 |

# Chapter Twelve

# Locomotive Working

Bristol express engines and drivers almost had the monopoly of the B&E, one exception being the Friday morning excursion, which at one time was worked through to Newton Abbot by a London engine. E. L. Ahrons, in *Locomotive and Train Working in the Latter Part of the Nineteenth Century*, said that he believed the engine remained at Newton Abbot for the week, the crew returning home on the cushions; the idea being to keep London men acquainted with the B&E road in case of emergency.

The B&E 2-4-0s were stabled at Taunton for piloting passenger trains up Wellington bank to Whiteball Tunnel, and were also used on the Chard branch. Towards the end of the nineteenth century, goods trains between Bristol and Taunton were worked by standard gauge B&E 0-6-0s. After riding on broad gauge singles between Bristol and Taunton in 1891, the Reverend A. H. Malan recorded,

> The men, in fact, are bound to *stand* during the whole of their run on quick trains because they could not sit down much without being shaken to pieces.
>
> On curves the engine seemed unusually steady, in consequence, no doubt, of the flanges all pressing against that rail which bore the centrifugal force.
>
> A long stretch of straight rail was infinitely worse; for a bad length of rail here and there would cause the wheels to bang against the metals, first on one side and then the other, with a series of jerks, and deafening crashes, like the united blows of many hammers breaking up iron plates in a foundry yard. It seemed, on these occasions, as if the tyres of the wheels, especially the big driving wheels, were bound to snap, or the spokes to break off at the axles.

The line in the Durston area was low-lying and not infrequently subject to severe flooding. On such occasions – such as in November and December 1875, when the line was underwater for nine weeks – in order to provide sufficient steam to haul the train through the flood, as the depth of water was sufficient to douse a fire, a pilot engine was coupled in front of the train engine either at Bridgwater or Durston. By running very slowly, they were able to draw the train through the flood, though by the time they reached dry land, steam was almost exhausted as the engines' fires were out.

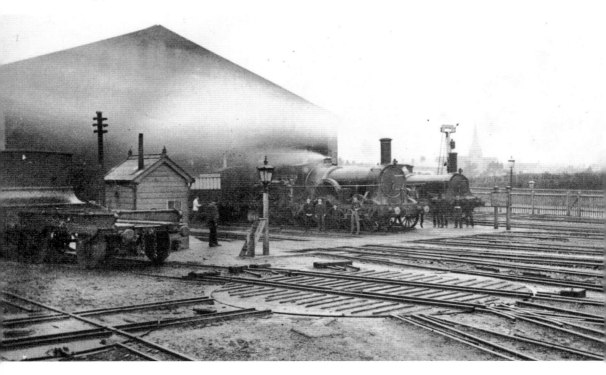

The south end of Taunton station in 1885, with 4-2-2 No. 2008, ex-B&E No. 9, and a 2-4-0 beyond. Notice the wagon turntable in the centre foreground. In order to balance the turntable, mixed gauge required four rails, instead of the usual three. (*Canon Brian Arman collection*)

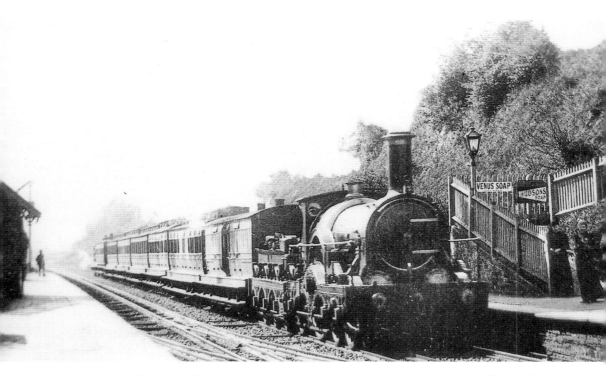

A Rover class 4-2-2 heads an Up express through Flax Bourton *c.* 1890. (*Author's collection*)

It took approximately nine minutes to travel through flood-water 1½ miles in length and 3 feet deep. This method was repeated a year later when, for five weeks, water 5 feet 3 inches deep covered the line. Only the parapet rail of the bridge over the River Parrett was visible above the floods.

On 5 January 1877, the fire of the engine hauling the Down Flying Dutchman was extinguished by floods, and re-lighting it took one and a half hours. The following night an Up train was delayed at Bridgwater, having had its fire doused by the floods as the line at Durston was under 1 feet 8 inches of water; on 10 January, the water was 2 feet 9 inches deep, and 3 feet deep on the 11th. It was not until 21 February that water had drained from every part of the line and even then, on the eastern side of the embankment the water remained very deep.

In the Great Blizzard of January 1881, several trains were snowed up at Brent Knoll. Two hundred navvies were set clearing the line, where the drift was 6 miles long and up to 20 feet deep. A goods trains was blocked in Uphill Cutting, and on 18 January the 7.50 a.m. Weston-super-Mare to Weston Junction became stuck in a drift midway along the branch, snow being above the running board. Passengers returned on foot. The following day, a 0-6-0 goods engine was sent from Bristol to release it.

In March 1891, men were sent to clear snow from the line at Brent Knoll. The fast newspaper train followed the snow-clearers to Brent Knoll. Fortunately, the men heard the newspaper train approaching and leapt on to the bank. The engine struck the van in which the men had travelled.

The broad gauge 4-2-2 Iron Duke and its crew at Bristol 11 November 1890. (*Revd A.H. Malan*)

# Chapter Thirteen

# Train Services

The initial service between Bristol and Bridgwater offered eight trains daily each way, stopping trains taking one and a half hours for the distance of 44¾ miles, while expresses only took one hour ten minutes. The B&E only ran the legal minimum of one third class train Bristol to Taunton. By June 1865, ten trains ran in each direction between Temple Meads and Taunton, plus four only to Weston-super-Mare. Most trains called at all stations. The fastest train took sixty-four minutes each way between Bristol and Taunton. A slip coach was dropped at Highbridge for working over the Somerset Central Railway, which at that time was broad gauge. Later, slips were made from other trains at Yatton and Taunton.

In May 1882 the GWR made the dramatic announcement that, from 1 June, all trains between Paddington and Penzance would carry third class passengers, apart from the Up and Down Flying Dutchman expresses. Hitherto only a small percentage of trains had carried third class passengers, and those often at inconvenient times.

By April 1910, the service offered twelve Down trains to Taunton, plus five to Weston-super-Mare; two trains slipped coaches at Taunton. There were seventeen Up trains, two slipping coaches at Bridgwater. Eleven trains ran between Weston-super-Mare and Bristol. The fastest express between Bristol and Taunton took fifty-one minutes. In 1927 Bridgwater was served by no less than three slip coaches daily and Yatton by one.

In July 1938, twenty-nine trains ran Bristol to Taunton, plus twenty-one to Weston-super-Mare. In the reverse direction were twenty, plus fifteen to Weston-super-Mare and one Weston-super-Mare to Wells. The fastest Down train took fifty-one minutes and the fastest Up fifty-four minutes. In 1972, nineteen Down and seventeen Up trains ran between Bristol to Taunton, the fastest Down taking forty-three minutes and the fastest Up forty-two minutes.

In May 2012, forty-seven trains ran to Taunton from Bristol, plus seventeen from Weston-super-Mare, while in the other direction are forty-three Down trains and seventeen to Weston-super-Mare. The fastest trains between Bristol and Taunton took thirty-one minutes both ways.

In 1870, the B&E ran an excursion from Bristol to Glastonbury and Poole via the Somerset & Dorset Railway. In 1906, the GWR ran a half-day excursion from Weston-super-Mare to London. Leaving at 12.15 p.m., it arrived Paddington at 3.45. The fare was 4s 9d return, and a meal in the luncheon car cost 2s.

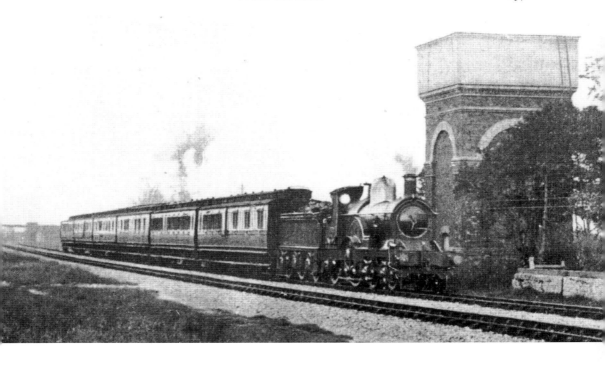

*Above:* A 3001 class 4-2-2 working the Down Flying Dutchman, passes the former Weston Junction, in June 1894. (*Author's collection*)

*Right:* Advertisement from an excursion booklet, 1908.

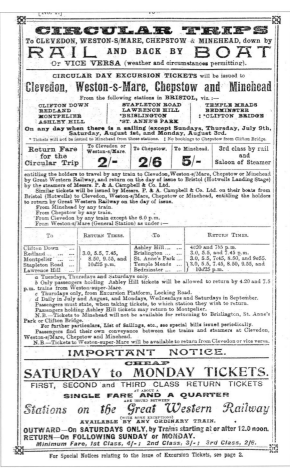

PLEASE RETAIN THIS HANDBILL FOR REFERENCE

WESTERN     BRITISH RAILWAYS    REGION

## *Half-Day Excursion Bookings*

# EACH
# WEDNESDAY & SATURDAY

### JUNE 10th to SEPTEMBER 19th inclusive

TO

# BURNHAM-on-SEA

| FROM | DEPART B | DEPART D | RETURN FARE THIRD CLASS ONLY | ARRIVAL ON RETURN |
|---|---|---|---|---|
| **BRISTOL—** | p.m. | p.m. | s. d. | p.m. |
| TEMPLE MEADS   .. .. | 12 40 | 12 42 | 4/0 | 8 27 |
| WESTON-SUPER-MARE | 1 28 | 1 20 | 1/6 | 7 36 |
| TAUNTON   ..   ..   .. | 1 20 | 1 20 | 3/9 | 7 34 |
| BRIDGWATER ..   .. | 1 42 | 1 41 | 2/0 | 7 10 |
| **BURNHAM-ON-SEA**   arr. | 2 20 | 2 25 | **B**—Wednesday only. **D**—Saturday only. | |
| **Return from BURNHAM-ON-SEA** .. | 6.45 p.m. the same day. | | | |

Children under Three years of age, Free; Three and under Fourteen years of age, Half-fare.

## IT WOULD ASSIST THE RAILWAYS IN PROVIDING ADEQUATE ACCOMMODATION IF INTENDING PASSENGERS WOULD OBTAIN THEIR TICKETS IN ADVANCE.

**NOTICE AS TO CONDITIONS.**—These tickets are issued subject to the Conditions of issue of ordinary passenger tickets, where applicable, and also to the special Conditions as set out in the Ticket, etc., Regulations, By-Laws and General Notices. Luggage allowances are as set out in these General Notices.

### Tickets can be obtained in advance at Booking Stations and Agencies.

Further information will be supplied on application to Stations, Agencies or to Mr. H. BOLTON, District Commercial Superintendent, Temple Meads Station, Bristol 1 (Telephone 21001, Extension 211 or 212); Mr. D. H. HAWKESWOOD, District Commercial Superintendent, Exeter (St. Davids) (Telephone 2281, Ext. 301, 302 or 303); or Mr. C. FURBER, Commercial Superintendent, Paddington Station, London, W.2.

Paddington Station, W.2,
June, 1953.

K. W. C. GRAND,
Chief Regional Officer.

Printed by J. W. Arrowsmith Ltd., Quay Street, Bristol.      (B7/539) H.D.

A June 1953 handbill advertising cheap trips to Burnham-on-Sea.

## FROM MONDAY 8 SEPTEMBER

# Day fares on some London trains

## WILL BE INCREASED

**These tables also show the relative ticket colours and train services**

| Class | Cheap off peak | | Cheap day | | Cheap off peak | |
| | 1st | 2nd | 1st | 2nd | 1st | 2nd |
| Ticket colour | Blue | Pink | Yellow | Buff | Blue | Pink |
|---|---|---|---|---|---|---|
| Weston-super-Mare | 80s | 50s | 90s | 60s | 80s | 50s |
| Yatton / Nailsea and Backwell | 80s | 45s | 90s | 55s | 80s | 45s |
| Bristol Temple Meads / Bath Spa | 75s | 40s | 85s | 50s | 75s · | 40s |
| Chippenham | 60s | 35s | 70s | 45s | 60s | 35s |

**Mondays to Fridays** *

| | | | | | | |
|---|---|---|---|---|---|---|
| Weston-super-Mare | d | — | 06 30e | 08 43e | 09 50 | — |
| Yatton | d | — | 06 42e | 08 20e | 09 41e | — |
| Nailsea and Backwell | d | — | 06 49e | 08 27e | — | — |
| Bristol Temple Meads | d | 06 20 | 07 20 | 09 15 | 10 15 | 11 15 |
| Bath Spa | d | 06 42 | 07 37 | 09 31 | 10 31 | 11 31 |
| Chippenham | d | 06 59 | 07 54 | 09 49 | — | 11 48 |
| Paddington | a | 08 50 | 09 25 | 11 30 | 12 10 | 13 30 |

\* Cheap off peak fares apply on all subsequent services and every train Saturdays and Sundays

e   Change at Bristol Temple Meads

# Come back by any train from Paddington except the 17 35 Pullman

W 311

A 1969 leaflet warning of an increase in fares to Paddington.

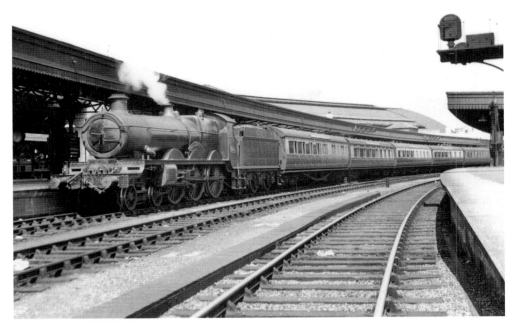

Star class 4-6-0 No. 4060 *Princess Eugenie* at Temple Meads with the 11.25 a.m. Cardiff to Goodrington Sands, May 1937. (*E. J. M. Hayward*)

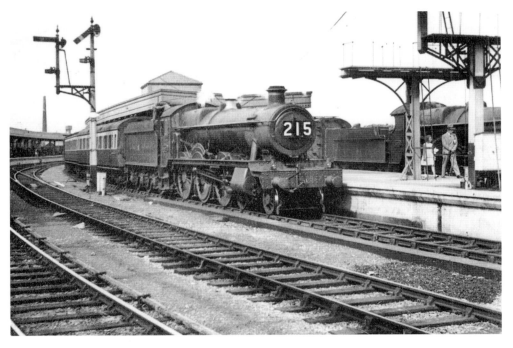

4-6-0 No. 5927 *Guild Hall* heads a twelve-coach Birkenhead to Paignton train at Temple Meads, 4 August 1934. (*E. J. M. Hayward*)

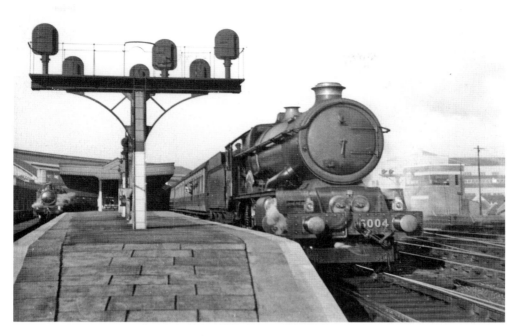

4-6-0 No. 6004 *King George III* leaves Temple Meads with an emergency Paddington to Penzance express run in lieu of the Cornish Riviera, September/October 1939. Its buffers shine beautifully. On the left, a 4575 class 2-6-2T, carrying the express headcode, heads a train to Weston-super-Mare. (*E. J. M. Hayward*)

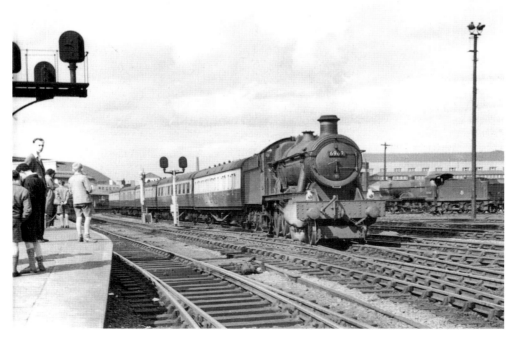

Modified Hall class 4-6-0 No. 6969 *Wraysbury Hall* at Temple Meads with the 3.30 p.m. to Taunton, 25 April 1953. Ex-LMS Compound 4-4-0. No. 40917 is on the right. (*R. E. Toop*)

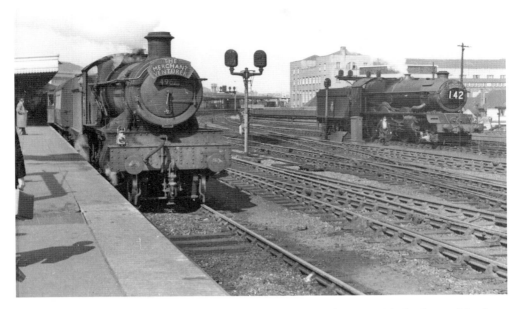

4-6-0 No. 4967 *Shirenewton Hall* at Temple Meads, 16 April 1955, with the Down Merchant Venturer, is about to take it on to Weston-super-Mare. No. 6009 *King Charles II*, which had hauled it from Paddington, stands on the right. (*R. E. Toop*)

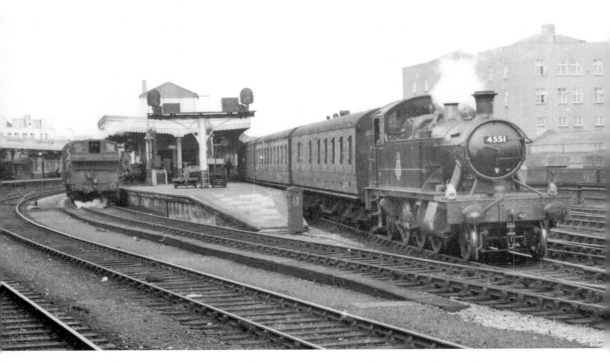

45XX class 2-6-2T No. 4551 heads a non-stop train to Weston-super-Mare, 5 September 1953. (*R. E. Toop*)

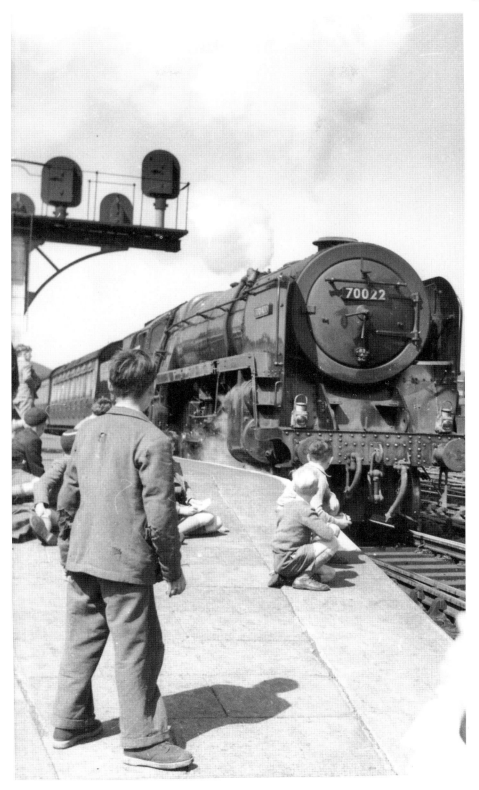

Britannia class 7P 4-6-2 No. 70022 *Tornado* at Temple Meads with a train to Plymouth, 2 June 1953. (*R. E. Toop*)

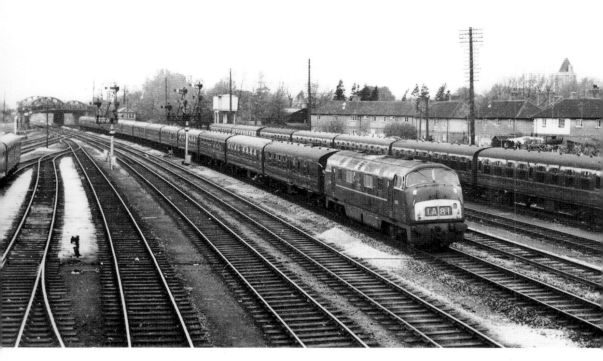

Diesel-hydraulic Warship class D818 *Glory* approaches Taunton with the Up Cornish Riviera Express, 27 April 1963. (*R. E. Toop*)

In 1907, Midland Railway guards worked through MR excursion trains to Weston-super-Mare, the GWR paying ½*d* per mile per guard.

Weston was a popular destination for local Sunday school outings. On 29 June 1909, 4,000 such pupils arrived at the resort and a total of 76,000 in June and July 1912.

On Bank Holidays in the 1950s, trains ran each way between Bristol and Weston-super-Mare at intervals of about six minutes – approximately the time taken to clear the longer block sections. To ease identification, every train was allocated a reporting number, displayed on the locomotive and on both sides of the front and rear coaches.

As the railways were used intensively for the war effort, private travel by train was discouraged with such slogans as 'Is your journey really necessary?' and excursion trains were withdrawn. The very first post-war excursion train steamed out of Paddington at 8.45 a.m. on 15 August 1946, and the 500 reserved seats on the Kiddies' Express were sold out long before that date.

A large line-side notice at the approach to Puxton & Worle requested drivers of trains for Locking Road station to sound the whistle code 'One Long; One Crow'. On arrival at Locking Road, an engine was attached to the rear, either to return it to Bristol for another load of passengers, or to take it to a stabling point.

At Weston, accommodation in the carriage sidings was insufficient, so all wagons were cleared from the goods yard to enable coaching stock to be stabled there. Also, many of the loops between Weston and Bristol were also used for this purpose.

Between 5.30 p.m. and 11.00 p.m. trains left Weston every seven or eight minutes. Those only proceeding to Temple Meads used the Bristol Avoiding line, in order to approach the station from the east and thus be ready to return to Weston for another load.

A writer to the *Bath Chronicle* on 8 March 1877 pointed out some strange fare anomalies:

> If you're travelling Bristol to Exeter by any train except express it's cheaper to go via Bath: Bristol – Bath 11½d; Bath – Exeter 7s 3d; whereas Bristol – Exeter is 12s 8d.
>
> Should you be travelling from Bath to Exeter, and wish to find out what your fare is before asking for your ticket, don't be angry when you discover that in the table of fares hung up at Bath station, there is a blank opposite the word 'Exeter'. This is an infringement of the law of the land, but the Great Western is a very important Company, and rises superior to the paltry regulations as private individuals are amenable to.
>
> Again, check any tendency to wrath if you are charged 9s 5d as a minimum fare Bath to Bridgwater, 45 miles, whereas a friend travelling in the same train to Exeter, 87 miles, pays 7s 3d.
>
> If, again, you have been enjoying your drawing-room and smoking-room alternately from Birmingham to Bristol in a Pullman car on the Midland, at a cost of 13s 10d for 94 miles, be sure not to exhibit any signs of irritation when you are charged 12s 6d for the additional 75½ miles from Bristol to Exeter in a second class Great Western carriage, and told, it you want to smoke, that you must not enter one of the new carriages. Comparisons are odious and only indulged in by second-class minds. It is only discontented and fretful travellers who recollect that there is an alternative route to both London and Exeter by Templecombe, by which third class passengers are conveyed by all trains, and twice a day in good Midland carriages.

## Chapter Fourteen

# Coaches

B&E coaches resembled those of the GWR, but windows of the first B&E second class coaches were oval in shape and could be opened; initially, second class coaches had no windows. The compartments were certainly not spacious – width was so limited that passengers' knees had to be interlocked. Wheel covers projected through the floor, limiting foot space and causing a tripping hazard. When Captain Wynne of the Board of Trade reported in May 1854 on communication between guard and driver, he commented that the B&E, unlike the GWR, had a communication rope along the tops of the coaches.

A B&E first class coach was 24 feet long, 9 feet wide, and 6 feet high inside, was carried on six wheels and rated about 7 tons 9 cwt. Each compartment had eight seats upholstered in best Morocco leather. Some compartments were sub-divided by a longitudinal partition containing a glazed door with a roller blind. This door was a popular fitting, as it created a private compartment for a small family, or with a larger one, elder children and parents could be separated from the younger.

In 1864 a first class coach cost £650, a third £400 and a coal wagon £120. Coaches were painted brown until October, when the upper panels were painted white and then varnished producing cream.

In 1872 new rolling stock was built in the Bridgwater works for Weston-super-Mare excursion trains. Mostly composite stock, one coach inspected by the *Bristol Times & Mirror* reporter had a guard's 'box'. There were first and second class smoking compartments with spittoons, while others had just first and second class compartments. These new coaches were 18 inches wider than older stock and had more space between the seats. All were upholstered, the second class having curtains and elbow rests at the end of the coach seats. The first class coaches had outer windows of wire gauze so that when the glass windows were opened, smuts and insects could not enter. Coaches had double-roofs to keep out the summer heat.

When the GWR took over the B&E in 1876, it acquired 263 coaching vehicles, nearly all of which had been built at Bridgwater. Some had Wheatley's patent door locks, which caught when slammed, but were found liable to let the doors open while running unless the handles were turned. The B&E anticipated the GWR in constructing convertible coaches, and in 1874 turned out some with standard gauge bodies set on broad gauge frames.

A third class coach, built at the Bristol works of the B&E in 1875. (*Author's collection*)

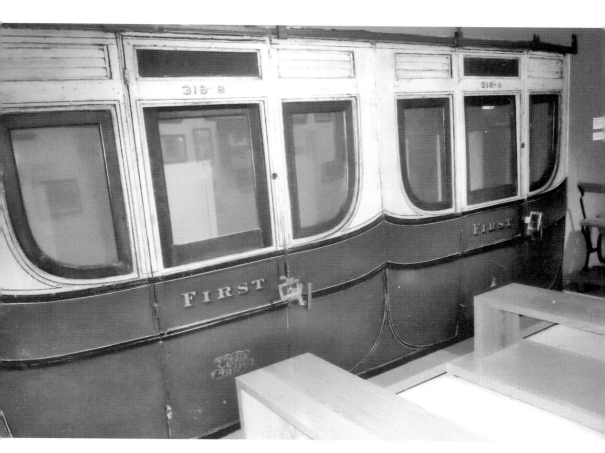

The side of a B&E coach in GWR livery exhibited at the M Shed museum, Bristol. (*Author's collection*)

B&E coaches came in for strong criticism in a letter to the *Bath Chronicle* of 6 April 1876:

> The GWR have taken latterly to making free use of the third class carriages of their latest acquisition the 'Bristol and Exeter'. Anything more skilfully contrived for ensuring the misery of the third class passenger than these carriages is inconceivable – I travelled in one to Taunton the other day.
>
> It consisted simply of horizontal and vertical boards; so narrow was it that to find room for one's knees was a mathematical problem of extreme difficulty; it was also crowded. I returned to Bath first class at a fare of over 2½d a mile. There was just room to stand up in the carriage; no light at all was given us until we reached Bristol a few minutes before seven, and for the rest of the way one feeble lamp was made to make duty for two compartments.
>
> The same evening I am told, some twenty people who had waited at Taunton station for the third class train which is stated in the Company's time bills to run in connexion with the last train to Bristol and Bath, were turned out on Bristol platform between ten and eleven, and kept till nearly one o'clock, in consequence of the Bristol and Exeter train being so late at Bristol that the Bath train did not wait for it.

Between 1879 and 1883, eight-wheel GWR broad gauge coaches were not on bogies, but had rigid inner axles, while the two outer axles had side-play. Third class vehicles seated seven on each side. The chain-hung spring gear caused a monotonous rattle, which became tiresome on a long journey.

As the end of the broad gauge was in sight, some coaches were built as convertibles – standard gauge bodies on broad gauge underframes. Some built prior to 1888 had the eight-wheel lateral side-play arrangement mentioned above, but others built after that date were given broad gauge bogies.

Local trains consisted mostly of six-wheeled stock, some with bodies entirely of iron with flat roofs. Nearly all had wheels with open spokes, many of the double elliptical pattern.

At Weston-super-Mare, corridor coaches up to 63 feet in length were frequently turned on the table to place all corridors on the same side. As a 'B-set' forming a workmen's train ran from Weston-super-Mare to Filton, and an alternate method of turning was, by prior arrangement, to attach a coach to the rear of this set and run it round the triangle at Stoke Gifford and Patchway.

# Chapter Fifteen

# Staff

When the B&E took over working its line in 1849, the GWR staff were taken on, but from 1855 men in the goods department were employed by the contractor J. C. Wall.

The B&E was plagued with poor permanent way; perhaps the decaying timber may have been due to some of the kyanised timber being destroyed by fire in April 1841. Wrought-iron crossings were certainly needed to replace those of cast iron, and the inferior burnt ballast substituted with gravel or broken stone.

The B&E continued the GWR practice of having a travelling porter in a hooded seat on the tender to watch the train, but around 1854 this was replaced, and the guard given a raised seat offering a view backwards and forwards through a window in the raised roof. He could communicate with the driver by means of a rope passing over the coaches to a lever operating the brake whistle.

Until around 1865, stationmasters wore plain clothes and a top hat but no badge of office. There were at least two guards to every passenger train, to open and close doors, attend to the luggage and work the brakes, as in the early days these could not be controlled by the engine driver. When he wanted to stop, in addition to applying brakes on the engine, or tender, he would blow the brake whistle in order to alert the guards to apply them.

Porters were dressed in 'green plush' corduroy until 1852 when the green was changed to brown, as green was found liable to fade and look dirty from exposure to weather. Green was resumed in 1859. All the men, even porters, wore top hats, those of the police being of beaver with a leather crown and leather side stays. In 1859 policemen were given caps, these being more comfortable. In 1852 the company supplied:

> Passenger guards: 1 great coat, 1 frock coat; 2 waistcoats, 2 pairs of trousers, 2 pairs of boots and 1 cap annually.
>
> Goods guards: 1 great coat, 1 jacket, 1 waistcoat, 2 pairs of trousers, 2 pairs of boots and 1 cap annually.
>
> Police: 1 great coat and 1 cape every 2 years; 1 dress coat, 2 pairs of trousers, 2 pairs of boots, 1 stock and 1 hat annually.
>
> Porters: 1 cape every 2 years; 2 jackets, 2 pairs of boots and 1 cap annually.

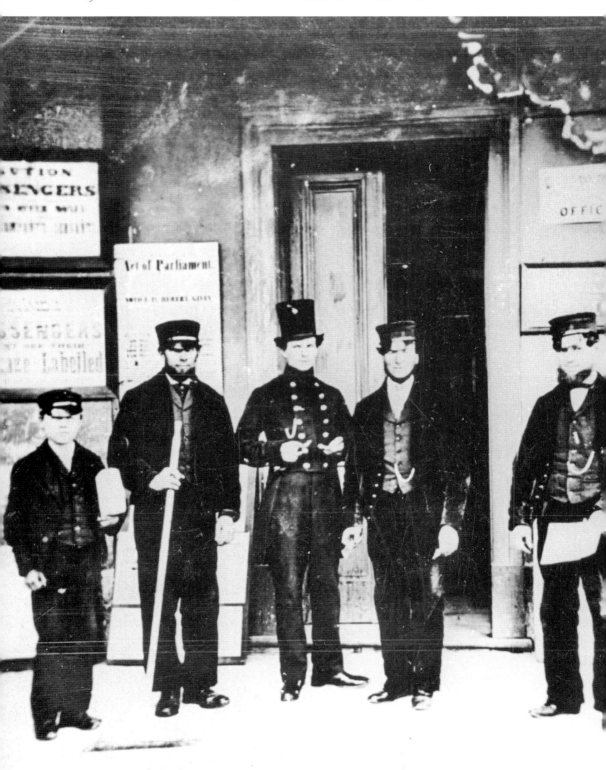

Bridgwater station in 1859, showing the staff outside the booking office: a signalman, centre, wears a top hat, and beside him are three porters and a lad porter. (*P. J. Squibbs collection*)

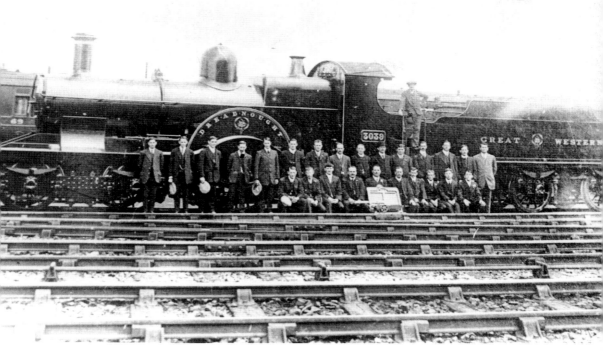

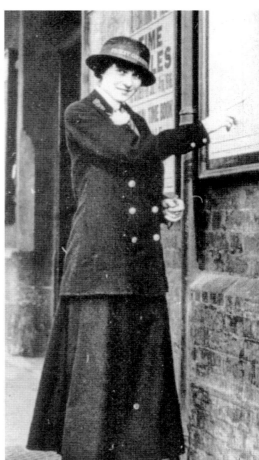

*Above:* The Taunton Mutual Improvement class,
*c.* 1910, posed in front of 3001 class 4-2-2 No. 3039
*Dreadnought* and steam rail motor No. 69. (*Author's
collection*)

*Right:* A woman ticket collector at Taunton during
the First World War. Notice her buttonhole. (*Author's
collection*)

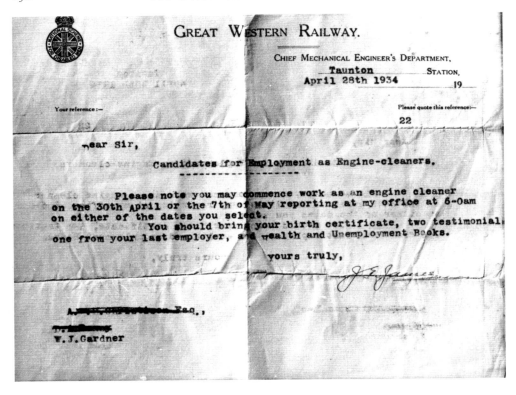

GREAT WESTERN RAILWAY.

CHIEF MECHANICAL ENGINEER'S DEPARTMENT,

Taunton STATION,

April 28th 1934 19

Your reference :—

Please quote this reference :—

22

Dear Sir,

Candidates for Employment as Engine-cleaners,

Please note you may commence work as an engine cleaner on the 30th April or the 7th of May reporting at my office at 6-0am on either of the dates you select.

You should bring your birth certificate, two testimonial one from your last employer, and Health and Unemployment Books.

yours truly,

J.E. James

A.~~~~~~~~~~~~~~ Esq.,

W.J.Gardner

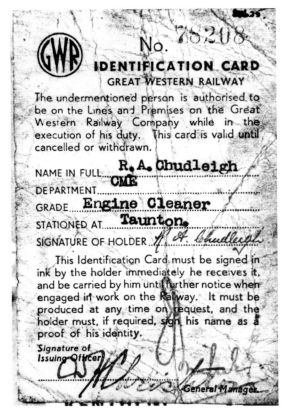

No. 78208

IDENTIFICATION CARD
GREAT WESTERN RAILWAY

The undermentioned person is authorised to be on the Lines and Premises on the Great Western Railway Company while in the execution of his duty. This card is valid until cancelled or withdrawn.

NAME IN FULL R. A. Chudleigh
DEPARTMENT CME
GRADE Engine Cleaner
STATIONED AT Taunton.
SIGNATURE OF HOLDER R. A. Chudleigh

This Identification Card must be signed in ink by the holder immediately he receives it, and be carried by him until further notice when engaged in work on the Railway. It must be produced at any time on request, and the holder must, if required, sign his name as a proof of his identity.

Signature of
Issuing Officer

General Manager

*Above:* Letter to W. J. Gardner informing him of his post as engine cleaner.

*Left:* R. A. Chudleigh's GWR Identification Card.

Engine drivers and firemen initially were mostly enrolled from the North of England, and were chosen for their mechanical, rather than literary, skills. Many of them were illiterate; in fact, Brunel said in 1841 that non-reading men were the best drivers as their minds were not so liable to wander.

The rule book declared,

> Every engineman and fireman must appear on duty dressed in white fustian clothes, which are to be clean every Monday morning, or on Sunday, when he may be required to work on that day.

Drivers were granted bonuses for good conduct and the economical working of their locomotives.

Being a railway servant could be a very dangerous job. In April 1879, Thomas Buckley had his foot cut off during shunting operations at Yatton. The GWR, anxious to offer him suitable employment, suggested that he learn the telegraph, but this he was unable to do. He was then sent to Cheddar as a ticket collector, but after only one day at this job, gave it up saying that his head was affected.

In March 1880, neighbours saw him through the window hacking his wife's head with a bill hook. They went in, halted the attack and called the doctor and police.

Charged with attempting to murder his wife, he was remanded to the Long Ashton petty sessions. The *Bristol Times & Mirror* commented, 'His wife is progressing favourably.'

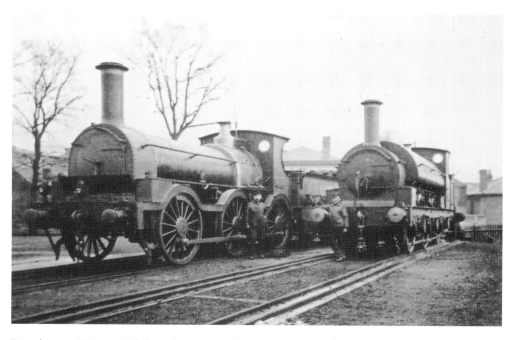

Broad gauge No. 2088, left, and a standard gauge 0-6-0ST, right, at Taunton locomotive depot. As the latter is on the turntable road, four rails are provided to ensure that a locomotive is correctly balanced on the table. (*Canon Brian Arman collection*)

# Chapter Sixteen

# Permanent Way

Every permanent way man was required by the B&E to be a member of the Permanent Way Benefit Club, or similar society. No permanent way employee was allowed to keep a public house or other place of sale of liquor, or carry on any trade or business either by himself directly, or indirectly through some member of his family. The infraction of this rule led to instant dismissal.

The 1864 Rule Book said that, although every portion of the line demands the utmost care and attention, Creech Junction demands very special attention, as did timber bridges and viaducts.

Each inspector was required to ride over his district at least once a fortnight in the end carriage of a train in order to observe more carefully the rough parts of the line.

Although economy should be borne in mind,

> no desire of saving expense, either in materials or labor [sic], will be held to excuse the continuance for a single hour of any part of the permanent way, works or stations, in a condition, of the stability and perfect security of which there is the smallest doubt.

A ganger was required frequently to test the gauge personally. The correct gauge was a width of 7 feet ¼ inch, but an allowance of ¼ inch beyond this was made on all flat curves, or curves where the offset in 22 yards did not exceed 3 inches. Where the offset was between 3 and 5 inches, the allowance beyond the correct gauge was ⅜ inch, or if the curve was still sharper, the allowance could be a trifle more, but in no case should it exceed ½ inch without special orders. The 'offset' is the standard method of working out the radius of a curve; the greater the offset, the sharper the curve.

J. J. MacDonnell, who had taken over from William Gravatt in 1851, wrote to the directors about the need for constant renewal of timber 'which had not been originally creosoted'. He attempted to improve the permanent way by dispensing with the long timber under Brunel's bridge rails and substituting shaped iron plates. This so-called improvement was disliked by drivers, as it offered a rough and dangerous ride, and also by the plate layers, who found it difficult to maintain a goods 'top'. Nevertheless, some remained on the main line near Brent Knoll until after 1876.

To accommodate standard gauge trains, a third rail was laid Highbridge to Durston in November 1867; on the Dunball Wharf branch in November 1868; Durston to Taunton in May 1875, and Bristol to Highbridge on 1 June 1875. The Weston-super-Mare branch was mixed gauge from 1 July 1875 and standard gauge only from 30 June 1879.

A trial length of flat-bottomed rail was laid near Brean Down Halt around 1947, at a time when bullhead rail was standard.

Being a railway servant could be risky. In August 1841, the ballast between Flax Bourton and Bristol was being attended to at night. The gang broke off at 11.00 p.m. to avoid danger until the mail had passed. During the break on 27 August, they all fell asleep and the head of an 'aged man', James Chorley, was across a rail. The mail approached without waking any of the sleeping men. James's head was severed and his trunk divided just below his chest.

A driver oils his Hall class 4-6-0 at the head of an Up semi-fast train at Weston-super-Mare, *c.* 1939, while on the right a 51XX class 2-6-2T is by the East signal box. (*E. J. M. Hayward*)

# Chapter Seventeen

# Signalling

The B&E, like the GWR, was equipped with Brunel's disc and crossbar signals. When a disc showed, this meant that the line was clear, but a crossbar indicated danger. A board or fantail signal indicated caution. The signals were governed by the use of time interval. After the passing of a train, signals remained at danger for three minutes, caution for seven minutes and after ten minutes, signals were restored to their normal position of clear. After 1852 times were modified to five minutes at danger, five at caution after a passenger train; or eight minutes at danger and seven at caution after a goods. After ten or fifteen minutes, signals were restored to all right. The serious drawback to this system was that if, for some reason, a train came to a standstill out of sight of a signalman, the only way of protecting its rear was for a guard to walk back and in some cases this he might be unable to do if, say, he had been injured in a derailment.

Serious but not fatal collisions, at Weston Junction and Nailsea in 1865, warned the directors that the time interval system left something to be desired. Over the next two years, and well ahead of the GWR and most other companies, they installed the block telegraph and starting signals. This placed a distance between each train, making it impossible for a train to hit the rear of another.

When the B&E took over working in 1849, it continued with the GWR pattern signals, though the wind apertures in them were of a slightly different design, and the fantail caution signals rather smaller. The company's engineer, Francis Fox, designed a turn-over signal, where the disc was fixed at right angles through the centre of the crossbar and turned on a horizontal rather than vertical axis. This was claimed to be easier to work by wire and more readily fitted with an electric repeater. It was used almost exclusively for distant signals and was peculiar to the B&E. The B&E never used semaphore signals, as Fox considered that they gave a less positive signal than the disc and crossbar. Points were worked by capstan.

Although the B&E was one of the first lines to introduce the block telegraph, interlocking of points and signals, thus making it mechanically impossible to create a conflicting path for a train, came rather later than on many railways. The first locking frame was installed in 1870, for controlling the level crossing at Highbridge of the Somerset & Dorset over the B&E. Weston Junction was equipped by 1873 and, before its amalgamation with the GWR in 1876, almost all stations on the main line had been given Saxby & Farmer's interlocking frames.

The B&E form of disc and crossbar signal. (The disc is set above the crossbar at right-angles and only its edge is depicted here.)

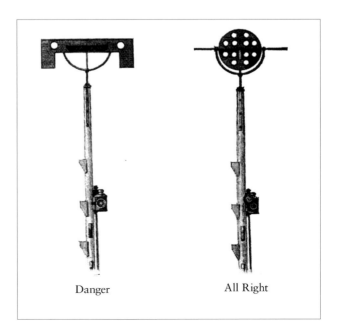

Danger                    All Right

A B&E turnover signal relating to the Down line – the tips of the crossbar point downwards, whereas those applying to the Up line point upwards.

Tyers' block instrument, installed in signal boxes between Bristol and Taunton in 1866 to enable the line to be divided into sections. A train was only permitted to enter a section if that section was clear.

The large Yatton West signal box, September 1968. (*Author's collection*)

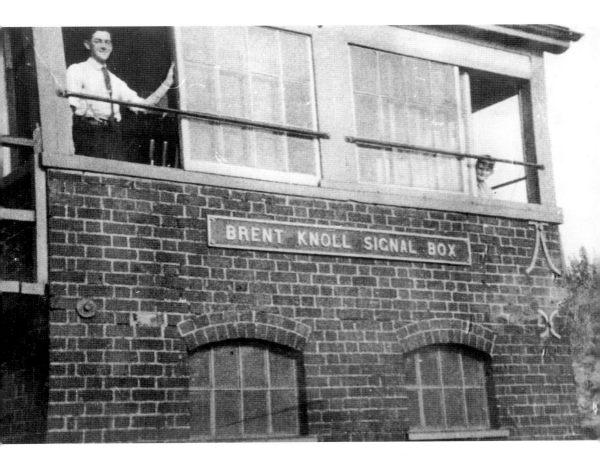

Signalman Wilf Talbot in Brent Knoll signal box *c.* 1942. (*Author's collection*)

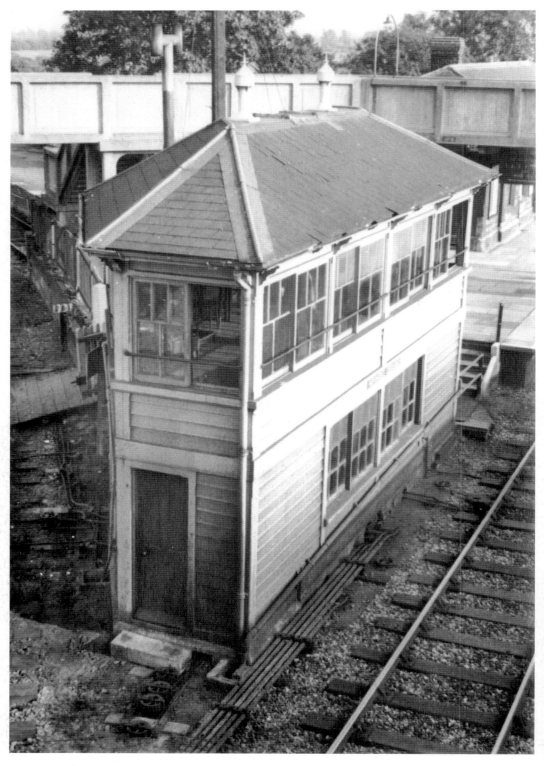

Highbridge Crossing signal box owes its unusual shape to the fact that it is fitted in the angle between the Great Western line, right, and the Somerset & Dorset to the left. View taken on 1 June 1966. The box closed on 20 March 1972. (*Author*)

The electric telegraph (as opposed to the block telegraph), was installed between Bristol and Exeter in the summer of 1852 by the Electric Telegraph Company. The B&E took these lines over in 1859, but ten years later they were transferred to the government, as were other railways' telegraphs, the B&E retaining some wires for railway messages. The telegraph was not only useful for railway officials. On 6 February 1857, a Mr Cavill had received £54 for beans delivered to Yatton station. A third class train had stopped there for some time in order to allow an express to pass, and while waiting, many passengers alighted, one of them relieving Mr Cavill of his purse. By the time he realised his loss, the train had left. The telegraph was used to apprehend a man who had acted suspiciously.

Around 1866 the B&E ruled that each train had to carry a white target at the back of its last vehicle in addition to or in place of the tail lamp. This gave a much clearer indication to a signalman that the train was complete.

Automatic Train Control was installed on the line in 1931, this admirable safety device giving drivers an audible warning of signal positions.

1972 saw the closing of signal boxes between Parson Street Junction and Cogload Junction, including the Weston super-Mare Loop, signals coming under the control of the Bristol MAS box.

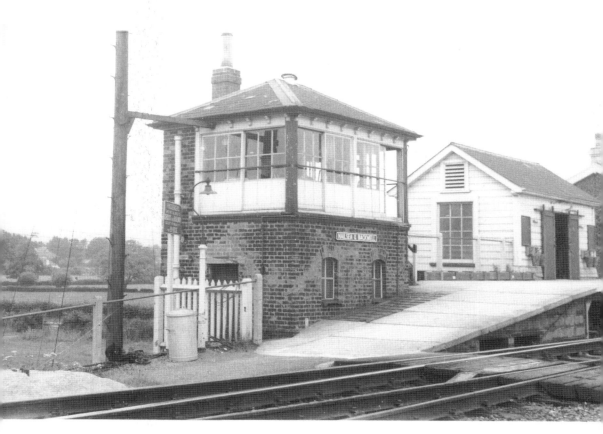

Nailsea & Backwell signal box. The parcels lock-up is on the right. (*T. J. Saunders*)

# Chapter Eighteen

# GWR Buses

Three GWR Clarkson steam buses from Cheddar were transferred to Bridgwater in 1906 to run services to Stogursey and Holford. Unsuccessful, in July they were replaced with Milnes-Daimler and Straker-Squire vehicles. On 23 September 1907 the service included Middlezoy. Still unprofitable, the Bridgwater depot closed on 31 October 1908.

The GWR ran a bus service at Weston-super-Mare from the station to Worlebury and Old Pier, in the summer extending along a private road through delightful woods to Sand Bay. The route passed to the Bristol Tramways & Carriage Company on 20 July 1931.

On 31 December 1928, an experimental Mondays-only GWR bus service was run from Portishead to Clevedon, Yatton and Claverham. Unsuccessful, it was withdrawn on 1 July 1929.

---

## DAILY during JULY, AUGUST and SEPTEMBER,

### Combined Rail and Road Motor Tickets will be issued to

# HOLFORD (For Holford Glen via Bridgwater.)

| FROM | AT | | Return Fare, 3rd class by Rail to Bridgwater & Road Motor to Holford. | FROM | AT | | Return Fare, 3rd class by Rail to Bridgwater & Road Motor to Holford. |
|---|---|---|---|---|---|---|---|
| | A.M. | A.M. | | | A.M. | P.M. | |
| Clifton Down .. | 8A†23 | 12A‡36 | | Lawrence Hill .. | 8A†44 | 12A‡46 | |
| Redland .. .. | 8A†25 | 12A‡38 | **5/6** | St. Anne's Park . | 8 †43 | — | **5/6** |
| Montpelier .. .. | 8A†27 | 12A‡40 | | Temple Meads .. | 9 † 7 | 1 ‡ 20 | |
| Stapleton Road .. | 8A†42 | 12A‡44 | | Bedminster.. .. | 8A†37 | — | |
| | | | | Ashley Hill .. .. | 8A†39 | 12A‡24 | |

### A Change at Temple Meads.

† Passengers travelling by this train arrive at Bridgwater at 10.34 a.m., and proceed at 10.35 a.m. by the G.W.R. Co.'s Road Motors, arriving at Holford (Plough Hotel) at 12.5 p.m.

‡ Passengers travelling by this train arrive at Bridgwater at 2.30 p.m., and proceed at 2.35 p.m. by the G.W.R. Co.'s Road Motors, arriving at Holford (Plough Hotel) at 4.0 p.m.

As the Motor times are subject to alterations, intending passengers should verify the times before starting.

**The tickets will be available for return on the day of issue by the Motor Omnibus leaving Holford (Plough Hotel) at 5.55 p.m., which connects with Up and Down trains at Bridgwater.**

*The Motor Omnibuses call at Cornhill, Wembdon, Cannington, Keenthorne, Nether Stowey, Dodington, and Holford.*

---

**For Special Notices relating to the issue of Excursion Tickets, see page 2.**

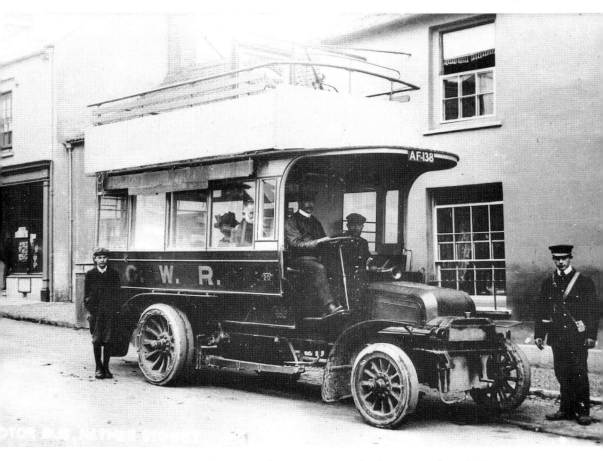

*Above:* From 1 July until 31 October 1908, the GWR operated a bus service from Bridgwater to Holford and Kilve; it was not a financial success. Here Driver Hancock is at the wheel of 20 hp Milnes-Daimler AF 138, fleet No. 20. The conductor, with cash bag and ticket punch, stands to the right. (*Author's collection*)

*Opposite:* Extract from a 1908 excursion booklet, advertising a trip using a GWR bus between Bridgwater and Holford.

# Chapter Nineteen

# Accidents & Mishaps

The B&E had a marvellous record and claimed that it never killed a passenger. The broad gauge was inherently safe, and what would have been a disaster on the standard gauge was only fatal to the footplate crew of a broad gauge train.

Although the line between Bristol and Taunton had seen no fatality to passengers in the B&E era, it did have perhaps more than its fair share of incidents.

One of the first occurred on 9 July 1841 when, as the 4.00 p.m. train from Temple Meads reached Bridgwater, it struck a barrel of tar which had been placed near the rails, either by accident or maliciously. The carriage steps were struck off and both passengers and coaches were 'plentifully besprinkled with tar'. Then on 1 August a train was derailed near Backwell, but no passengers were injured.

On 9 April 1842, the first Down train to call at Yatton was the mixed train. The engine was detached to pick up a wagon, and the driver and fireman both left the footplate. The unattended locomotive then set off down the line, not stopping until it ran out of steam just before Bridgwater.

On 8 September 1852, the 9.45 a.m. express from Paddington was drawn onwards from Temple Meads by B&E 4-2-2 No. 20. The train consisted of an iron-built luggage van and two first and two second class coaches. No. 20 approached the Creech aqueduct at 44 mph, and immediately beyond, the locomotive derailed, ran into the embankment, the tender somersaulted and landed upside down on the boiler.

Fortunately the coupling behind the van broke, thus allowing the coaches to safely free-wheel past the derailment. So little were the passengers disturbed that one lady said that she saw an engine pass rapidly in a contrary direction and only afterwards realised it was the derailed locomotive of her train.

As the luggage van blocked both roads, Charles Fouracre, a ganger working nearby, had the presence of mind to run down the line to stop the Up express. The track was cleared by the simple expedient of attaching this Up express engine to the van and dragging it clear of the Up line, the express continuing on its way two hours late. The driver and fireman of the Down train received fatal injuries.

The Board of Trade inspector failed to discover the definite cause of the accident, but believed it could have been caused by a broken tender axle.

On 12 October 1852, an Up passenger train struck three stone wagons left on the main line west of Flax Bourton tunnel. The engine and tender were derailed, but no passenger injured. The first wagon was shattered to pieces and the other

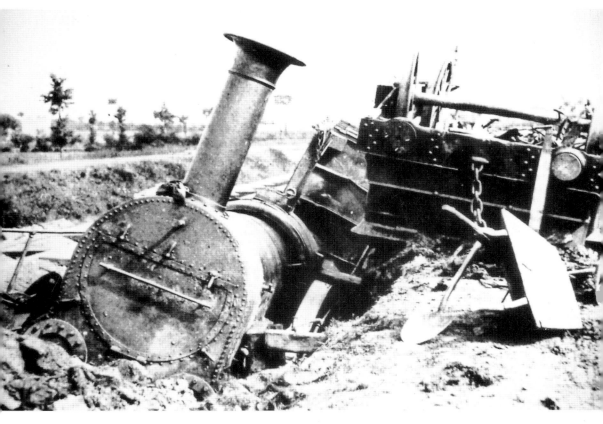

*Above and below:* B&E 4-2-2 No. 20 derailed at Creech, 8 September 1852. These are two of the earliest photographs of any railway accident. (*Broad Gauge Society collection*)

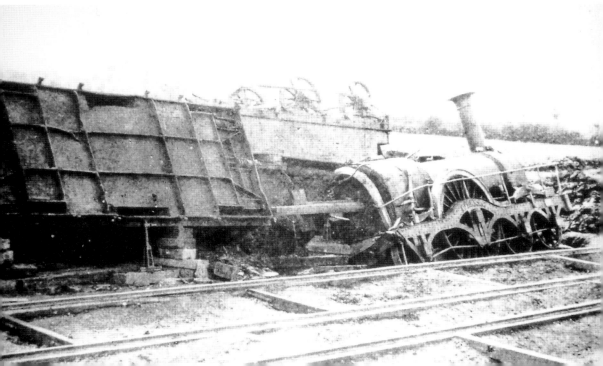

two propelled a quarter of a mile up the line. The train was delayed for two hours.

Passengers needed to be aware of theft while making a rail journey. In January 1855, Eliza Day of Clevedon caught the afternoon train from Yatton to Bristol. After sitting down, she placed five sovereigns and four shillings in a wallet which she put in the front pocket of her dress. On arrival at Nailsea, she discovered that the purse was empty.

At that station, Ann Griffin and William Henry Johnson had left her coach and entered another. On arrival at Bristol she informed the Bristol police. On searching Johnson, six sovereigns and four shillings were found on him. He denied all knowledge of Ann Griffin, yet they had lived together as man and wife at the Adam & Eve Inn, Lewin's Mead, Bristol.

On 20 March 1855, a railway-related accident occurred at Bristol. The large, flat-bottomed barge *John*, propelled by steam and belonging to Messrs Insall & Co., patent coke manufacturers of Cardiff, had discharged 130 tons of coke at the B&E's wharf, this smokeless fuel being used for its locomotives.

It left to go downstream, but as the tide had been unusually high, the ebb was extra strong. The barge was unladen, light and thus difficult to steer. Its master, concerned that she would strike the piers of the B&E bridge south of Temple Meads station, threw a warp out to bring the bows round, also reversing his engine. Nevertheless his vessel struck the bridge, causing no damage, and continued downstream. The tide still high, *John* struck the cast-iron girders of Bath Bridge, causing the whole structure to collapse across her bows and then sink. The vessel then continued on to Bedminster Bridge and, although of the same design as Bath Bridge, when struck it held firm.

On 18 April 1865 the Down express, which left Bristol eleven minutes late at 8.26 p.m., stopped at Weston Junction to repair a piston and, while halted, was struck in the rear by a Bristol to Weston-super-Mare stopping train, the locomotive of which pushed itself beneath the rear coach of the express and then travelled through the station with it, causing the Down platform's roof canopy to collapse. The timber building was so seriously damaged, and the beams and framework at each end so splintered, that for safety the structure had to be shored up.

Thomas Rigden, the express guard, heard the next train coming, opened the doors and got the passengers out before it was struck.

No passengers were severely injured, but aid coming from Weston-super-Mare was slow because the fire of the branch engine had been drawn for the night and steam had to be raised before it could pull coaches to the junction. Every available cab in Weston was used to carry the passengers. Both waiting rooms at the junction were used for treating the injured. As there was no local hospital, the Bath, Railway and Victoria hotels at Weston had to be used and the services of local GPs. Some of the injured were taken to a hotel at Clevedon.

One lady lost her purse with nine pounds in it, which she was holding at the time of the accident.

Driver John Quire and Fireman William Tottle both leapt off before the collision. They were brought before Weston magistrates and committed for trial,

charged with negligent conduct endangering the lives of passengers. The warning signal could be seen more than a mile away.

The following day the first Down train was derailed within 200 yards of the junction, due to the confusion of the previous night preventing the points from being changed.

Porter-guard Isaac Golding, on the 8.15 p.m. from Temple Meads which had left at 8.26, said that the brake whistle was not blown until just a few hundred yards before the station. When he heard it, he applied the brake as hard as he could. The Weston Junction signalman estimated the collision speed at 30 mph. Express Guard Rigden said that some of the passengers stepped out while the engine was being repaired, but had retaken their seats and the train was ready to leave when he heard the short train's brake whistle blown twice, and saw it only 200 yards away and approaching at 30 mph. As he could see that a collision was inevitable, he went to the last coach, opened the doors and asked passengers to leave.

George Farren, one of the passengers who escaped through the action of Thomas Rigden, expressed gratitude in a letter to *The Times*, thanking him for risking his own life to save those of his passengers.

When police Superintendent William Blackmore arrived from Bristol, he could see the red warning light at Weston Junction from a distance of about 2 miles. Blackmore asked the express engine driver to go forward to Highbridge to stop Up trains, but he was too shaken to carry out this order.

Sometimes the railway provided an event of human interest.

On the evening of 17 August 1867, a married Bristol man, aged about forty, said to be connected with a bank, at Weston-super-Mare had enticed a girl of sixteen to accompany him to Bristol.

The girl's relatives, hearing that she had gone to the station, proceeded there and discovered the couple comfortably seated in a compartment. The pair refused to leave until Superintendent Blackmore informed them that the coach was not coupled to the train.

The girl was taken home by her relatives and the man 'crowned and roughly used by the crowd'. Alone in a second class compartment, the man was teased and opera glasses used so females could recognize him and beware of the predator. He was promised a warm welcome at Bristol, but when the train arrived there, he could not be found.

On 24 July 1869, the points man had failed to set the road correctly and an Up excursion from Weston-super-Mare ran into a goods siding at Pylle Hill, striking a goods engine and precipitating passengers to the floor. Driver Jones, on this locomotive, anticipating the collision, reversed his engine thus lessened the impact. Both locomotives were slightly damaged.

In June 1870 Corporal Thompson and Sapper Thompson of the 1st Somerset Engineers (Nailsea) Corps fired their carbines out of the window of a train travelling between Bristol and Nailsea. At the Court of Inquiry held at the Corps' headquarters, Nailsea, charges of insubordination were proved and both men dismissed from the Corps.

An accident occurred to the Down Flying Dutchman on 30 April 1875, the *Bristol Times & Mirror* reporting, 'The occurrence is one that suggests

uncomfortable feelings as to the boasted efficiency of the "block system".' The accident happened close to the B&E express platform at Temple Meads. The train was due in at 2.21 p.m. and was punctual. It steamed slowly towards the station, but just as it approached the bridge by the Cut and before it could reverse into the B&E departure platform, a tender engine emerged from the nearby engine shed and ran across the Down line. The express engine was not derailed and neither were the coaches, but the left side of the tender engine was damaged. None of the footplate crews were injured, and most of the passengers were unaware that an accident had occurred.

As the line was blocked for over three hours, the express passengers were transferred to another train and only delayed for an hour. Powerful jacks lifted the erring engine and by 5.30 p.m. the line was clear for traffic. 'It is a curious thing that at this point where the tender engine crossed, was a switchman's box with a man on duty for the very purpose of preventing the possibility of such accidents.'

On 27 July 1876, Driver William Dunscombe left Taunton twenty minutes late with the Up Flying Dutchman. His engine was 4-2-4T No 2001, which had been built at Bristol eight years earlier.

Already having gained three minutes while descending the incline of 1 in 180 on the Bristol side of Flax Bourton Tunnel, oscillation was violent, the engine

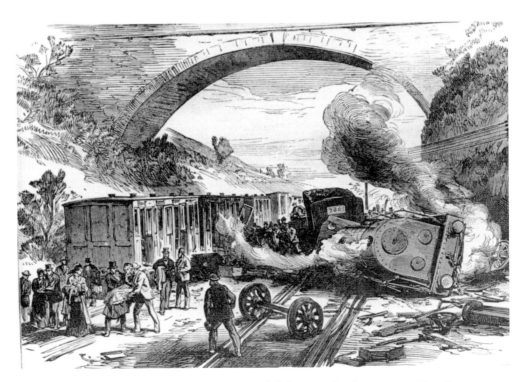

No. 2001, ex-B&E 4-2-4T No. 39, overturned following derailment near Flax Bourton, 27 July 1876. The engine was withdrawn following this accident. The drawing is not too accurate: the smoke box door is too small and the two cylinder covers are not precisely placed. The locomotive's number appears to be on the front of the tender, which being a tank engine, it did not have! (*Courtesy: Illustrated London News*)

mounted the right-hand rail, ran along its surface for about 12 yards and then jumped off. No. 2001 ran in the 6 foot for 30 yards and cut across the Down line. It carried on for another 50 yards before striking the embankment and falling over. The coupling chain behind the engine broke, allowing the train to free-wheel safely past.

Guard John Watts, despite a broken arm, sprained ankle and cuts, had the presence of mind to collect two red flags from his wrecked van and offered them to passengers, to walk along the line either side of the derailment in order to warn approaching trains. Fireman James Randall had been killed instantly and Driver Dunscombe fatally injured.

A number of passengers cut themselves climbing through carriage windows they had smashed in order to get out, doors having been locked on both sides. Fourteen injured passengers were taken to Long Ashton, where they received hospitality from the villagers. One injured passenger, offered a derisory one shilling compensation by the GWR, had it raised to £450 by the Court. Captain Tyler, at the Board of Trade inquiry, blamed the faulty track and said speed should be reduced to 40 mph at certain locations and that he would walk over all the line between Bristol and Exeter to determine its condition.

Again it was difficult to attribute the cause. No. 2001 had only returned from overhaul at Swindon works twelve days before, and the inquest attributed derailment to the uneven permanent way. No. 2001 was so badly damaged that she had to be scrapped. The following year, the remaining three engines of the same class were converted to tender engines as opinion had changed, now believing that tank engines were not considered suitable for hauling express trains.

On 26 November 1883 a gardener, John Hawkins, aged fifty-six, was returning to Nailsea from Bristol on the 9.25 p.m. In his compartment, three men were playing cards and insisted that he joined their game. On his refusal, near Flax Bourton they opened the door and pushed him out. A wheel passed over his left arm, nearly severing it at the shoulder and he also suffered a severe scalp wound.

On 30 April 1907, there were the makings of a disaster when the 9.00 a.m. passenger train from Chard, consisting of 0-4-2T No. 537 and four coaches, was struck at Taunton by a shunting engine emerging from the goods shed. One passenger was killed, six injured, one railway servant killed and three coaches wrecked.

On Sunday 20 June 1909, the 7.25 a.m. from Plymouth was derailed at Highbridge. Due to permanent way work taking place at Dunball, it was run 'wrong line' to Highbridge. As it was regaining the correct road, 100 yards north of the platform, it derailed on the crossover, the locomotive striking a goods train. The first two coaches of the seven-coach train were wrecked. Passengers were carried in another train to Temple Meads and a special provided for those bound for Paddington.

0-4-2T No. 5812, in November 1946, was left with the regulator open while steam was being raised in Taunton shed. In due course she moved along and hopped over the substantial metal lugs protecting the end of the shed road and pushed through the shed wall, coming to a halt with its buffer beam and smoke box door protruding into the street.

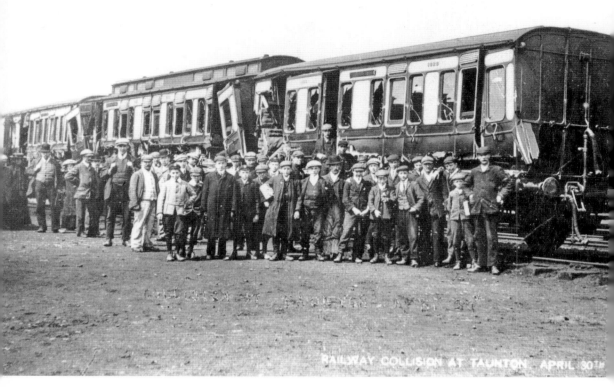

The coaches involved in the collision at Taunton on 30 April 1907. (*Author's collection*)

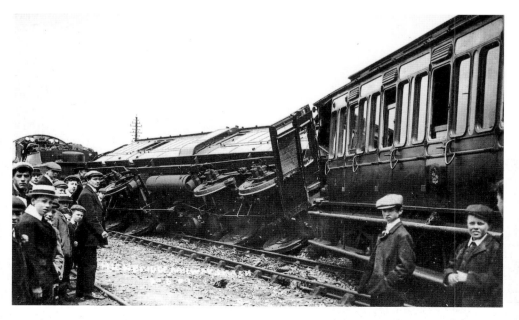

Derailment at Highbridge, 20 June 1909. The engine has lost its cab roof. No railway staff are present in this image. (*Author's collection*)

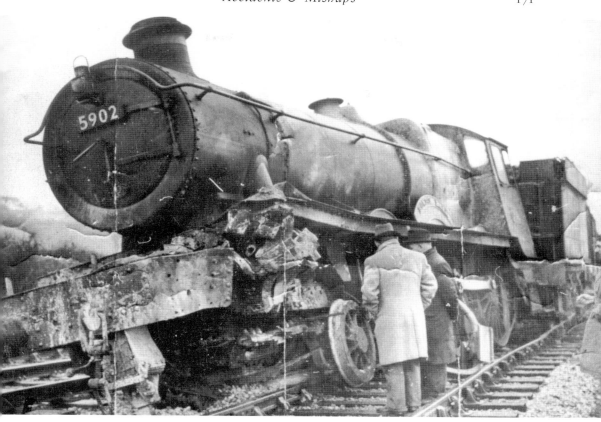

*Above and below:* 4-6-0 No. 5902 *Howick Hall* at Uphill Junction, 21 January 1951, following a collision with a light engine. (*Author's collection*)

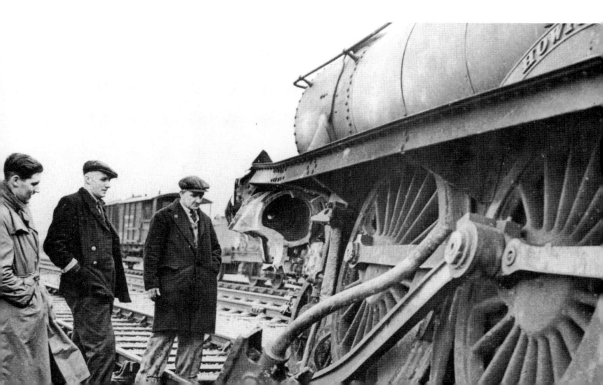

The main line was blocked on 21 January 1951 following a collision at Uphill Junction, 2.55 a.m., between a light engine and a goods train. Both locomotives and several wagons were derailed and the footplate crews taken to hospital, suffering from shock and cuts, but were not detained. The goods guard suffered shock. All traffic was diverted over the Up Loop line, which was unaffected. The line reopened the same day at 6.20 p.m.

On 23 October 1974, the 18.28 from Ince and Elton to Bridgwater, carrying Shellstar bagged fertiliser, arrived at Bridgwater at 04.55. No. 47441 stopped before crossing over to the yard. Shortly after it had come to a halt, the 19.42 Derby to Exeter Riverside freight, hauled by Class 45 No. 125, collided with its rear at about 45 mph. (No. 125 had yet to be renumbered in the TOPS system). The force was sufficient to thrust the Shellstar train and its locomotive forward for 100 feet. No. 125 was severely damaged at both ends, both cabs being crushed. The guard riding in the rear cab was fatally injured, but the driver and second man escaped with minor injuries. The accident was attributed to both drivers having fallen asleep. Unfortunately No. 125 was fitted with a different type of automatic warning system to that used at Bridgwater, so the driver would not have received any audible warnings after leaving Bristol, and would have relied solely on the visible sighting of signals.

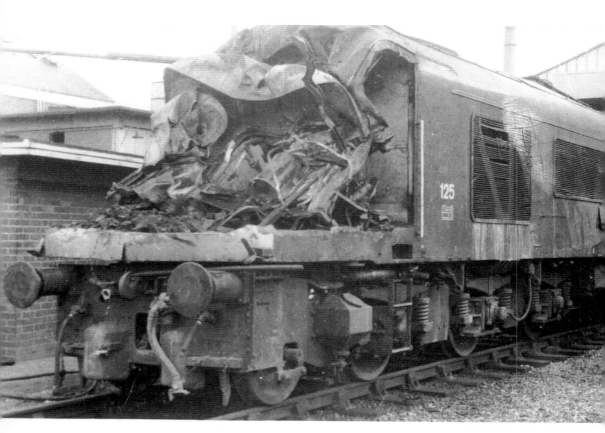

A damaged cab of Class 45 No. 125; sustained during a collision with the rear end of a train at Bridgwater, 23 October 1974. (*John Stamp*)

# Chapter Twenty

# Mail Robbery on the Bristol & Exeter Railway

On the evening of New Year's Day 1849, the Up mail, which left Plymouth at 6.15 p.m., consisted of a Post Office van and tender, plus six or seven first and second class coaches. On arrival at Bridgwater, the bags of letters that had been collected and sorted on the journey were placed in the Post Office tender behind the Post Office van and securely locked.

When the train reached open country, two young men with first class tickets swung open their carriage door, braced themselves against the cold night wind and clambered along the running board with the aid of a wool stapler's hook. One closed the coach door while his companion, standing on a ledge only 1½ inches wide, worked furiously to open the door of the Post Office tender.

Opening the door, he waved to his accomplice and they both set to work breaking the seals, cutting strings and slashing open the packages and letters inside. They concentrated on bankers' parcels and registered letters, which they scooped into their pockets and into two sacks they had brought with them. They made no attempt to hide the robbery and left the floor littered with wrappings and opened small mail bags. The noise of the wheels was more than sufficient to hide any sound they made, so there was no possibility of the Post Office sorters in the next van hearing them.

The job accomplished, they made their way back to their carriage and, after the train had drawn into Temple Meads, left it quite openly.

Work had made them thirsty, so they walked to the Talbot Inn at Bath Street and ordered two glasses of brandy and water from Jane Cramp, the barmaid. The time was about a quarter past midnight.

Meanwhile there was great excitement at Temple Meads. On arriving there, the mail guard went to the tender to deliver the Bristol bags and, unlocking the door, found to his horror that nearly all the bags had been tampered with – some cut open, while others had their seals broken off and the string untied. A cursory examination told him that all the money, registered letters and bankers' parcels had been abstracted.

Meanwhile the two men had finished their brandy at the Talbot Inn and left a few minutes before 1.00 a.m. for a brisk walk back to the station. They arrived some minutes before the Down mail and before the booking office was open. Mr Lee, a retired tradesman living in Clifton, came up and, as he did so, the taller of the two men drew back into the shadows. Lee made a remark on the train's

non-arrival to the shorter man, who did not reply but joined his friend under the arch. They went away and whispered. This was a foolish move as it excited Lee's curiosity and he watched them unobserved.

The booking office eventually opened and Samuel Wilton, the booking clerk, issued two first class tickets to Exeter to a man, noticing another fellow nearby trying to keep out of sight.

When the train arrived it consisted of two second class coaches behind the engine, followed by the travelling Post Office, the Post Office tender and a first class coach.

As the two clerks who sorted the letters were considered insufficient to carry it out in the time allowed, it was practice for the mail guard, Leonard Barrett, to be withdrawn from the mail tender to assist them. Arriving at Bristol, Barrett was informed of the robbery of the Up mail and, while waiting in the Travelling Post office with the sorters, looked out anxiously from time to time along the platform to check his van, for he did not want his mail stolen.

As the bell rang for departure, Fisher, the policeman, had shown a man to the leading compartment of the first class coach and was about to close the door when he noticed a short man coming from behind a pillar supporting the roof and asked, 'Are you going on?' The man looked into the compartment, saw the passenger already there and exclaimed, 'No, no,' he then turned as his friend emerged from the lavatory.

The railway guard, Joseph Reinhart, approached and said, 'Gentlemen, you are delaying the time: show your tickets, please.' The shorter man said, 'We prefer this,' and moved as if he was going to enter the third compartment. The men were not keen on going in because it was already occupied by Mr Andrews, a solicitor from Modbury, South Devon. However, they had to make the best of it. In order to give themselves more privacy, they crossed over the half in which he sat, closed the folding door which divided the compartment in half and pulled down the green blind.

As they passed Mr Andrews, one of them carelessly dropped some string on the floor and to while away the time he rolled it up, but found one end trapped in the folding door. Mr Andrews soon settled down to sleep and thought no more of the passengers on the other side of the door.

When the train stopped at Bridgwater, Leonard Barrett, the mail guard, went to his tender to remove the bags for that town, but noticed that they had been misplaced. He immediately informed Messrs Burchel and Silk, the two Post Office clerks, who then accompanied him to the tender. They observed that the twine had been cut, the seals broken and the bags retied with fresh string, thinner than that used by the Post Office.

Barrett called the GWR guards, Reinhart and Thomas, and told them to take care that no one left the station. He believed that it would have been possible for one of the first class passengers to have reached the tender, but that it would have been an impossible feat from the second class because the distance between the coaches was 5 feet.

When he inspected the first class compartments he found Mr Barlow, who was a GWR director, and Mr Emmett, a railway contractor, in one (curiously a ladies'

compartment); in another a young man of seventeen lying down; in another a single gentleman; and in yet another, the blinds were pulled down and nothing could be seen, but he could hear talking in a low voice.

At Bridgwater the platform was on the opposite side of the coach to that at Bristol, so the two men were now on the platform side. Reinhart opened the door and put his hand into one of the door pockets. He drew out two crepe masks. He tried another pocket and found a candle. Reinhart moved a cushion and this caused one of the men to stand, but he kept his handkerchief close to his face, which was also partly covered by his Jim Crow hat.

He put his heel on the platform and guard Thomas spotted something attached to it – some string and sealing wax. The passenger's coat was pulled and he sat down, slightly moving his handkerchief. Thomas believed he recognised him. He appeared very similar to a former GWR guard named Poole, who had been dismissed the previous May after the robbery of some sovereigns in transit from London to Truro. Thomas gave this information to Barlow, the director, who had come up. Barlow spoke to Poole three times and received no reply. He shook his hat, lifted it and said, 'Ah! Poole, you are very sleepy tonight.'

All idea of further search was abandoned. Poole's accomplice was taken into Mr Andrew's compartment and with him was Williams, a Bridgwater policeman. Andrews himself was transferred to the same compartment as Poole, together with Reinhart and Gibbons. The latter was the superintendent of the Plymouth police, who very conveniently was travelling on the train.

The train left Bridgwater for Exeter. Barlow noticed Poole's hand moving under his cloak. He seized it and found a pocket book. Inside were a pair of false moustachios and a length of string. Even if the crepe masks were not evidence, false moustachios were. Barlow put his hand into Poole's cloak pocket and found a piece of sealing wax. Poole disclaimed any knowledge of his companion, stating that he had travelled alone from Exeter to Bristol early the previous morning. On arrival at Exeter St David's, the prisoners were taken to a waiting room to be searched.

Back in the first class coach, Guard Thomas took a lantern and lifted up a cloth which had fallen from the seat on which Poole had been sitting. Not altogether surprised, he took out a bundle of stolen letters. Quite obviously, no one but Poole could have put them there.

Letters were brought to the waiting room and placed on the table. Poole said, 'Why could not these things have been found at Bridgwater when the carriage was searched?' to which he received the reply that no regular search was made.

The prisoners were handed over to the Exeter police, and later that morning Henry Poole, and a man who refused to give his name, were charged at the Guildhall with opening mailbags and stealing the contents. As the mail guard had to go to Plymouth, the magistrates remanded the prisoners until Saturday 6 January.

The trial of the ex-Guard Henry Poole and Edward Nightingale, a horse dealer of Hoxton, took place on 23 March 1849. The jury returned a verdict of guilty against both prisoners, who were sentenced to be transported for fifteen years.

A strange coincidence came to light. Twenty-two years previously, Nightingale's father had been prosecuted, but acquitted, of robbing bags from the Dover mail.

# Chapter Twenty-One

# Subsequent History of
# the Travelling Post Office

Mail pick-up apparatus was installed at Yatton in 1859 and Weston Junction in September 1869. As Plymouth was increasingly used by mail boats, in 1869 the Plymouth & Bristol TPO (Foreign Mails) was introduced, and by 1915 slipped a mail van at Bedminster for Bristol.

At the end of the nineteenth century, the Post Office was very efficient. Letters posted in Bridgwater at 1.30 p.m. were delivered in London the same evening at 9.15 p.m.

In 1906, the first non-stop runs were made from Plymouth to Paddington, with ocean mails, and this involved slipping two vans containing north country mails at Bedminster, the locomotive and remaining two vans using the Bristol Avoiding line. The train's usual formation was three large elliptical-roofed stowage vans with a TPO sorting van at the rear. As sorting had been completed by the time Bedminster was reached, the TPO van was one of the two slipped.

From the early 1990s, the 00.55 Bristol Parkway to Penzance TPO called at Yatton, as it was sited conveniently for Lulsgate Airport. Mail carriage by rail ceased in May 2000.

## BEDMINSTER
### Slipping Vehicles, not conveying Passengers, from Ocean Specials running from Plymouth to London.

1. The Bristol portion of fast Ocean specials running from Plymouth to London via Bristol Relief Line and Box in accordance with Tables G and H of Mr. Morris' Notice, No. 83 (9th issue), dated November, 1909, will be slipped at Bedminster in accordance with the following regulations :—

2. A telegram will be despatched to Inspector Burt and Mr. Phillips, Bristol, as well as to the Station Master at Bedminster, giving the time of departure from Mill Bay Crossing of the Ocean train, which will have on it a portion to be slipped at Bedminster, and this message must state what vehicles the slip portion consists of.

3. On receipt of this message arrangements must be made at once for an Engine to be sent from Bristol to Bedminster to arrive there half-an-hour before the Ocean special is expected, calculated on the scheduled running times shewn in Notice No. 83.

4. This Engine will stand in readiness in the Siding on the down side at Bedminster, and Inspector Burt must arrange for a competent man to be at Bedminster to couple it on to the slip portion when it arrives at the platform.

5. The slip portion must then be taken into Bristol to be discharged there, and the Slip Guard must be returned to Plymouth by the first available Train.

6. The standard instructions for working slip coaches shewn in the General Appendix to the Rule Book must be strictly observed.

7. The place for slipping will be a point 730 yards on the West side of Bedminster Signal Box, just before reaching the Under Bridge on the West side of Bedminster Station, and about half way between the Bedminster Up Distant Signal (which is fixed on the Portishead Junction up starter, and is 1632 yards from Bedminster Signal Box) and Bedminster Up Home Signal. The slip portion must be brought to a stand at the Bristol end of Bedminster platform.

8. The Bedminster Station Master or person in charge must see that the Signalman at Bedminster, Portishead Junction, Pylle Hill Junction, and Pylle Hill are advised immediately information is received that an Ocean Special with a slip portion is coming forward, and the Signalmen must be prepared to have the line clear, so that no check will take place to the Train.

9. After having slipped the Bristol portion, the main Train will run to London via the Relief Line and Box, as shewn in Notice No. 83.

*See page 173 for further instructions re slipping vehicles with new slipping apparatus.*

Instructions for slipping mail vans at Bedminster, given in the *Appendix to the Service Time Table, March 1910.*

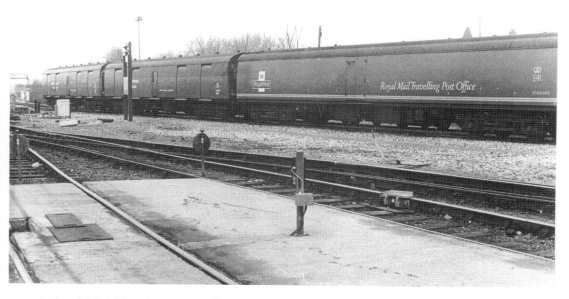

A Royal Mail Travelling Post Office coach at Barton Hill Depot, Bristol, 22 January 1996. (*Author*)

# Appendix

# Traffic Dealt with 1903–33

| STATION. | YEAR. | STAFF | | TOTAL RECEIPTS. | PASSENGER TRAIN TRAFFIC. | | | | Receipts. | |
|---|---|---|---|---|---|---|---|---|---|---|
| | | Supervisory and Wages (all Grades). | Paybill Expenses. | | Tickets issued. | Season Tickets. | Passengers (including Season Tickets, etc.) | Parcels. | Miscellaneous | |
| | | No. | £ | £ | No. | No. | £ | £ | £ | |
| Bristol (Temple Meads) Passenger. (‡) | 1903 | 434 | 27,234 | 242,705 | 1,047,925 | * | 175,873 | 38,370 | 28,462 | |
| | 1913 | 318 | 28,085 | 260,174 | 1,119,898 | * | 201,595 | 38,457 | 20,122 | |
| | 1923 | 389 | 60,638 | 484,511 | 1,215,840 | 7,425 | 373,329 | 84,676 | 26,506 | |
| | 1924 | 348 | 59,891 | 497,591 | 1,211,076 | 7,536 | 390,244 | 79,872 | 27,475 | |
| | 1925 | 310 | 56,134 | 479,784 | 1,211,676 | 8,413 | 370,484 | 80,798 | 28,502 | |
| | 1926 | 300 | 52,506 | 446,908 | 1,087,574 | 8,763 | 333,405 | 83,363 | 30,140 | |
| | 1927 | 333 | 61,965 | 451,018 | 1,106,613 | 9,505 | 338,496 | 85,054 | 27,468 | |
| | 1928 | †330 | †61,789 | 451,225 | 1,100,184 | 9,547 | 334,837 | 87,208 | 29,180 | |
| | 1929 | †337 | †61,745 | 442,121 | 1,071,039 | 7,762 | 323,819 | 90;484 | 27,818 | |
| | 1930 | †339 | †64,164 | 431,277 | 1,022,635 | 7,979 | 315,821 | 89,404 | 26,052 | |
| | 1931 | †338 | †61,831 | 403,911 | 916,558 | 6,774 | 293,811 | 85,987 | 24,113 | |
| | 1932 | †340 | †60,410 | 381,344 | 844,269 | 5,934 | 277,067 | 79,418 | 24,859 | |
| | 1933 | †336 | †61,937 | 387,871 | 856,778 | 6,076 | 270,882 | 91,026 | 25,063 | |
| Bristol (Temple Meads) Goods. | 1903 | * | * | 688,163 | | | | | | |
| | 1913 | 969 | 70,877 | 736,257 | | | | | | |
| | 1923 | 948 | 161,672 | 1,154,785 | | | | | | |
| | 1924 | 990 | 165,950 | 1,102,667 | | | | | | |
| | 1925 | 990 | 172,190 | 1,129,094 | | | | | | |
| | 1926 | 996 | 166,798 | 1,101,749 | | | | | | |
| | 1927 | 994 | 177,904 | 1,163,844 | | | | | | |
| | 1928 | 994 | 182,616 | 1,153,540 | | | | | | |
| | 1929 | 994 | 183,674 | 1,127,758 | | | | | | |
| | 1930 | 1,035 | 186,109 | 1,060,706 | | | | | | |
| | 1931 | 1,037 | 187,270 | 1,002,945 | | | | | | |
| | 1932 | 1,097 | 187,566 | 890,493 | | | | | | |
| | 1933 | 1,065 | 183,935 | 890,691 | | | | | | |
| Bedminster .. | 1903 | 21 | 1,725 | 4,636 | 56,089 | * | 3,894 | 455 | 287 | |
| | 1913 | 10 | 831 | 5,904 | 70,928 | * | 5,783 | 109 | 12 | |
| | 1923 | 11 | 2,258 | 12,106 | 139,470 | 120 | 11,750 | 271 | 85 | |
| | 1924 | 11 | 2,018 | 13,829 | 141,132 | 110 | 13,529 | 249 | 51 | |
| | 1925 | 11 | 2,067 | 15,236 | 157,789 | 169 | 14,920 | 242 | 74 | |
| | 1926 | 11 | 1,887 | 12,660 | 133,024 | 151 | 12,387 | 241 | 32 | |
| | 1927 | 13 | 2,167 | 13,399 | 131,946 | 140 | 13,056 | 254 | 89 | |
| | 1928 | 13 | 2,366 | 12,257 | 130,174 | 128 | 11,944 | 262 | 51 | |
| | 1929 | 13 | 2,336 | 11,487 | 125,174 | 91 | 11,145 | 253 | 89 | |
| | 1930 | 13 | 2,426 | 9,263 | 108,002 | 57 | 9,029 | 108 | 36 | |
| | 1931 | 13 | 2,319 | 8,210 | 94,548 | 66 | 8,004 | 188 | 18 | |
| | 1932 | 13 | 2,318 | 7,236 | 90,153 | 66 | 7,079 | 140 | 17 | |
| | 1933 | 13 | 2,416 | 8,207 | 94,878 | 100 | 8,068 | 125 | 14 | |
| Parson Street Platform. | 1927 | | | Opened 666 | August, 5,966 | 1927. 3 | 632 | 33 | 1 | |
| | 1928 | Incl uded | | 4,763 | 51,981 | 11 | 4,653 | 105 | 5 | |
| | 1929 | wi th | | 5,868 | 66,373 | 21 | 5,778 | 88 | 2 | |
| | 1930 | Bedmi nster. | | 5,336 | 60,648 | 24 | 5,230 | 93 | 13 | |
| | 1931 | | | 4,741 | 51,856 | 18 | 4,622 | 106 | 13 | |
| | 1932 | | | 4,917 | 54,500 | 30 | 4,839 | 75 | 3 | |
| | 1933 | | | 5,871 | 67,293 | 16 | 5,775 | 92 | 4 | |

* Not available.  † Including Telegraph Staff and Expenses from 1928.  ‡ G.W. and L.M. & S. J
but only G.W. staff & traffic are given.  § Includes Staff & Paybills for Stapleton Road prior to
‖ Staff and Paybills for Stapleton Road and Lawrence Hill included with Temple Meads aft

# STATIONS.

**BRISTOL DIVISION.**
(Steventon to Highbridge.)

| | Forwarded. | | Received. | | | Coal and Coke "Not Charged" (Forwarded and Received). | Total Goods Tonnage. | Total Receipts (excluding "Not Charged" Coal and Coke). | Livestock (Forwarded and Received). | Total Carted Tonnage (included in Total Goods Tonnage). |
|---|---|---|---|---|---|---|---|---|---|---|
| "Charged." | Other Minerals. | General Merchandise. | Coal and Coke "Charged." | Other Minerals. | General Merchandise. | | | | | |
| s. | Tons. | Tons. | Tons. | Tons. | Tons. | Tons. | Tons. | £ | Wagons. | Tons. |
| ,649 | 207,639 | 875,275 | 111,716 | 241,364 | 221,585 | 72,811 | 1,776,039 | 688,163 | 14,170 | 371,873 |
| ,904 | 70,956 | 893,993 | 81,741 | 36,815 | 375,765 | 90,194 | 1,584,458 | 736,257 | 10,811 | 446,353 |
| ,854 | 41,837 | 654,136 | 74,367 | 57,579 | 411,818 | 144,031 | 1,403,622 | 1,154,785 | 7,200 | 398,217 |
| ,462 | 45,473 | 667,360 | 92,716 | 73,762 | 407,809 | 164,074 | 1,455,656 | 1,102,667 | 7,701 | 417,218 |
| ,013 | 38,986 | 683,502 | 82,257 | 77,017 | 427,347 | 184,493 | 1,498,615 | 1,129,094 | 5,508 | 426,914 |
| ,514 | 43,473 | 654,899 | 58,159 | 78,232 | 415,191 | 159,834 | 1,436,302 | 1,101,749 | 4,746 | 403,452 |
| ,487 | 51,837 | 659,535 | 100,244 | 68,219 | 419,972 | 185,312 | 1,492,606 | 1,163,844 | 3,600 | 415,582 |
| ,945 | 48,281 | 656,679 | 88,801 | 61,751 | 418,535 | 178,332 | 1,459,324 | 1,153,540 | 3,749 | 453,364 |
| ,726 | 51,430 | 637,117 | 104,205 | 63,944 | 449,377 | 187,173 | 1,498,972 | 1,127,758 | 4,341 | 440,733 |
| ,913 | 40,846 | 579,374 | 100,299 | 71,819 | 454,747 | 176,947 | 1,428,945 | 1,060,706 | 3,761 | 410,087 |
| ,100 | 46,651 | 538,323 | 98,199 | 111,031 | 443,007 | 170,325 | 1,411,636 | 1,002,945 | 3,041 | 387,587 |
| ,484 | 40,279 | 479,208 | 74,128 | 82,282 | 409,270 | 170,986 | 1,259,637 | 890,493 | 2,427 | 369,809 |
| ,070 | 32,486 | 492,524 | 69,159 | 70,120 | 416,414 | 174,421 | 1,259,194 | 890,691 | 2,027 | 406,057 |

No Goods Traffic dealt with.

28

# TRAFFIC DEALT WIT[...]

| STATION. | YEAR. | STAFF. | | TOTAL RECEIPTS. | PASSENGER TRAIN TRAFFIC. | | | | | |
| --- | --- | --- | --- | --- | --- | --- | --- | --- | --- | --- |
| | | Supervisory and Wages (all Grades). | Paybill Expenses. | | Tickets Issued. | Season Tickets. | Receipts. | | | |
| | | | | | | | Passengers (including Season Tickets, etc.) | Parcels. | Miscellaneous. | |
| | | No. | £ | £ | No. | No. | £ | £ | £ | |
| Steventon to Long Ashton Platform. | High | bridge | (contd.) | Opened | July, 1 | 926. | | | | |
| | 1926 | | | 185 | 2,363 | 14 | 164 | 20 | 1 | |
| | 1927 | Incl | uded | 355 | 4,745 | 37 | 303 | 50 | 2 | |
| | 1928 | wi | th | 356 | 5,257 | 34 | 315 | 41 | — | |
| | 1929 | Bri | stol | 328 | 4,834 | 24 | 280 | 48 | — | |
| | 1930 | (T. | M.). | 214 | 4,267 | 3 | 191 | 23 | — | |
| | 1931 | | | 143 | 3,243 | 8 | 143 | — | — | |
| | 1932 | | | 119 | 3,191 | 8 | 119 | — | — | |
| | 1933 | | | 105 | 2,969 | 2 | 105 | — | — | |
| Flax Bourton (†) | 1903 | 8 | 525 | 2,566 | 21,676 | * | 1,351 | 208 | 233 | 1, |
| | 1913 | 8 | 592 | 2,392 | 18,877 | * | 1,124 | 153 | 187 | 1, |
| | 1923 | 6 | 1,103 | 3,264 | 7,129 | 194 | 946 | 172 | 334 | 1, |
| | 1924 | 6 | 1,068 | 3,224 | 6,321 | 188 | 926 | 151 | 478 | 1, |
| | 1925 | 6 | 1,081 | 4,021 | 6,512 | 162 | 872 | 176 | 1,035 | 2, |
| | 1926 | 6 | 1,049 | 3,832 | 6,048 | 147 | 803 | 155 | 888 | 1, |
| | 1927 | 6 | 1,098 | 4,525 | 5,819 | 118 | 676 | 173 | 840 | 1, |
| | 1928 | 6 | 1,072 | 3,651 | 5,388 | 104 | 612 | 167 | 705 | 1, |
| | 1929 | 6 | 1,232 | 4,928 | 4,587 | 81 | 579 | 183 | 297 | 1, |
| | 1930 | 6 | 1,282 | 5,028 | 4,010 | 99 | 517 | 188 | 310 | 1, |
| | 1931 | 6 | 973 | 1,990 | 3,976 | 97 | 409 | 167 | 251 | |
| | 1932 | 5 | 792 | 1,698 | 3,748 | 75 | 407 | 152 | 162 | |
| | 1933 | 5 | 799 | 1,599 | 4,140 | 65 | 412 | 144 | 64 | |
| Nailsea and Backwell. | 1903 | 7 | 462 | 2,895 | 25,020 | * | 1,652 | 123 | 12 | 1, |
| | 1913 | 7 | 519 | 3,716 | 31,358 | * | 2,386 | 160 | 67 | 2, |
| | 1923 | 8 | 1,328 | 7,906 | 27,325 | 1,001 | 3,862 | 430 | 98 | 4, |
| | 1924 | 8 | 1,302 | 7,832 | 26,662 | 881 | 3,887 | 389 | 94 | 4, |
| | 1925 | 8 | 1,320 | 8,033 | 28,431 | 851 | 3,972 | 394 | 84 | 4, |
| | 1926 | 8 | 1,285 | 7,131 | 26,224 | 876 | 3,689 | 394 | 87 | 4, |
| | 1927 | 8 | 1,309 | 7,808 | 27,860 | 854 | 3,826 | 409 | 50 | 4, |
| | 1928 | 8 | 1,302 | 7,117 | 27,324 | 803 | 3,509 | 412 | 32 | 4, |
| | 1929 | 8 | 1,255 | 7,524 | 23,942 | 830 | 3,256 | 413 | 28 | 3, |
| | 1930 | 8 | 1,286 | 6,040 | 18,951 | 650 | 2,800 | 400 | 38 | 3, |
| | 1931 | 8 | 1,217 | 5,878 | 19,088 | 725 | 2,759 | 279 | 41 | 3, |
| | 1932 | 8 | 1,224 | 5,373 | 18,303 | 727 | 2,585 | 230 | 30 | 2, |
| | 1933 | 8 | 1,225 | 5,730 | 21,249 | 695 | 2,604 | 222 | 29 | 2, |
| Yatton .. .. | 1903 | 33 | 2,079 | 8,103 | 55,058 | * | 3,833 | 322 | 839 | 4, |
| | 1913 | 37 | 2,641 | 8,618 | 57,177 | * | 4,339 | 257 | 1,083 | 5, |
| | 1923 | 43 | 6,260 | 12,785 | 59,898 | 787 | 5,913 | 324 | 1,610 | 7, |
| | 1924 | 43 | 6,457 | 13,614 | 64,146 | 775 | 6,434 | 321 | 1,586 | 8, |
| | 1925 | 44 | 6,839 | 14,733 | 66,222 | 792 | 6,240 | 337 | 1,877 | 8, |
| | 1926 | 41 | 6,426 | 13,119 | 56,350 | 657 | 5,722 | 339 | 1,407 | 7, |
| | 1927 | 40 | 6,575 | 14,097 | 64,371 | 744 | 6,049 | 358 | 1,350 | 7, |
| | 1928 | 40 | 6,467 | 13,046 | 68,164 | 747 | 5,964 | 327 | 1,138 | 7, |
| | 1929 | 40 | 6,432 | 12,592 | 71,427 | 698 | 5,932 | 318 | 862 | 7, |
| | 1930 | 41 | 6,868 | 14,883 | 67,398 | 763 | 5,830 | 316 | 249 | 6, |
| | 1931 | 41 | 6,366 | 12,933 | 64,048 | 691 | 5,301 | 334 | 747 | 6, |
| | 1932 | 39 | 6,175 | 11,352 | 61,311 | 626 | 4,808 | 374 | 640 | 5, |
| | 1933 | 37 | 5,880 | 10,967 | 62,245 | 606 | 4,786 | 335 | 330 | 5, |
| Puxton and Worle. | 1903 | 7 | 480 | 3,302 | 8,617 | * | 436 | 90 | 897 | 1, |
| | 1913 | 12 | 981 | 5,186 | 7,390 | * | 378 | 147 | 2,493 | 3, |
| | 1923 | 10 | 1,855 | 7,620 | 4,890 | 60 | 437 | 294 | 4,640 | 5, |
| | 1924 | 10 | 1,717 | 7,924 | 5,063 | 35 | 383 | 341 | 4,717 | 5, |
| | 1925 | 10 | 1,794 | 7,893 | 5,712 | 66 | 369 | 379 | 4,730 | 5, |
| | 1926 | 10 | 1,725 | 7,187 | 4,819 | 42 | 340 | 349 | 4,042 | 4, |
| | 1927 | 10 | 1,796 | 7,986 | 5,053 | 67 | 412 | 394 | 4,572 | 5, |
| | 1928 | 10 | 1,827 | 7,537 | 5,022 | 86 | 407 | 431 | 4,574 | 5, |
| | 1929 | 13 | 2,182 | 9,032 | 6,825 | 68 | 470 | 523 | 5,237 | 6, |
| | 1930 | 14 | 2,426 | 9,517 | 6,635 | 65 | 435 | 605 | 5,792 | 6, |
| | 1931 | 14 | 2,245 | 10,338 | 5,598 | 54 | 399 | 668 | 5,773 | 6, |
| | 1932 | 14 | 2,369 | 10,823 | 5,735 | 52 | 385 | 605 | 5,615 | 6, |
| | 1933 | 14 | 2,236 | 8,300 | 4,509 | 51 | 366 | 629 | 4,123 | 5, |
| Weston Milton Ht. (‡) | 1933 | — | — | Opened 51 | July, 19 432 | 33. — | 51 | — | — | |

* Not available. † Controlled by Nailsea and Backwell from February, 1932.
‡ Controlled by Weston-super-Mare.

29

# STATIONS.

| | | GOODS TRAIN TRAFFIC. | | | | | | | | |
| Forwarded. | | | Received. | | | Coal and Coke "Not Charged" (Forwarded and Received). | Total Goods Tonnage. | Total Receipts (excluding "Not Charged" Coal and Coke). | Livestock (Forwarded and Received). | Total Carted Tonnage (included in Total Goods Tonnage). |
| Coal and Coke "Charged." | Other Minerals. | General Merchandise. | Coal and Coke "Charged." | Other Minerals. | General Merchandise. | | | | | |
| Tons. | Tons. | Tons. | Tons. | Tons. | Tons. | Tons. | Tons. | £ | Wagons. | Tons. |
| --- | --- | --- | --- | --- | --- | --- | --- | --- | --- | --- |
| | | | No Goods Traffic dealt with. | | | | | | | |
| 8 | 14 | 82 | 1,347 | 492 | 432 | 1,193 | 3,560 | 774 | 3 | 268 |
| | — | 145 | 1,136 | 1,077 | 761 | 1,285 | 4,410 | 928 | 45 | 255 |
| | — | 174 | 881 | 136 | 1,454 | 1,299 | 3,044 | 1,812 | 39 | 345 |
| 11 | 63 | 205 | 1,123 | 290 | 1,437 | 1,690 | 4,819 | 1,669 | 112 | 272 |
| 15 | 903 | 248 | 902 | 170 | 1,718 | 1,917 | 5,873 | 1,938 | 58 | 296 |
| 23 | 20 | 150 | 550 | 1,006 | 1,469 | 1,502 | 4,720 | 1,986 | 110 | 293 |
| 10 | — | 364 | 1,114 | 2,705 | 1,670 | 2,556 | 8,419 | 2,836 | 110 | 376 |
| | | 390 | 543 | 219 | 2,074 | 2,590 | 5,816 | 2,167 | 101 | 254 |
| | 40 | 153 | 551 | 212 | 3,358 | 2,303 | 6,617 | 3,869 | 87 | 251 |
| | 8 | 153 | 480 | 199 | 3,094 | 2,534 | 7,068 | 4,018 | 116 | 209 |
| | 4 | 88 | 332 | 231 | 856 | 2,783 | 4,294 | 1,163 | 119 | 146 |
| | 12 | 147 | 205 | 132 | 735 | 2,512 | 3,743 | 977 | 64 | 120 |
| 27 | 21 | 150 | 203 | 206 | 391 | 2,274 | 3,277 | 979 | 29 | 195 |
| | 836 | 163 | 4,265 | 736 | 429 | 634 | 7,063 | 1,108 | — | 265 |
| | 212 | 235 | 3,469 | 363 | 1,143 | 1,397 | 6,819 | 1,103 | — | 478 |
| | 426 | 632 | 5,029 | 855 | 1,286 | 1,723 | 9,951 | 3,516 | — | 908 |
| 16 | 839 | 522 | 2,795 | 622 | 1,536 | 2,372 | 8,702 | 3,462 | — | 819 |
| 7 | 1,622 | 467 | 1,803 | 742 | 1,722 | 2,735 | 9,098 | 3,583 | — | 771 |
| 51 | 974 | 500 | 899 | 1,444 | 1,136 | 2,855 | 7,859 | 2,961 | — | 819 |
| 33 | 720 | 624 | 1,816 | 1,018 | 1,269 | 3,360 | 8,849 | 3,523 | — | 1,014 |
| | 365 | 470 | 2,779 | 187 | 1,537 | 2,856 | 8,194 | 3,074 | — | 798 |
| 9 | 467 | 575 | 4,348 | 840 | 1,643 | 3,415 | 11,297 | 3,827 | — | 863 |
| 9 | 214 | 533 | 2,750 | 187 | 1,003 | 3,452 | 3,148 | 2,802 | — | 872 |
| 9 | 76 | 492 | 3,864 | 228 | 1,081 | 3,205 | 8,545 | 2,799 | — | 938 |
| | 78 | 461 | 3,409 | 162 | 858 | 3,563 | 8,531 | 2,528 | — | 843 |
| 14 | 170 | 727 | 3,383 | 88 | 792 | 3,130 | 8,304 | 2,875 | — | 1,173 |
| 27 | 24 | 1,468 | 2,367 | 1,501 | 1,781 | 1,494 | 8,662 | 3,109 | 246 | 1,358 |
| 35 | 146 | 1,611 | 2,353 | 1,034 | 2,125 | 1,360 | 8,654 | 2,939 | 220 | 1,256 |
| 40 | 100 | 882 | 2,784 | 643 | 2,416 | 2,276 | 9,241 | 4,938 | 313 | 1,188 |
| 96 | 103 | 783 | 2,573 | 434 | 2,956 | 2,708 | 9,753 | 5,273 | 234 | 1,320 |
| 53 | 196 | 1,418 | 2,317 | 623 | 3,049 | 2,889 | 10,545 | 6,279 | 250 | 1,662 |
| 30 | 175 | 2,049 | 1,830 | 453 | 2,341 | 2,048 | 8,926 | 5,651 | 250 | 1,393 |
| 80 | 105 | 1,836 | 2,391 | 280 | 3,019 | 3,241 | 10,952 | 6,340 | 217 | 1,654 |
| 89 | 269 | 946 | 1,343 | 402 | 3,444 | 3,051 | 9,544 | 5,617 | 205 | 1,347 |
| 61 | 163 | 1,204 | 1,412 | 641 | 3,674 | 3,133 | 10,288 | 5,480 | 220 | 1,473 |
| 19 | 145 | 894 | 1,329 | 522 | 6,810 | 3,096 | 12,815 | 8,488 | 275 | 1,519 |
| 18 | 121 | 852 | 1,416 | 545 | 4,657 | 3,210 | 10,819 | 6,551 | 201 | 1,519 |
| 11 | 50 | 613 | 1,445 | 727 | 4,304 | 3,144 | 10,294 | 5,530 | 152 | 1,379 |
| | 59 | 751 | 1,473 | 224 | 4,156 | 3,096 | 9,759 | 5,516 | 106 | 1,404 |
| 16 | 601 | 728 | 1,180 | 901 | 1,379 | 1,601 | 6,397 | 1,879 | 258 | 831 |
| | 157 | 1,352 | 526 | 3,404 | 2,442 | 1,610 | 9,491 | 2,168 | 193 | 592 |
| | | 624 | 136 | 161 | 2,752 | 1,226 | 4,899 | 2,249 | 96 | 522 |
| 17 | — | 507 | 190 | 282 | 3,166 | 1,532 | 5,694 | 2,483 | 70 | 539 |
| | — | 276 | 169 | 1,025 | 3,099 | 1,437 | 6,006 | 2,415 | 99 | 503 |
| 35 | — | 508 | 103 | 2,304 | 2,330 | 1,627 | 6,907 | 2,456 | 115 | 376 |
| 18 | 667 | 430 | 584 | 230 | 1,750 | 2,713 | 6,392 | 2,608 | 83 | 518 |
| 30 | 206 | 452 | 400 | 206 | 1,219 | 3,725 | 6,238 | 2,125 | 129 | 414 |
| 77 | 539 | 528 | 263 | 351 | 1,898 | 4,302 | 7,958 | 2,802 | 151 | 607 |
| 10 | 63 | 590 | 286 | 243 | 1,323 | 4,471 | 6,986 | 2,685 | 171 | 675 |
| 32 | 298 | 713 | 476 | 948 | 1,754 | 5,069 | 9,290 | 3,498 | 78 | 725 |
| 9 | 40 | 636 | 403 | 2,556 | 1,848 | 5,408 | 10,900 | 4,218 | 45 | 804 |
| 8 | 18 | 891 | 217 | 78 | 1,230 | 5,492 | 7,934 | 3,182 | 65 | 822 |

30

# TRAFFIC DEALT WI

| STATION. | YEAR. | STAFF. | | TOTAL RECEIPTS. | PASSENGER TRAIN TRAFFIC. | | | | |
|---|---|---|---|---|---|---|---|---|---|
| | | Supervisory and Wages (all Grades). | Paybill Expenses. | | Tickets Issued. | Season Tickets. | Passengers (including Season Tickets, etc.) | Parcels. | Miscellaneous |
| | | No. | £ | £ | No. | No. | £ | £ | £ |
| Steventon to Weston-super-Mare. Passenger. | High bridge (contd.). | | | | | | | | |
| | 1903 | 55 | 3,049 | 42,313 | 210,712 | * | 33,864 | 6,728 | 1,721 |
| | 1913 | 50 | 4,416 | 52,310 | 257,564 | * | 43,571 | 6,595 | 2,144 |
| | 1923 | 58 | 10,502 | 89,026 | 284,509 | 4,414 | 81,457 | 3,679 | 3,890 |
| | 1924 | 56 | 10,520 | 90,370 | 281'420 | 4,427 | 83,107 | 3,548 | 3,715 |
| | 1925 | 56 | 10,801 | 95,563 | 291,389 | 4,701 | 83,885 | 7,075 | 4,603 |
| | 1926 | 56 | 9,849 | 90,010 | 257,999 | 4,379 | 78,883 | 6,790 | 4,337 |
| | 1927 | 55 | 10,528 | 91,778 | 277,889 | 4,363 | 79,330 | 8,368 | 4,080 |
| | 1928 | 56 | 10,752 | 87,051 | 271,759 | 3,934 | 75,437 | 8,263 | 3,351 |
| | 1929 | 56 | 10,659 | 80,359 | 249,269 | 4,249 | 69,247 | 8,178 | 2,934 |
| | 1930 | 56 | 10,641 | 75,147 | 220,570 | 4,251 | 64,559 | 7,924 | 2,664 |
| | 1931 | 56 | 10,241 | 68,784 | 196,090 | 4,006 | 58,576 | 7,789 | 2,419 |
| | 1932 | 56 | 10,038 | 64,823 | 183,364 | 3,662 | 54,557 | 7,982 | 2,334 |
| | 1933 | 56 | 10,128 | 62,877 | 173,423 | 3,577 | 52,936 | 7,823 | 2,118 |
| Weston-super-Mare Goods. | 1903 | * | * | 26,388 | | | | | |
| | 1913 | 28 | 2,142 | 33,340 | | | | | |
| | 1923 | 28 | 4,877 | 56,368 | | | | | |
| | 1924 | 28 | 4,781 | 55,615 | | | | | |
| | 1925 | 28 | 5,426 | 56,729 | | | | | |
| | 1926 | 29 | 4,709 | 53,950 | | | | | |
| | 1927 | 28 | 4,415 | 58,527 | | | | | |
| | 1928 | 29 | 4,568 | 52,757 | | | | | |
| | 1929 | 29 | 4,508 | 54,695 | | | | | |
| | 1930 | 29 | 4,641 | 51,884 | | | | | |
| | 1931 | 28 | 4,562 | 49,782 | | | | | |
| | 1932 | 27 | 4,214 | 46,480 | | | | | |
| | 1933 | 26 | 4,342 | 48,263 | | | | | |
| Bleadon and Uphill. (‡) | 1903 | 2 | 128 | 691 | 9,157 | * | 417 | 102 | 172 |
| | 1913 | 2 | 151 | 1,133 | 12,482 | * | 583 | 106 | 444 |
| | 1923 | 6 | 1,058 | 1,285 | 6,113 | 45 | 666 | 99 | 520 |
| | 1924 | 6 | 1,047 | 1,026 | 5,696 | 15 | 638 | 81 | 307 |
| | 1925 | 6 | 966 | 659 | 5,530 | 2 | 399 | 78 | 182 |
| | 1926 | 6 | 797 | 719 | 4,531 | 14 | 40? | 82 | 237 |
| | 1927 | 5 | 903 | 709 | 3,902 | 16 | 339 | 76 | 294 |
| | 1928 | 5 | 907 | 648 | 3,686 | 5 | 350 | 72 | 226 |
| | 1929 | 5 | 900 | 498 | 2,551 | 15 | 234 | 67 | 197 |
| | 1930 | 5 | 888 | 630 | 2,522 | 20 | 405 | 77 | 148 |
| | 1931 | 4 | 578 | 467 | 1,429 | 28 | 388 | 64 | 15 |
| | 1932 | 4 | 591 | 426 | 1,504 | 14 | 365 | 48 | 13 |
| | 1933 | 5 | 662 | 508 | 1,726 | 31 | 447 | 51 | 10 |
| Brean Road Platform | | | | Opened | June, 1929. | | Included with | and | Bleadon Uphill. |
| Brent Knoll (§) | 1903 | 7 | 385 | 4,795 | 12,352 | * | 812 | 158 | 1,653 |
| | 1913 | 8 | 443 | 6,073 | 14,628 | * | 1,271 | 124 | 3,122 |
| | 1923 | 9 | 1,448 | 12,641 | 14,839 | 110 | 1,938 | 393 | 7,642 |
| | 1924 | 9 | 1,396 | 13,297 | 17,217 | 114 | 2,067 | 299 | 8,578 |
| | 1925 | 9 | 1,420 | 13,405 | 19,425 | 152 | 2,232 | 172 | 8,192 |
| | 1926 | 9 | 1,283 | 10,217 | 18,172 | 93 | 1,985 | 157 | 5,737 |
| | 1927 | 9 | 1,307 | 11,850 | 19,687 | 78 | 2,152 | 138 | 7,012 |
| | 1928 | 8 | 1,273 | 10,847 | 16,891 | 127 | 1,988 | 154 | 6,347 |
| | 1929 | 8 | 1,266 | 11,065 | 12,327 | 296 | 1,740 | 304 | 6,681 |
| | 1930 | 8 | 1,219 | 9,231 | 8,066 | 159 | 1,318 | 362 | 5,710 |
| | 1931 | 9 | 1,275 | 5,293 | 5,545 | 140 | 1,129 | 367 | 2,810 |
| | 1932 | 8 | 1,229 | 5,349 | 4,801 | 112 | 984 | 383 | 2,978 |
| | 1933 | 6 | 670 | 4,022 | 5,380 | 113 | 986 | 314 | 1,787 |
| Highbridge.. (†) | 1903 | 23 | 1,411 | 15,801 | 48,951 | * | 5,000 | 1,229 | 1,547 |
| | 1913 | 23 | 1,967 | 19,872 | 54,983 | * | 6,326 | 1,400 | 1,532 |
| | 1923 | 34 | 5,141 | 35,616 | 58,000 | 177 | 8,840 | 5,253 | 3,440 |
| | 1924 | 33 | 5,273 | 34,239 | 59,299 | 224 | 9,718 | 4,748 | 3,820 |
| | 1925 | 32 | 5,254 | 33,197 | 58,352 | 286 | 9,521 | 4,023 | 4,164 |
| | 1926 | 32 | 4,978 | 33,319 | 53,057 | 315 | 9,099 | 3,422 | 5,274 |
| | 1927 | 33 | 5,297 | 35,869 | 54,016 | 307 | 9,428 | 3,633 | 6,556 |
| | 1928 | 33 | 5,333 | 32,059 | 55,036 | 381 | 9,038 | 3,042 | 5,787 |
| | 1929 | 33 | 5,201 | 31,832 | 50,168 | 626 | 8,848 | 2,793 | 5,903 |
| | 1930 | 32 | 5,275 | 27,678 | 39,834 | 596 | 8,033 | 2,639 | 4,085 |
| | 1931 | 32 | 5,073 | 25,644 | 33,629 | 521 | 7,363 | 2,329 | 4,098 |
| | 1932 | 31 | 4,878 | 22,118 | 34,082 | 542 | 7,148 | 1,969 | 2,692 |
| | 1933 | 20 | 4,904 | 21,044 | 30,143 | 496 | 6,026 | 2,130 | 2,711 |

* Not available.    † Includes Burnham R.O. from 1927.    § Controlled by Highbridge February, 1933.    ‡ Controlled by Weston-super-Mare from January, 1931.

31

STATIONS.

| | Forwarded. | | Received. | | | Coal and Coke "Not Charged" (Forwarded and Received). | Total Goods Tonnage. | Total Receipts (excluding "Not Charged" Coal and Coke). | Livestock (Forwarded and Received). | Total Carted Tonnage (Included in Total Goods Tonnage). |
|---|---|---|---|---|---|---|---|---|---|---|
| | Other Minerals. | General Merchandise. | Coal and Coke "Charged." | Other Minerals. | General Merchandise. | | | | | |
| | Tons. | Tons. | Tons. | Tons. | Tons. | Tons. | Tons. | £ | Wagons. | Tons. |
| | 5,411 | 5,214 | 6,679 | 10,141 | 20,908 | 30,009 | 78,832 | 26,388 | 459 | 14,553 |
| | 14,047 | 6,809 | 4,241 | 8,962 | 25,654 | 34,354 | 94,573 | 33,340 | 394 | 17,703 |
| | 12,372 | 4,465 | 26,521 | 4,993 | 23,732 | 30,520 | 102,696 | 56,368 | 423 | 12,889 |
| | 14,302 | 5,290 | 26,261 | 7,213 | 25,261 | 29,425 | 108,162 | 55,615 | 350 | 12,510 |
| | 14,004 | 4,087 | 21,985 | 4,938 | 26,669 | 32,332 | 105,087 | 56,729 | 428 | 13,621 |
| | 13,780 | 5,048 | 18,944 | 5,019 | 25,986 | 21,700 | 91,234 | 53,950 | 418 | 12,550 |
| | 11,612 | 5,888 | 22,624 | 4,766 | 27,003 | 36,633 | 108,931 | 58,527 | 411 | 13,371 |
| | 7,917 | 6,213 | 19,485 | 4,434 | 25,950 | 33,937 | 98,384 | 52,757 | 382 | 13,024 |
| | 12,636 | 7,222 | 22,532 | 3,482 | 25,497 | 34,432 | 108,072 | 54,695 | 414 | 12,985 |
| | 3,969 | 6,422 | 20,400 | 2,898 | 24,917 | 35,174 | 101,608 | 51,884 | 357 | 12,393 |
| | 7,450 | 5,803 | 19,412 | 3,343 | 26,182 | 38,740 | 104,185 | 49,782 | 298 | 11,807 |
| | 6,603 | 5,309 | 21,840 | 2,742 | 23,538 | 30,298 | 92,508 | 46,480 | 241 | 11,545 |
| | 6,147 | 6,364 | 27,043 | 2,784 | 24,957 | 25,730 | 95,364 | 48,263 | 199 | 11,892 |
| | | | No Goods Traffic dealt with. | | | | | | | |
| 7 | 5 | 328 | 285 | 781 | 2,076 | 1,075 | 4,557 | 2,172 | 923 | 354 |
| 4 | — | 235 | 462 | 308 | 2,096 | 929 | 4,034 | 1,556 | 652 | 299 |
| 9 | — | 168 | 440 | 230 | 3,221 | 1,760 | 5,819 | 2,668 | 316 | 400 |
| | — | 89 | 450 | 536 | 3,096 | 1,877 | 6,957 | 2,353 | 293 | 416 |
| | | 189 | 243 | 718 | 3,534 | 2,047 | 6,731 | 2,809 | 372 | 441 |
| 8 | 20 | 53 | 238 | 480 | 3,200 | 1,074 | 5,098 | 2,338 | 374 | 297 |
| 5 | 5 | 176 | 380 | 349 | 3,110 | 2,154 | 6,218 | 2,548 | 260 | 468 |
| | — | 136 | 359 | 212 | 3,498 | 1,841 | 6,046 | 2,358 | 203 | 300 |
| | — | 267 | 210 | 158 | 3,162 | 1,958 | 5,755 | 2,340 | 174 | 489 |
| 5 | 27 | 108 | 187 | 173 | 2,823 | 2,481 | 5,819 | 1,841 | 146 | 293 |
| 4 | — | 72 | 296 | 87 | 1,051 | 3,054 | 4,594 | 987 | 60 | 178 |
| | 7 | 79 | 284 | 68 | 735 | 3,232 | 4,405 | 1,004 | 102 | 294 |
| 8 | | 51 | 245 | 74 | 621 | 2,161 | 3,170 | 935 | 55 | 222 |
| 08 | 3,167 | 3,076 | 1,145 | 683 | 3,620 | 580 | 12,369 | 7,935 | 1,007 | 4,039 |
| 30 | 3,891 | 3,621 | 1,390 | 757 | 3,735 | 946 | 14,470 | 10,614 | 1,576 | 5,499 |
| 38 | 3,650 | 3,272 | 1,464 | 2,572 | 4,836 | 2,680 | 18,112 | 18,083 | 1,226 | 5,531 |
| 17 | 2,379 | 3,129 | 1,669 | 1,624 | 4,537 | 3,631 | 17,386 | 15,953 | 1,266 | 5,541 |
| 20 | 1,850 | 2,741 | 2,146 | 2,354 | 5,271 | 2,508 | 17,190 | 15,489 | 1,200 | 4,811 |
| 42 | 1,322 | 2,729 | 2,121 | 2,335 | 5,010 | 2,489 | 16,418 | 15,524 | 1,333 | 4,717 |
| 24 | 1,033 | 2,647 | 1,891 | 2,255 | 4,620 | 4,389 | 17,259 | 16,252 | 1,333 | 4,218 |
| 66 | 2,756 | 2,112 | 1,603 | 806 | 4,796 | 3,767 | 16,076 | 14,192 | 1,185 | 4,553 |
| 82 | 2,871 | 2,458 | 1,590 | 1,467 | 4,656 | 3,372 | 16,596 | 14,288 | 1,067 | 4,411 |
| 40 | 1,221 | 2,479 | 1,535 | 529 | 3,949 | 3,228 | 12,981 | 12,921 | 991 | 4,292 |
| 24 | 1,176 | 2,455 | 1,976 | 284 | 3,355 | 2,695 | 11,965 | 11,854 | 735 | 3,679 |
| 42 | 842 | 2,119 | 2,488 | 128 | 2,861 | 1,777 | 10,457 | 10,309 | 521 | 4,364 |
| 22 | 1,002 | 2,561 | 3,065 | 57 | 3,240 | 1,560 | 11,607 | 11,077 | 380 | 4,364 |

4

## TRAFFIC DEALT WI

| STATION. | YEAR. | Supervisory and Wages (all Grades). | Paybill Expenses. | TOTAL RECEIPTS. | Tickets Issued. | Season Tickets. | Passengers (including Season Tickets, etc.) | Parcels. | Miscellaneous. |
|---|---|---|---|---|---|---|---|---|---|
| | | No. | £ | £ | No. | No. | £ | £ | £ |
| **Highbridge to Newton Abbot.** | | | | | | | | | |
| Dunball | 1903 | 6 | 351 | 308 | 7,615 | * | 255 | 39 | 14 |
| ( ‡ ) | 1913 | 6 | 348 | 341 | 6,155 | * | 295 | 44 | 2 |
| | 1923 | 6 | 1,069 | 719 | 6,417 | 12 | 508 | 63 | 148 |
| | 1924 | 6 | 964 | 1,337 | 6,306 | 11 | 1,060 | 56 | 221 |
| | 1925 | 6 | 991 | 835 | 5,937 | 3 | 500 | 48 | 287 |
| | 1926 | 5 | 778 | 570 | 4,500 | 6 | 299 | 59 | 212 |
| | 1927 | 5 | 727 | 758 | 5,840 | 11 | 452 | 60 | 246 |
| | 1928 | 5 | 797 | 780 | 6,002 | 15 | 378 | 58 | 344 |
| | 1929 | 4 | 649 | 806 | 5,336 | 40 | 311 | 70 | 425 |
| | 1930 | 4 | 594 | 832 | 3,916 | 38 | 251 | 63 | 518 |
| | 1931 | 4 | 563 | 241 | 2,769 | 17 | 176 | 61 | 4 |
| | 1932 | 4 | 563 | 250 | 2,221 | 31 | 189 | 59 | 2 |
| | 1933 | 4 | 577 | 238 | 2,467 | 22 | 177 | 61 | — |
| **Dunball Wharf** | | | | Included with Bridgwater. | | | | | |
| Bridgwater Passr. | 1903 | * | 1,933 | 21,236 | 114,865 | * | 15,467 | 3,196 | 2,573 |
| | 1913 | 35 | 2,594 | 21,846 | 114,485 | * | 15,613 | 3,137 | 3,096 |
| | 1923 | 47 | 8,157 | 30,623 | 112,499 | 727 | 23,872 | 2,440 | 4,311 |
| | 1924 | 47 | 7,984 | 29,966 | 113,701 | 688 | 23,707 | 2,203 | 4,056 |
| | 1925 | 47 | 8,061 | 32,257 | 114,695 | 902 | 25,264 | 2,385 | 4,608 |
| | 1926 | 45 | 7,221 | 30,796 | 101,025 | 713 | 22,484 | 3,470 | 4,842 |
| | 1927 | 44 | 6,876 | 31,124 | 109,288 | 742 | 23,390 | 3,894 | 3,840 |
| | 1928 | 45 | 7,497 | 32,050 | 120,487 | 777 | 23,437 | 4,112 | 4,501 |
| | 1929 | 45 | 7,315 | 31,711 | 110,269 | 1,201 | 22,508 | 4,029 | 5,174 |
| | 1930 | 44 | 7,441 | 30,131 | 103,732 | 1,418 | 21,388 | 4,126 | 4,617 |
| | 1931 | 42 | 6,935 | 27,458 | 89,767 | 1,456 | 19,383 | 3,909 | 4,166 |
| | 1932 | 34 | 5,485 | 24,820 | 86,831 | 1,150 | 18,074 | 3,605 | 3,141 |
| | 1933 | 34 | 5,230 | 22,472 | 87,000 | 901 | 17,680 | 3,573 | 1,219 |
| Bridgwater Goods | 1903 | * | * | 64,472 | | | | | |
| | 1913 | * | 2,086 | 63,519 | | | | | |
| | 1923 | 50 | 7,631 | 98,072 | | | | | |
| | 1924 | 47 | 7,877 | 99,476 | | | | | |
| | 1925 | 47 | 9,113 | 107,035 | | | | | |
| | 1926 | 43 | 8,390 | 97,202 | | | | | |
| | 1927 | 43 | 8,239 | 105,243 | | | | | |
| | 1928 | 44 | 7,672 | 100,741 | | | | | |
| | 1929 | 45 | 7,699 | 102,793 | | | | | |
| | 1930 | 44 | 8,154 | 101,748 | | | | | |
| | 1931 | 44 | 7,901 | 90,721 | | | | | |
| | 1932 | 41 | 7,478 | 82,364 | | | | | |
| | 1933 | 43 | 7,712 | 81,823 | | | | | |
| Durston | 1903 | 15 | 907 | 4,979 | 14,588 | * | 1,303 | 204 | 215 |
| | 1913 | 15 | 1,090 | 5,488 | 13,918 | * | 1,061 | 153 | 361 |
| | 1923 | 15 | 2,336 | 7,844 | 12,384 | 71 | 1,286 | 232 | 1,851 |
| | 1924 | 15 | 2,201 | 6,225 | 12,174 | 66 | 1,151 | 172 | 941 |
| | 1925 | 15 | 2,251 | 5,723 | 10,972 | 66 | 1,093 | 163 | 462 |
| | 1926 | 15 | 2,157 | 6,008 | 10,563 | 43 | 1,036 | 204 | 905 |
| | 1927 | 15 | 2,072 | 6,887 | 13,214 | 41 | 1,046 | 209 | 874 |
| | 1928 | 15 | 2,087 | 4,469 | 12,767 | 58 | 927 | 231 | 550 |
| | 1929 | 15 | 2,136 | 5,032 | 13,451 | 111 | 958 | 184 | 670 |
| | 1930 | 14 | 2,161 | 6,026 | 14,261 | 206 | 954 | 163 | 568 |
| | 1931 | 14 | 2,008 | 3,032 | 14,747 | 171 | 872 | 157 | 292 |
| | 1932 | †19 | 2,468 | 2,989 | 22,215 | 117 | 1,152 | 167 | 247 |
| | 1933 | 19 | 2,730 | 2,942 | 24,490 | 77 | 1,219 | 150 | 155 |
| Creech St. Michael Halt. | | | | Opened August, 1928. Included with Thornfalcon up to April, 1932, and with Durston from May, 1932. | | | | | |

* Not available.     † Includes Staff transferred from Thornfalcon.     ‡ Controlled by Bri

5

## STATIONS.

| | Goods Train Traffic. | | | | | | | | | |
|---|---|---|---|---|---|---|---|---|---|---|
| | Forwarded. | | Received. | | | Coal and Coke "Not Charged" (Forwarded and Received). | Total Goods Tonnage. | Total Receipts (excluding "Not Charged" Coal and Coke). | Livestock (Forwarded and Received). | Total Carted Tonnage (included in Total Goods Tonnage). |
| | Other Minerals. | General Merchandise. | Coal and Coke "Charged." | Other Minerals. | General Merchandise. | | | | | |
| | Tons. | Tons. | Tons. | Tons. | Tons. | Tons. | Tons. | £ | Wagons. | Tons. |
| | | | | No Goods Traffic dealt with. | | | | | | |
| | 36,609 | 48,584 | 4,914 | 9,044 | 28,607 | 2,897 | 217,827 | 64,472 | 1,905 | 12,090 |
| | 32,112 | 66,872 | 8,262 | 12,618 | 34,789 | 9,186 | 202,891 | 63,519 | 2,032 | 14,999 |
| | 28,264 | 49,509 | 13,959 | 15,484 | 30,009 | 19,398 | 160,802 | 98,072 | 1,660 | 15,895 |
| | 42,300 | 50,380 | 14,741 | 22,655 | 33,239 | 19,814 | 193,280 | 99,476 | 1,672 | 15,513 |
| | 46,237 | 52,702 | 13,574 | 31,329 | 38,646 | 22,692 | 215,045 | 107,065 | 1,696 | 16,235 |
| | 41,888 | 49,849 | 16,097 | 22,031 | 37,791 | 23,723 | 195,707 | 97,202 | 1,687 | 14,583 |
| | 46,908 | 49,857 | 14,382 | 28,020 | 38,467 | 26,842 | 212,248 | 105,243 | 1,804 | 16,416 |
| | 45,794 | 51,271 | 9,201 | 18,022 | 39,556 | 23,630 | 199,070 | 100,741 | 2,016 | 14,674 |
| | 57,109 | 46,009 | 7,891 | 17,855 | 38,306 | 23,219 | 199,461 | 102,793 | 2,082 | 14,176 |
| | 50,466 | 41,668 | 11,139 | 10,935 | 38,589 | 23,248 | 193,221 | 101,748 | 1,997 | 14,178 |
| | 48,375 | 33,452 | 10,143 | 8,010 | 38,177 | 27,490 | 178,046 | 90,721 | 1,705 | 13,486 |
| | 33,032 | 31,520 | 8,522 | 5,790 | 35,775 | 25,185 | 166,857 | 82,364 | 1,302 | 16,365 |
| | 33,302 | 26,475 | 8,961 | 5,105 | 37,536 | 29,874 | 169,064 | 81,823 | 1,198 | 20,013 |
| | 86 | 1,872 | 137 | 2,995 | 948 | 175 | 6,213 | 3,257 | 568 | 671 |
| | — | 2,296 | 142 | 3,147 | 1,049 | 1,581 | 8,245 | 3,913 | 679 | 1,175 |
| | 151 | 1,463 | 183 | 4,809 | 1,527 | 1,435 | 9,568 | 4,475 | 236 | 907 |
| | 24 | 1,241 | 128 | 6,132 | 1,353 | 1,563 | 10,441 | 3,961 | 228 | 645 |
| | 222 | 1,711 | 112 | 4,989 | 1,132 | 1,598 | 9,770 | 4,005 | 212 | 553 |
| | 921 | 1,164 | 78 | 3,569 | 1,069 | 891 | 7,692 | 3,863 | 223 | 476 |
| | 1,552 | 1,342 | 84 | 2,945 | 1,177 | 2,104 | 9,220 | 4,668 | 209 | 669 |
| | 223 | 1,090 | 20 | 1,851 | 1,123 | 1,700 | 6,013 | 2,761 | 193 | 600 |
| | 1,767 | 888 | 72 | 195 | 1,051 | 1,566 | 5,546 | 3,220 | 208 | 567 |
| | 1,789 | 886 | 137 | 1,229 | 1,987 | 1,458 | 7,486 | 4,341 | 219 | 375 |
| | 346 | 657 | 154 | 94 | 671 | 1,516 | 3,447 | 1,731 | 191 | 389 |
| | 351 | 572 | 81 | 50 | 331 | 1,386 | 2,771 | 1,423 | 182 | 320 |
| | 377 | 635 | 113 | 39 | 373 | 1,169 | 2,706 | 1,418 | 149 | 541 |

6

## TRAFFIC DEALT WI'

| STATION. | YEAR. | Supervisory and Wages (all Grades). | Paybill Expenses. | TOTAL RECEIPTS. | PASSENGER TRAIN TRAFFIC. | | | | | | |
|---|---|---|---|---|---|---|---|---|---|---|---|
| | | | | | Tickets Issued. | Season Tickets. | Receipts. | | | | |
| | | | | | | | Passengers (including Season Tickets, etc.) | Parcels. | Miscellaneous | | |
| | | No. | £ | £ | No. | No. | £ | £ | £ | | |
| **Highbridge to Taunton Passr.** | Newton Abbot (*contd.*). | | | | | | | | | | |
| | 1903 | * | 8,578 | 46,077 | 223,175 | * | 34,332 | 7,268 | 4,477 | 40 | |
| | 1913 | 151 | 11,460 | 55,177 | 252,341 | * | 43,259 | 6,560 | 5,358 | 53 | |
| | 1923 | 183 | 31,854 | 89,776 | 269,204 | 491 | 74,543 | 7,115 | 8,118 | 89 | |
| | 1924 | 183 | 31,762 | 92,459 | 250,845 | 416 | 76,815 | 6,682 | 8,962 | 91 | |
| | 1925 | 177 | 33,144 | 92,110 | 260,938 | 452 | 77,267 | 6,121 | 8,722 | 91 | |
| | 1926 | 177 | 30,712 | 89,815 | 233,821 | 406 | 72,893 | 9,368 | 7,554 | 89 | |
| | 1927 | 174 | 28,719 | 92,994 | 237,357 | 403 | 75,556 | 9,881 | 7,557 | 91 | |
| | 1928 | 176 | 28,233 | 94,415 | 238,774 | 375 | 76,417 | 9,901 | 8,097 | 90 | |
| | 1929 | 171 | 26,659 | 90,936 | 231,736 | 407 | 73,906 | 10,203 | 6,827 | 96 | |
| | 1930 | 172 | 26,777 | 89,922 | 215,335 | 609 | 72,394 | 10,824 | 6,704 | 89 | |
| | 1931 | 171 | 28,879 | 83,990 | 198,292 | 595 | 66,904 | 10,649 | 6,437 | 83 | |
| | 1932 | 170 | 29,375 | 78,011 | 186,257 | 641 | 61,151 | 10,468 | 6,392 | 73 | |
| | 1933 | 164 | 27,245 | 73,684 | 169,458 | 1,508 | 58,090 | 10,195 | 5,399 | 73 | |
| **Taunton Goods** | 1903 | * | * | 54,163 | | | | | | | |
| | 1913 | * | 3,209 | 57,522 | | | | | | | |
| | 1923 | 45 | 7,765 | 96,284 | | | | | | | |
| | 1924 | 48 | 8,693 | 96,904 | | | | | | | |
| | 1925 | 48 | 8,425 | 88,952 | | | | | | | |
| | 1926 | 50 | 8,244 | 91,118 | | | | | | | |
| | 1927 | 50 | 8,823 | 102,436 | | | | | | | |
| | 1928 | 52 | 8,660 | 97,175 | | | | | | | |
| | 1929 | 52 | 8,593 | 95,667 | | | | | | | |
| | 1930 | 52 | 10,290 | 97,148 | | | | | | | |
| | 1931 | 58 | 9,697 | 101,332 | | | | | | | |
| | 1932 | 56 | 9,263 | 83,265 | | | | | | | |
| | 1933 | 57 | 9,633 | 86,553 | | | | | | | |

**T STATIONS.**

GOODS TRAIN TRAFFIC.

| | Forwarded. | | Received. | | | Coal and Coke "Not Charged" (Forwarded and Received). | Total Goods Tonnage. | Total Receipts (excluding "Not Charged" Coal and Coke). | Livestock (Forwarded and Received). | Total Carted Tonnage (included in Total Goods Tonnage). |
|---|---|---|---|---|---|---|---|---|---|---|
| Coke "Charged." | Other Minerals. | General Merchandise. | Coal and Coke "Charged." | Other Minerals. | General Merchandise. | | | | | |
| ns. | Tons. | Tons. | Tons. | Tons. | Tons. | Tons. | Tons. | £ | Wagons | Tons. |
| 177 | 1,851 | 19,758 | 21,310 | 13,693 | 37,422 | 26,393 | 120,604 | 54,163 | 1,975 | 23,750 |
| 312 | 766 | 21,255 | 16,642 | 13,386 | 42,681 | 31,799 | 126,841 | 57,522 | 2,115 | 25,556 |
| 1,302 | 1,336 | 15,377 | 13,053 | 21,901 | 41,179 | 36,736 | 130,884 | 96,284 | 1,306 | 23,975 |
| 1,512 | 2,328 | 16,009 | 16,613 | 20,112 | 45,408 | 36,079 | 138,061 | 96,904 | 1,335 | 25,484 |
| 1,106 | 3,311 | 15,061 | 13,108 | 17,407 | 43,719 | 39,603 | 133,315 | 88,952 | 1,295 | 24,400 |
| 168 | 2,376 | 15,006 | 12,343 | 19,066 | 46,379 | 29,484 | 124,822 | 91,118 | 1,139 | 24,374 |
| 137 | 3,063 | 15,845 | 15,163 | 23,636 | 48,400 | 40,726 | 146,970 | 102,436 | 1,122 | 25,519 |
| 341 | 1,903 | 15,567 | 15,875 | 15,275 | 48,510 | 33,794 | 131,265 | 97,175 | 1,260 | 24,174 |
| 322 | 2,593 | 15,277 | 15,844 | 13,380 | 48,556 | 40,684 | 136,656 | 95,667 | 1,067 | 24,295 |
| 475 | 3,030 | 13,394 | 20,632 | 12,743 | 50,536 | 35,467 | 136,277 | 97,148 | 1,270 | 23,521 |
| 659 | 1,807 | 14,270 | 15,214 | 21,970 | 55,620 | 41,757 | 151,297 | 101,332 | 1,000 | 23,722 |
| 378 | 1,545 | 12,699 | 18,150 | 8,093 | 46,157 | 35,995 | 123,017 | 83,265 | 782 | 26,469 |
| 682 | 1,930 | 15,122 | 24,230 | 6,567 | 46,422 | 32,868 | 127,830 | 86,553 | 800 | 29,231 |

# Bibliography

## Books

Ahrons, E. L., *Locomotive & Train Working in the Latter Part of the Nineteenth Century*, Volume 4 (Heffer, 1952).

Biddle, G., and Nock, O. S., *The Railway Heritage of Britain* (Michael Joseph, 1983).

*Bradshaw's Railway Guide* (various years).

Clark, R. H., and Potts, C. R., *An Historical Survey of Selected Great Western Railway Stations*, Vols 1 to 4 (OPC, 1976–85).

Clinker, C. R., *Register of Closed Passenger Stations & Goods Depots* (Avon-Anglia, 1988).

Coleman, T., *The Railway Navvies* (Penguin, 1968).

Cooke, R. A., *Track Layout Diagrams of the GWR & BR WR*, Section 16 and 19A (1990 and 1992).

Hateley, R., *Industrial Locomotives of South West England* (Industrial Railway Society, 1977).

Lyons, E., *An Historical Survey of Great Western Engine Sheds, 1947* (OPC, 1974).

Lyons, E., and Mountford, E., *An Historical Survey of Great Western Engine Sheds, 1837–1947* (OPC, 1979).

MacDermot, E. T., Clinker, C. R., and Nock, O. S., *History of the Great Western Railway* (Ian Allan, 1964 and 1967).

Maggs, C. G., *Bristol Railway Panorama* (Millstream, 1990).

Maggs, C. G., *Rail Centres: Bristol* (Ian Allan, 1996).

Maggs, C. G., *GWR Principal Stations* (Ian Allan, 1987).

Maggs, C. G., *Taunton Steam* (Millstream, 1991).

Oakley, M., *Somerset Railway Stations* (Dovecot Press, 2002).

Oakley, M., *Somerset Stations Then & Now* (Dovecot Press, 2011).

Oakley, M., *Bristol Railway Stations* (Redcliffe, 2006).

Railway Correspondence & Travel Society, *Locomotives of the Great Western Railway*, Vols 1 to 14 (RCTS, 1952–93).

Thomas, D. St J., *Regional History of the Railways of Great Britain, Volume 1, The West Country* (David & Charles, 1981).

Whitbread, J. R., *The Railway Policeman* (Harrup, 1961).

Williams, F. S., *Our Iron Roads* (1883).

# Newspapers and Journals

*Bath & Cheltenham Gazette*
*Bath Chronicle*
*Bristol Gazette*
*Bristol Journal*
*Bristol Mercury*
*Bristol Standard*
*Bristol Times & Mirror*
*Engineering*
*Felix Farley's Bristol Journal*
*Illustrated London News*
*Railway Magazine*
*Somerset County Gazette*
*Western Daily Press*
*Weston Mercury*

# Index